NEW DIRECTIONS FOR PHILANTHROPIC FUNDRAISING

Cathlene Williams
Association of Fundraising Professionals

Lilya Wagner
The Center on Philanthropy at Indiana University

COEDITORS-IN-CHIEF

THE TRANSFORMATIVE POWER OF WOMEN'S PHILANTHROPY

Martha A. Taylor
University of Wisconsin Foundation
Women's Philanthropy Institute

Sondra Shaw-Hardy
Women's Philanthropy Institute

EDITORS

T0340157

JOSSEY-BASS™
An Imprint of
⊛WILEY

Number *50*
Winter *2005*

THE TRANSFORMATIVE POWER OF WOMEN'S PHILANTHROPY
Martha A. Taylor, Sondra Shaw-Hardy (eds.)
New Directions for Philanthropic Fundraising, No. 50, Winter 2005
Cathlene Williams, Lilya Wagner, Coeditors-in-Chief

NEW DIRECTIONS FOR PHILANTHROPIC FUNDRAISING (print ISSN 1072-172X; online
ISSN 1542-7846) is indexed in Higher Education Abstracts and Philanthropic Index.

Microfilm copies of issues and articles are available in 16 mm and 35 mm, as well as
microfiche in 105 mm, through University Microfilms Inc., 300 North Zeeb Road,
Ann Arbor, Michigan 48106-1346.

NEW DIRECTIONS FOR PHILANTHROPIC FUNDRAISING is part of the Jossey-Bass
Nonprofit and Public Management Series and is published quarterly by Wiley
Subscription Services, Inc., A Wiley Company, at Jossey-Bass, 989 Market Street,
San Francisco, California 94103-1741.

SUBSCRIPTIONS cost $109.00 for individuals and $228.00 for institutions, agencies,
and libraries. Prices subject to change. Refer to the order form at the back of this
issue.

EDITORIAL CORRESPONDENCE should be sent to Lilya Wagner, The Center on Phi-
lanthropy at Indiana University, 550 West North Street, Suite 301, Indianapolis, IN
46202-3162, or to Cathlene Williams, Association of Fundraising Professionals,
1101 King Street, Suite 700, Alexandria, VA 22314.

www.josseybass.com

Contents

What decision-making role does a husband or wife have over charitable giving? Brown presents answers based on research about couples and shows the differences when the decision maker is a woman.

more than $3 billion created by women since 1996 and highlight examples of several of these foundations whose grant making affects the lives of women and girls.

Taylor defines five new initiatives for the women's philanthropy movement and raises a call to action for women's philanthropy for this generation.

This chapter provides basic references on women's philanthropy by the editors, including the Six C's of women's giving, ten effective strategies for women philanthropists, and twelve tips for development professionals. Also included is a resource list of women's philanthropy national organizations.

Special Foreword

Dear Colleagues,

On behalf of the members and staff of the Association of Fundraising Professionals, I congratulate Jossey-Bass for the service provided to the philanthropic community by publication of New Directions for Philanthropic Fundraising. It has been our pleasure to be involved in coediting this publication with the Indiana University Center on Philanthropy since 2001, and we appreciate the opportunity it has given many AFP members to write meaningful, in-depth articles that have helped to advance our body of knowledge about fundraising and philanthropy.

Paulette V. Maehara, CFRE, CAE
President and CEO
Association of Fundraising Professionals

Dear Colleagues,

This issue of New Directions for Philanthropic Fundraising marks the end of a remarkable project initiated by Jossey-Bass in cooperation with the Center on Philanthropy and the Association of Fundraising Professionals (AFP). Begun in 1993, the quarterly series has resulted in fifty publications. It was designed as an instrument to mediate between research and practice. It often helped translate research into practice. It also often helped practitioners organize and formulate their thoughts about practical issues in ways that moved beyond anecdotal and experiential writing.

Papers from the center's annual symposium, "Taking Fundraising Seriously," have been published in twelve of the New Directions for Philanthropic Fundraising journals. Notable among these

NEW DIRECTIONS FOR PHILANTHROPIC FUNDRAISING, NO. 50, WINTER 2005 © WILEY PERIODICALS, INC.
Published online in Wiley InterScience (www.interscience.wiley.com) • DOI: 10.1002/pf.123

were the issues containing Paul Schervish's groundbreaking work on the new physics of philanthropy, the issue on professionalism in fundraising, and the best-selling issue of all time, *Women as Donors.* It is interesting to note that the first volume was entitled *Fundraising Matters*; this last volume will again be about women in philanthropy. This seems a perfect way to open and close the series.

The past fifteen years have seen a major rise in the number and quality of publications dedicated to theoretical and practical research related to philanthropy and fundraising. Publications such as AFP's *Advancing Philanthropy,* the Council for the Advancement and Support of Education's *Journal on Educational Advancement, Association for Healthcare Philanthropy Journal,* and the National Committee on Planned Giving's *Journal of Gift Planning* have all filled part of the niche that the New Directions for Philanthropic Fundraising series was meant to fill. Today, well-researched information, well-thought-out best practices, and the interpretation of research into practice are readily available to practitioners through a variety of media, including the Internet. It is our hope that loyal readers of the New Directions for Philanthropic Fundraising series will turn to these for the information they formerly found in New Directions. The center will continue to publish *Philanthropy Matters* as a way to interpret research for practitioners and will develop additional publications of its own related to the work of the Lake Family Institute on faith and giving, the Women's Philanthropy Institute, and the various symposia and conferences that it sponsors. On behalf of all who contributed to New Directions for Philanthropic Fundraising, thank you for your support. We hope you continue to view the Center on Philanthropy, Jossey-Bass, and the Association of Fundraising Professionals as primary sources for your continuing information needs.

Best wishes.

Cordially,
Eugene R. Tempel
Executive Director
Center on Philanthropy

Editors' Notes

AS THE TWENTY-FIRST century moves ahead, women continue to expand their knowledge, expertise, influence, and leadership in every aspect of our society, including business, government, and the non-profit and philanthropic sectors. Female-owned businesses generate $2.46 trillion annually, employ 19.1 million people, and account for nearly half of all privately held firms in the United States (Center for Women's Business Research, 2004) The National Bureau of Labor Statistics estimates that women will overtake men in management and professional positions over the next three decades.

In the world of professional philanthropy, women head some of the largest and most influential foundations, including the Ford Foundation and Pew Charitable Trusts. More and more women individual donors are either alone or with their spouse making the "Million Dollar List" created by Indiana University's Center on Philanthropy. Women already control more than 50 percent of the wealth in the United States. That number is bound to explode as women increase their earning power and as they receive, by virtue of outliving their male spouses by seven years, much of the projected $41 trillion transfer of wealth. Even today an estimated 90 percent of women are left in charge of family financial affairs at some point in their lifetimes. Armed with this impressive case, development professionals throughout the nation are developing increased focus and specialized approaches to working with women as donors. Women are poised to become significant philanthropists as never before, ready to transform the world and themselves in the process.

NEW DIRECTIONS FOR PHILANTHROPIC FUNDRAISING, NO. 50, WINTER 2005 © WILEY PERIODICALS, INC.
Published online in Wiley InterScience (www.interscience.wiley.com) • DOI: 10.1002/pf.124

Significant changes in the way fundraising is conducted have occurred in the past decade in particular. The male model worked well for many years with its "technocratic" way of approaching donors, especially male donors. This approach was hierarchical, based on loyalty, competition, and peer pressure. The changing demographics of the United States created a near revolution in the way fundraising is conducted. With the rise of women earning, inheriting, and controlling money, a new market exploded, and this market demanded a contemporary mode of approaching donors. The approach is based on connection rather than competition, relationships rather than individualism. These same techniques have been found to also apply to many male donors as well, particularly those who are baby boomers and Gen-Xers.

Some may even say that the modern women and philanthropy movement is a revolution. It has surely tranformed the way development is conducted. It has changed the face of the nonprofits and institutions that have benefited from women philanthropists' generosity. And it has transformed the lives of the women philanthropists in the process. But it has succeeded to its current degree of success only because of revolutionary women—women who were passionate about the possibilities of women and philanthropy and were willing to challenge time and again. Some of these women had advocated for the equal rights amendment in the 1980s, and others would never have identified themselves as feminists. But all shared a common sense of what women could accomplish with their philanthropic gifts once they had socioeconomic clout. This is the transformative power of women's philanthropy.

During the past decade, great strides have been made in women's giving through women's funds, United Ways, universities, giving circles, and community foundations. Women have given millions and millions of new dollars when they have found their voices through their philanthropy. Early on, the Indiana University Center on Philanthropy and Jossey-Bass Publishers recognized the impact of women on philanthropy and published two volumes on the subject. The first, printed in 1993 and edited by Joan M. Fisher and Abbie J. von Schlegell, dealt with women as donors, and the

second, published in 1998 and edited by Julie C. Conroy, focused on women as fundraisers.

This volume, *The Tranformative Power of Women's Philanthropy*, was compiled in large part from presentations delivered at a women and philanthropy symposium, "The Modern Women's Philanthropy Movement: Gaining Momentum," held to an overflow crowd in Indianapolis in August 2005 at the Center on Philanthropy. The discussions in the chapters that follow vary from the practical to the theoretical. The authors speak from their own personal experience or present research to underscore how women have brought about change in the ways women are approached to give but also the projects and programs to which they give. In addition, the chapters provide a means to encourage more deliberation on and research into these topics and to create a fresh level of knowledge and understanding. Only because of lack of space and time were some topics omitted. Further publications will be needed to address such topics as women, faith, and philanthropy.

The women who have contributed to this volume are pioneers in the field of women and philanthropy. They have had the vision to see what needs to be done to make the world a better place. We asked each of them to explain why they became interested in women's philanthropy and how they have adapted or challenged the status quo. Separately and together, their personal stories weave a story of the women's philanthropy movement that is gaining momentum.

Bonita Banducci, the author of Chapter Three, says that her passion and work for women's leadership took on a new dimension when she was an investor in the Hunger Project. She learned that the key to ending hunger in the world had been identified as investment in and development of women—including the poorest of poor women. At the United Nations Non-Government Organization Conference on Women in Beijing 1995, Banducci saw the need to foster the partnership of women in business with women in development for sustainable global development. Since then she has seen the field of philanthropy erupt with opportunities for powerful alliances of women from all sectors. She says that this is boldly

exciting to her and finds herself immersed in social entrepreneur projects where women in philanthropy are an integral part—and she is "a woman in philanthropy."

Jessica Bearman, one of the authors of Chapter Eight, says, "I have always been interested in women's distinct competencies and how those gifts can be used to make a difference in families, business, philanthropy, and in the larger society." Bearman believes that women's particular ways of doing things are often undervalued, especially when they diverge from a more traditional male model: "That's why I have been particularly fascinated by examples of successful ventures created by women that draw on women's strengths and preferences."

Watching the growth of women's giving circles has been inspirational to Buffy Beaudoin-Schwartz, another author of Chapter Eight. She says that this has had a profound effect on her both professionally and personally. "I have had so much fun encouraging the growth of giving circles that I have had to join a few too!" Beaudoin-Schwartz claims that her experience with giving circles has allowed her to stretch as a philanthropist while learning about grant making and issues affecting women and girls.

While teaching a course on the economics of gender and family, Eleanor Brown, the author of Chapter Five, developed an interest in how couples decide about saving, spending, and giving money. She says, "Through that course, I developed an interest in decision-making authority within couples, particularly in the importance of women's success in the labor market as it has an impact on and influences the disposition of household resources for discretionary purposes such as philanthropic giving."

Author and feminist philanthropist Tracy Gary, who wrote Chapter Seven, says her interest in women and philanthropy began when she attended her parents' events and funding meetings. "I became conscious in the 1970s how many men seemed to rule checkbooks and all the financial institutions and corporations." Through her mother's fundraising activities, Gary realized that women and girls seemed to be the majority of those in poverty and affected by discrimination. That led to her starting a women's fund

in the late 1970s. Never tiring, Gary says, "I find myself inspired today, even thirty-plus years later, by women's dedication and passion for justice."

Claire Gaudiani, the author of Chapter Two, attributes the dynamic women she met doing the research for her book, *The Greater Good: How Philanthropy Drives the American Economy and Can Save Capitalism*, as the reason for her focus on the unique role women have played in building American society. She says, "Women have given ideas, muscle, and money, yes to do good and also to help others do well. The history is rich, and the current energy continues in our midst today." Gaudiani refers to her "activist heart" when she says she wants to tell these stories to inspire girls and women of the twenty-first century to repeat and even exceed their female forebears.

Twenty years ago as a freelance researcher, Katherine Jankowski, one of the authors of Chapter Eleven, became interested in women and philanthropy. Over the next two decades, she continued her interest and read as much as she could about the subject. Today, as a partner in a research firm with her husband, Jankowski says, "I believe that women are poised to lead a new conversation about the role of private action for public good, and I see research as a way of connecting networks of philanthropists with organizations that effect change."

As a graduate student, Cynthia Jasper, the author of Chapter Four, received a doctoral fellowship from Helen Cooper Mercer whom she says she did not know and had never met. "The thoughtfulness of this gift was truly inspiring," she says. "And years later after hearing about the Center for Women and Philanthropy at the University of Wisconsin-Madison which was funded by Kathryn Vaughan, I thought of all the possibilities to help promote the generosity of women such as Helen Cooper Mercer and Kathryn Vaughan."

Jeanie Lovell, who wrote Chapter Ten, is another author whose experience in graduate school sparked an interest in women and philanthropy. She was looking for thesis topics, and the issue of women's impact within the intergenerational transfer of wealth

came to her attention. She says, "Working at a coeducational college with changing demographics, I was especially interested in learning more about women's philanthropy as I saw our donor base evolving, with women graduates now as the majority." Lovell was further inspired by the books, articles, and other written materials she read and the women she interviewed. "My passion for this topic has grown from there," she says.

Understanding women's giving patterns and developing an appropriate initiative in response to these patterns has been a major focus for Michele Minter at Princeton University. Minter, the author of Chapter Nine, says, "This rewarding experience as a fundraiser has been balanced by my work as volunteer chair for the grant-making committee of the Fund for Women and Girls at the Princeton Area Community Foundation." Minter believes that women have an increased awareness of the compelling needs pertaining to women and are maturing as independent philanthropists.

After working for theoretically progressive, male-led nonprofit organizations in the 1980s, Kimberly Otis, one of the authors of Chapter Eleven, says that when she went to work for a New York City–based women's organization, "working in a female-run environment opened up a new world of mentoring, mutual support, and purpose for me." She compared this experience with that of the male-led organizations: "As opposed to feeling like I was working for the man who was the head of the organization where I was employed, working for a women's organization felt more like I was working with a team for a good cause. It was not only a more nurturing environment, but also a much more inspiring and motivating one. I felt suddenly that if women could pull together, the potential for real social change was enormous."

Ellen Remmer's involvement with women and philanthropy began at home with the family foundation that she, her mother, and two sisters founded in 1990. The family dedicated the foundation to reducing the feminization of poverty by helping disadvantaged girls take charge of their lives. Remmer, the author of Chapter Six, says that while each of them has been profoundly affected by this shared philanthropic experience, the impact on her mother was

truly transformational. She says, "Mother had been very much the 'woman behind the man' in my father's successful business career. With the foundation and other philanthropic activities, she became an outspoken leader, advocate, and inspiration to others."

As a researcher, Tracey Rutnik, one of the authors of Chapter Eight, found that women were a central force in charitable giving and yet often were overlooked. "I believe that this is because they are underrepresented in the ranks of well-known philanthropists," Rutnik says. But she was thrilled when she found that giving circles present a new avenue for women to give, connect with one another, and demonstrate leadership in their communities and the field of philanthropy.

Our involvement began twenty years ago when one of us wondered why women were not giving to their educational institutions in the same way as they were represented as students and alumnae, and recruited the other of us to help her find out. Over those twenty years, women and philanthropy has been our passion. We truly believe we were called to this endeavor by something larger than ourselves. In the process, we have been privileged to be part of a national movement and to make the most incredible friends who were always assisting, creating, and supporting us in making women and philanthropy a mainstream cause.

We thank the Center on Philanthropy for its support of women and philanthropy and for providing a home for the Women's Philanthropy Institute. We especially appreciate the efforts of Andrea Pactor, program manager for the Women's Philanthropy Institute, for all her help with this volume. The University of Wisconsin Foundation, Lois Anderson, Jeanne Daniels, and Sharon Stark were also most helpful.

We are proud to have been a part of this significant effort and to see the gains made in the field of women and philanthropy. But as with any other major effort, it was done in conjunction with many, many people, several of whom have written chapters for this volume. All of the chapter authors lead busy and active personal and professional lives and yet found the time to share their distinctive point of view, including their successes and struggles, to increase

the library of written work on this important subject. We continue to be inspired by their experience and wisdom and thank them for always believing that women can and will make this world a better place through their philanthropy.

We thank our families for their devoted support to our life's work in women's philanthropy, especially our husbands, Gary Antoniewicz and the late Larry Hardy. We dedicate this volume to our mothers, Nedra Beatrice Chase and Esther Hougen Taylor, whose models of love and generosity to the world have been ours to emulate.

Reference

Center for Women's Business Research. "A Fact Sheet." Nov. 30, 2005. http://www.womensbusinessresearch.org/mediacenter/nationalstatetrends/total.htm.

<div align="right">

Sondra Shaw-Hardy
Martha A. Taylor
Editors

</div>

SONDRA SHAW-HARDY *is a cofounder of the Women's Philanthropy Institute and a speaker and consultant for the institute.*

MARTHA A. TAYLOR *is vice president of the University of Wisconsin Foundation, and cofounder of the Women's Philanthropy Institute.*

*Why did the modern women's philanthropy move-
ment come about, and how did it happen? Who was
involved, and what were their motivations? What
does this new way of giving and fundraising mean
for the future of philanthropy?*

1

The emergence and future of the modern women's philanthropy movement

Sondra Shaw-Hardy

TO GAIN MOMENTUM for the future, the modern women's philan-
thropy movement is building on the pioneering work of the past.
This chapter provides a brief review of the past that will help set
the stage for future trends. Appropriately, these trends will be
described in the words of contemporary women philanthropists.

History of the modern women's philanthropy movement

The modern women's philanthropy movement began as an out-
growth of the feminist movement with leaders like Gloria Steinem.
As women began obtaining economic independence through self-
employment or the change in marital tax laws, they gained control
of economic assets previously unknown to them. Building on their

NEW DIRECTIONS FOR PHILANTHROPIC FUNDRAISING, NO. 50, WINTER 2005 © WILEY PERIODICALS, INC.
Published online in Wiley InterScience (www.interscience.wiley.com) • DOI: 10.1002/pf.125

tradition of volunteerism, women began to use their monetary resources as never before and thus were able to see that philanthropy could have a major impact on society. As women understood the need to help women and girls gain economic independence and overcome issues of violence, they responded by establishing women's funds. This led to programs focusing on women and philanthropy in educational institutions, which were largely not focused only on women and girls, and, more recently, giving circles.

The women's funding movement began in 1977 when program officers in corporations and foundations and leaders such as Jing Lyman founded Women & Philanthropy to secure more funding for women and girls. In 1979 Tracy Gary launched the first modern women's foundation in San Francisco. The Women's Funding Network was founded in 1985 as a network for the women's funds. Early leaders were Carol Mollner, Marie C. Wilson, Mary Ellen Capek, Kimberly Otis, and later Christine Grumm.

On Mother's Day weekend in 1991, Martha Taylor and I visited Maddie Levitt in Des Moines, Iowa, and shared our vision of a national organization for women philanthropists. Through Levitt's belief in the vision and her generosity, the National Network of Women as Philanthropists (NNWP) was then established at the University of Wisconsin-Madison. The NNWP and media articles helped initiate the modern women's philanthropy movement. Fundamental principles of the women's funding movement were broadened beyond the focus of women and girls, and the message was taken into the mainstream of philanthropy. With Andrea Kaminski as executive director, NNWP was established as a clearinghouse of information on women's philanthropy and dedicated to education that included philanthropists, development professionals, and nonprofit leaders. NNWP launched a national newsletter, media articles, publications, and conferences in conjunction with several other groups, including the Council for Advancement and Support of Education (CASE).

Two important actions occurred during this time that accelerated the women and philanthropy movement. First, researchers and academics like Kathleen McCarthy (1982, 1990) and Theresa

Odendahl (1987) wrote books providing a historical perspective of women and philanthropy, building on the work of Gerda Lerner, emeritus professor of history at the University of Wisconsin–Madison. This was an enormous help in dispelling the notion that women had not been philanthropic and also provided role models for women of today.

The second was when the late Ann Castle established a bibliography of articles, books, dissertations, and other resources dealing with the topic of women and philanthropy. The development staff of The University of Michigan has honored Ann's memory by providing and maintaining a Web site (women-philanthropy. umich.edu) with this information.

In 1995, Taylor and I wrote the first major book about current women's philanthropy, *Reinventing Fundraising: Realizing the Potential of Women's Philanthropy* (Shaw and Taylor, 1995). Written for both women philanthropists and development officers, the book put forth a revolutionary concept: that women give differently than men do and want to be treated differently by development officers. Through focus groups and interviews, Taylor's and my research revealed women's primary motivations for their philanthropy that became known as "The Six C's of Women's Giving." Women want to give to change, create, commit, connect, collaborate, and celebrate. That same year, 1995, the first modern women's giving circle, the Washington Women's Foundation, was founded.

Other publications and articles appeared and began to form a body of literature around women and philanthropy. These included two in the New Directions for Philanthropic Fundraising series (Conroy, 1998; von Schlegell and Fisher, 1993). One important trend was the emergence of publications for philanthropists. In 1998 Tracy Gary and Melissa Kohner celebrated their new book, *Inspired Philanthropy: Creating a Giving Plan.* Although a useful guide for both men and women, Gary's long-time leadership as one of the founders of the women's philanthropy movement ensured that the principles of the book would be extremely valuable to women. The book became one the pillars in the donor education field and is now in its second edition.

NEW DIRECTIONS FOR PHILANTHROPIC FUNDRAISING • DOI: 10.1002/pf

In 2001, New Ventures in Philanthropy, a project of the Forum of Regional Association of Grantmakers, published *A Plan of One's Own: A Woman's Guide to Philanthropy*. This was a long-needed handbook for women. Buffy Beaudoin-Schwartz and the Association of Baltimore Area Grantmakers and WPI assisted in the development of this important and well-done publication.

Today more than one hundred women's funds exist in the United States and beyond. These funds have swept the country, advocating the support of women and girls especially as government funding has dwindled. One of the best resources on the history and future of the women's funds is *Women, Philanthropy, and Social Change: Visions for a Just Society*, edited by Elayne Clift (2005).

Beginning in the late 1980s and early 1990s, Martha Taylor from the University of Wisconsin Foundation, Madison, and Dyan Sublett and Karen Stone from the University of California Los Angeles created women and philanthropy major gift programs within higher educational institutions. Although slow to begin, these programs have continued to grow, particularly over the past five years. Even more important, hundreds of higher education institutions have embraced many of the concepts of the women's philanthropy movement by focusing more effort to involve and reach out to alumnae.

Colleen Willoughby from the Washington Women's Foundation led the recent women's giving circle movement where women pool their money and jointly participate in the grant making. The Women's Philanthropy Institute saw a need to provide a workbook for others who might want to start their own circle and has published a handbook, *Creating a Women's Giving Circle* (Shaw-Hardy, 2000). It has been estimated that more than two hundred types of women's giving circles now exist throughout the United States, most organized since 2000. Other forms of giving circles include the more than sixty United Way Women's Initiatives that have been formed since 2002 under the leadership of Melanie Sabelhaus, and the Impact 100 groups that also began in 2002 with Wendy Hushak Steel's guidance.

The movement's primary achievement is that it spawned individual women's gifts to programs of their choice ranging from the

environment and education to human services and cultural organizations. These women and their gifts have been incredibly important in giving the movement credibility. Maddie Levitt, Toby Lerner Ansin, Kay Vaughn, Oseola McCarty, Mary Gellerstedt, Nikki Tanner, Lindsay Morgenthaler, and many, many others stepped forward to lead the way in the early years of the modern women's philanthropic movement.

In October 1992, the Johnson Foundation and the University of Wisconsin-Madison sponsored a conference at Wingspread, the foundation's Conference Center in Racine, Wisconsin, to "address the complex issues of women's giving, including: the underlying values and attitudes of women and their roles as philanthropists; the worth of women's philanthropic activities; the different strategies and expectations of women as philanthropists; and the impact of women on public and private philanthropic organizations and foundations" (Thompson and Kaminski, 1993, p. ii). Leaders of the fledgling movement were invited and included one-third philanthropists, one-third nonprofit leaders, and one-third development officers. Donna E. Shalala, then University of Wisconsin-Madison chancellor and later secretary of health and human services under President William Clinton, gave the keynote speech on the first evening of the conference. She set the stage for the future in her keynote address when she said, "The new presence of women in philanthropy will open doors in a way that will have enormous resonance. . . . We will be able to create a new agenda with philanthropic power" (Thompson and Kaminski, 1993, pp. 4–5). Marie C. Wilson, then president of the Ms. Foundation, challenged the women present: "Something has so changed that we can have the kind of discussions we have been having today. Even a year and a half ago, we wouldn't have gotten women in the room asking, 'How do we build on our success?'" (Thompson and Kaminski, 1993, p. 29).

Many of the key leaders in women's philanthropy both then and over the next decade were at that October 1992 conference, including Mary Ellen Capek, Joan Fisher, Mary Caroline "Twink" Frey, Tracy Gary, Walteen Grady Truly, Kathleen D. McCarthy, Carol

Mollner, Wenda Moore, Catherine Muther, Kimberly Otis, Nicki Newman Tanner, and Martha Taylor. Strategic research and action steps were identified in creating a common agenda for women and philanthropy that would last over a decade.

Of the eight goals established at the Wingspread conference, three have been well addressed in these past twelve years: learn from organizations that have been successful in women's giving, promote women as leaders of traditional philanthropic organizations, and educate women about the merit and power of philanthropy and encourage them to pass this value on to future generations. Of the other goals, one in particular has fallen short: develop a shared marketing campaign to publicize the value of women's philanthropy. It is time to reenergize and set new goals to continue moving forward, which is what Taylor has done in the final chapter of this book.

The media's role in creating the movement

Of special interest is the key role of the media in forwarding the movement. The women's historian Gerda Lerner believes that groups not in power use underground ways of communicating and "create spaces for the exchange of ideas" (Lerner, 1993, pp. 232–233). Women's magazines and networking groups are ways women have built up their power structure and means to communicate over the years. Suffragettes used the newspapers and the women's club networks to advance their agenda to improve the status of women. This tradition continues today.

In 1991 *Ms.* magazine published two of the first articles about women and philanthropy entitled: "Confessions of a Feminist Fund-Raiser" by Kim Klein and "Funding Strategies for the 90s" by Laura Lederer. In 1992, Holly Hall's "Women's New Charity Clout" in the *Chronicle of Philanthropy* started her career in following the movement. In the next few years the *New York Times*, *Chronicle of Higher Education*, *Glamour*, *Working Woman*, and others published articles that also framed the beginnings of the growth of the movement.

But more than that, two major groups or movements started from news articles. The first was the Women's Philanthropy Institute (WPI). An article by Anne Matthews in the April 7, 1991, *New York Times Sunday Magazine*, "Alma Maters Court Their Daughters," featured Martha Taylor and the women's initiative of the University of Wisconsin Foundation, Madison. After reading the article, more than two hundred people contacted her. This interest and mailing list eventually led to the founding of the National Network on Women as Philanthropists by Sondra Shaw-Hardy and Martha Taylor in 1991, which has evolved into WPI, now part of the Center on Philanthropy at Indiana University.

The second is the *People* magazine article in 1998 featuring Colleen Willoughby and the Washington Women's Foundation (Miller and Kelley, 1998). This was the first publicity about the modern version of a major giving circle—not the old circle where a dollar or two was given. This new concept involved women giving a thousand dollars or more a year and voting on the use of the funds. The interest from that article launched the women's giving circle movement as it is known today. I got inspired and involved, founded a circle, and wrote a handbook on the concept. Others emulated the idea. New Ventures in Philanthropy organized a think tank in 2004 and issued a comprehensive report on giving circles by Jessica Bearman and Tracey Rutnik (2005).

Another form of giving circle, Impact 100, also was featured in an article in *People* magazine in 2003 (Grisby and Smolowe, 2003). From that article, the Cincinnati-based group led by Wendy H. Steele has spawned five more groups. An article in the August 2002 *Real Simple* magazine (Korelitz, 2002) inspired twenty Womenade giving circles around the country.

Future trends for women and philanthropy

From the 1970s to the 1990s, women's philanthropy slowly gained momentum primarily due to media attention and women's growing educational opportunities and life choices. Over the past decade, this

movement gained speed, particularly with the emergence of women's giving circles. Building on this momentum, several women were asked their opinions as to what the next decade holds. All of them believed women's philanthropy will not only continue to gain momentum, but will become a dynamic force and surely lead the way in all philanthropy and fundraising for these six reasons.

First is the acceleration of women's financial awareness, earnings, assets, and savvy. According to best-selling author Jennifer Openshaw (2002), "Any way you cut it, the largest bulk of inheritance assets eventually will end up in the hands of women in the next ten years" (p. 42). According to Paul Schervish and John Havens (1999), those assets could range from $46 trillion to $131 trillion. Along with that, women's career choices, earning power, and education levels will play a major role in women's increasing role in philanthropy over the next decade. But the major impact will be women's understanding of their finances and the power associated with that money. Tracy Gary has said that women's financial savvy will be to this generation what getting the vote was to their grandmothers and a driver's license to their mothers.

Second, women will increase their willingness to use their financial power to address the challenges and needs of society. Christine Lodewick from Connecticut, a philanthropist to her alma maters, the University of Wisconsin-Madison and the University of Connecticut, and to minority girls' programs in her community, says, "Women are learning not only to demand equal opportunity and recognition for their work, but also that having more power and money brings with it an increased responsibility to share." Lodewick states that "many of us older women still do not make that connection and younger women need to be taught the lessons."

As a result of studying earlier generations of women, author and professor Claire Gaudiani says, "American women are living the best and healthiest lives that any women have ever lived anywhere at any time. We are the generation of women that the world has been waiting for and we should do more than soak up the good life to make up for what previous generations did to make our lives what they

are." She believes that women can and will be the powerful break-through as thinkers and donors to address society's problems.

Third, through women's increased participation in the corporate and business world, they will direct this to giving back. Women have always seen societal needs and addressed them with their time. But with the emergence of women's financial awareness and success in the corporate world, women will be able to do this with both their time and their money. Leslie Lee, a founder of US Robotics, recently gave a $1 million gift to Inland Seas, an environmental group in northern Michigan that educates young people about the Great Lakes. Lee believes men give as a "form of currency . . . as a way to sit on a board." Lee gives because she is grateful and wants to give back. She stressed that as more and more women enter the corporate world, they will "feel grateful and obligated," as she does, "to give back."

Deborah Pass owns ATS Services with twenty-two offices in the Southeast and heads her family foundation. She states that in the corporate world, philanthropy is an educational process for women: "The more women learn and understand the process of giving, the more their giving is elevated and they see how their gift will make a difference and an impact. Then they educate others." The idea of leaving a legacy of giving back also plays a part here, as Pass points out that this educational process is happening in families as well, with women teaching their children about giving and giving back.

Fourth, women will continue to support women's giving circles and women and philanthropy programs. The Six C's of women's giving—create, change, connect, commit, collaborate, and celebrate—help explain many of the reasons that giving circles and women and philanthropy programs have become so popular. Women like to do projects with one another and do them in a way that addresses societal needs while also being fun. Emeritus professor and Television Food Network producer Doris Weisberg from Manhattan is a philanthropist for higher education and culture. After she became engaged in the University of Wisconsin–

Madison's higher education women's philanthropy program, she credited the program with her reason for making significant gifts to the university. "Because the institution had a special effort for women, I knew that I as a woman would be valued. My interest was piqued. I became involved and met some of my new best friends. Women's programs are an excellent way to involve women donors in a significant way."

Fifth, more women will give because they will be asked. The major reason women have said they did not give was that they had not been asked. But that is changing. Paula Smith from Tallahassee, Florida, has long been involved as a volunteer fundraiser. As chair of the $100 million Tallahassee Performing Arts Center campaign, she says that both women and men are being asked to give to the capital campaigns she has been involved with. Smith says in the past, only men were asked because it was believed that they controlled the money. "In more recent campaigns, volunteers and development staff have become aware of women's financial ability," Smith says. In addition, Smith believes that women themselves now understand that to get attention for their cause, they may have to give first.

Sixth, women will give more through major gifts and accept public recognition for their gifts. Many past gifts made by women were given anonymously and not revealed during their lifetimes. Yet Carolyn Planck made a substantial bequest to her alma mater, Purdue University, and allowed her name to be used. Planck said recognition was not a motivator; she wanted to encourage other women to give. She pointed out that unless you give, you do not have the power to ask. Planck says, "I have seen more and more women asking and suggesting that one another give. I believe that younger women are more willing to have their gifts recognized and hope women's anonymity is no longer an issue in years to come."

Conclusion

Women's philanthropy will increase in the next decades in response to human need and the opportunity to change the world. Since the

late 1970s when the modern women's philanthropy movement began, its growth has been astounding. Based on a strong past and foundation of altruistic principles, the movement will grow exponentially as women reach their full potential as philanthropists. As financial institutions begin paying much more attention to women and their investment potential, so too will institutions and organizations because, as Debaise (2004) wrote on the *Wall Street Journal* newswires, "Women have become the power behind the pen when it comes to charitable giving."

Based on the enormous growth of the modern women's philanthropy movement, particularly over the last decade, I am suggesting that three more Cs can be added to the Six C's that have explained women's philanthropic motivations. But these three C's are as a result of the motivations. They explain what women will be doing with their philanthropy: control, confidence, and courage. Women will take control of their money and their finances while insisting that institutions and organizations be held accountable for their gifts; become confident about their financial situation and their abilities as philanthropists and, as a result, be able to develop giving plans for their philanthropy; and have the courage to look at their values and the issues of society and use their philanthropy to help solve these issues. They will know that not everything will succeed, but that they were there, they cared, and they made a difference.

References

Bearman, J., and Rutnik, T. *Giving Together: A National Scan of Giving Circles and Shared Giving.* Baltimore, Md.: New Ventures in Philanthropy, 2005.

Castle, A. "Women and Philanthropy Bibliography." N.d. http://www. women-philanthropy.umich.edu/donors/.

Clift, E. (ed.). *Women, Philanthropy, and Social Change: Visions for a Just Society.* Medford, Mass.: Tufts University Press, 2005.

Conroy, J. C. (ed.). *Women as Fundraisers: Their Experience in and Influence on an Emerging Profession.* New Directions for Philanthropic Fundraising, no. 19. San Francisco: Jossey-Bass, 1998.

Debaise, C. "Women's Charitable Giving Exceeds Men's, Study Shows." Dow Jones Newswires, Dec. 16, 2004.

Gary, T., and Kohner, M. *Inspired Philanthropy: Creating a Giving Plan.* Berkeley, Calif.: Chardon Press, 1998.

Grisby, L., and Smolowe, J. "A Grand Hand." *People*, Jan. 27, 2003, pp. 107–108.

Hall, H. "Women's New Charity Clout." *Chronicle of Philanthropy*, June 16, 1992, pp. 1, 22–25.

Klein, K. "Confessions of a Feminist Fund-Raiser." *Ms*, Nov.–Dec. 1991, pp. 34–37.

Korelitz, J. H. "Second Helpings." *Real Simple*, Aug. 2002, pp. 85, 86, 88, 90.

Lederer, L. "Funding Strategies for the '90s." *Ms*, Nov.–Dec. 1991, pp. 38–42.

Lerner, G. *The Creation of Feminist Consciousness: From the Middle Ages to Eighteen-Seventy*. New York: Oxford University Press, 1993.

Matthews, A. "Alma Maters Court Their Daughters." *New York Times Magazine*, Apr. 7, 1991, pp. 40, 73, 77, 78.

McCarthy, K. D. *Noblesse Oblige: Charity and Cultural Philanthropy in Chicago, 1849–1929*. Chicago: University of Chicago Press, 1982.

McCarthy, K. D. *Lady Bountiful Revisited: Women, Power, and Philanthropy*. New Brunswick, N.J.: Rutgers University Press, 1990.

Miller, S., and Kelley, T. "Charity Belle: Colleen Willoughby Helps Women Give Money Away." *People*, Nov. 30, 1998, p. 149.

New Ventures in Philanthropy. *A Plan of One's Own: A Woman's Guide to Philanthropy*. Washington, D.C.: Forum of Regional Associations of Grantmakers, 2001.

Odendahl, T. "Lady Bountiful and Her Good Works." In *Women and Philanthropy: Past, Present and Future*. New York: Center for the Study of Philanthropy, Graduate School and University Center, City University of New York, 1987.

Openshaw, J. "Pulling Their Own Purse Strings." *Case Currents*, Mar. 2002, pp. 40–47.

Schervish, P., and Havens, J. *Millionaires and the Millennium: New Estimates of the Forthcoming Wealth Transfer and the Prospects for a Golden Age of Philanthropy*. Chestnut Hill, Mass.: Center on Wealth and Philanthropy, Boston College, 1999.

Shaw, S., and Taylor, M. *Reinventing Fundraising: Realizing the Potential of Women's Philanthropy*. San Francisco: Jossey-Bass, 1995.

Shaw-Hardy, S. *Creating a Women's Giving Circle*. Indianapolis: Women's Philanthropy Institute, Indiana University, 2000.

Thompson, A. I., and Kaminski, A. R. *Women and Philanthropy: A National Agenda*. Madison: Center for Women and Philanthropy, University of Wisconsin, 1993.

von Schlegell, A. J., and Fisher, J. M. (eds.). *Women as Donors, Women as Philanthropists*. New Directions for Philanthropic Fundraising, no. 2. San Francisco: Jossey-Bass, 1993.

SONDRA SHAW-HARDY *is a cofounder of the Women's Philanthropy Institute and speaks and consults for the institute.*

Women's philanthropic efforts throughout American history have created a transforming asset in the economic growth of the country, particularly in the arenas of upward mobility and human capital.

2

How American women's philanthropy helped build economic growth and a democratic society

Claire Gaudiani

THE PHILANTHROPIC WORK of American women has created a transforming asset in the economic growth of the country. Women's work has long been credited as a critically important asset to social life in community (McCarthy, 1990). This community or social uplift work has also powerfully strengthened the American economy in two critical ways. One is upward mobility. People in America's lower-income quintiles can advance and move up the ladder of success. More important, they know their children can. As a consequence, larger numbers of them work harder and invest in themselves, becoming assets to both themselves and the economic growth of the country.

The other is comity. Comity defines goodwill and cooperative spirit. Despite the many social injustices that are rampant in our country, comity characterizes American citizens' behavior toward one another despite socioeconomic differences. The poor do not hate the rich, and the rich do not despise the poor. Crime in America is not

class warfare. America's wealth does not need to live behind barbed wire fences or drive in armored vehicles to defend against fellow citizens. When compared with European countries, the upward mobility and comity developed by women's philanthropy have created a high level of positive economic impact in America.

This distinctive work of community and comity building is challenging and complex. Women's generosity has taken the lead by making breakthrough investments. Only later have the government and the private sector seen the wisdom of these solutions. Using their philanthropy to effect dramatic improvements in the opportunities for human capital advancement, generous women have enabled our economy to address complex problems efficiently and peacefully and to generate new assets in a timely way to meet economic and social needs. These outcomes have contributed to economic prosperity as they have bred both upward mobility and comity in America. At the conclusion of this brief overview, I will suggest the challenge that this history of American's women's philanthropy offers urgently to contemporary American women in our post 9/11, post-Katrina environment.

The breakthrough approaches that women's generosity has funded have transformed society so wisely and efficiently that they have often become a standard part of American life. Generally taken for granted within less than a generation, little national memory remains about how they came about or who put them in place. Many of these breakthrough solutions became a normalized part of life in which men and often the government became co-investors over time. This assimilation of tested philanthropic advances by women offered continuing benefit to the development of human capital and economic growth over decades, and even centuries.

Women's generosity initiates upward mobility

A signal attribute of American life is sending children of lower economic means to college on scholarship. This breakthrough idea in America began with Lady Mowlson, Anne Radcliffe, very early

in American history. In 1643, this wealthy childless woman gave the first scholarship fund to the first, and then only, colonial college, Harvard, which had been founded in 1636. Her scholarships gave the academically able sons of farmers and blacksmiths the financial support they needed to complete their higher education. The social implications were considerable.

Not only did her gift create a breakthrough in access to higher education for those whose family income would have precluded it, it also inspired the generosity of the very farmers and artisans whose sons had benefited or could benefit at some future time. Beginning in 1651, these working colonists voluntarily sent bushels of grain to the college to support the work there (Spain, 2001). A kind of first annual fund drive, the so-called corn tax, set a new standard of citizen engagement in funding education by diverse income levels. Not just a task for the wealthy, generosity slowly became something people of all income levels did. All levels felt responsible to ensure continued positive outcomes for the greater good.

Generosity at all income levels became a cultural norm in America 125 years before the sentiments of mutuality and commitments to equality were penned into the Declaration of Independence in 1776. Since Radcliffe's breakthrough gift, other Americans have followed her example and have given billions of private dollars to educate people outside their own families. Many millions of people from all over the world wanted to come to America because they learned of this cultural norm that could help to advance children of academic promise regardless of their provenance.

Rebecca Gratz, born in 1781, had another breakthrough idea for the new Republic: to develop and fund ways to enable Jewish immigrants—and eventually all immigrants—to remain fully within their religious and cultural heritage and also become fully American. We have been people of the hyphen ever since. In 1801, Gratz founded and served as secretary of the earliest women's philanthropic group in Philadelphia, the Female Association for the Relief of Women and Children in Reduced Circumstance. And in 1815 the Philadelphia Orphans Society showed her the desperate circumstances of poor widows and abandoned children (Ashton, 1998).

She became a major donor and fundraiser as well as a volunteer leader in defining a new identity for American women, including not only providing sustenance, both material and spiritual, to those in need, but legitimizing the preservation of the cultures and religions families came to America with while also becoming fully Americanized. Since she drew her friends from many different backgrounds and was surrounded by an active Christian community, she refused to let groups isolate themselves from each other. Since she believed Jewish women were uniquely responsible for the preservation of Jewish life in America, she worked to induce this thinking into Jewish communities and other ethnicities as well. Neither abandonment of cultures of origins nor isolating balkanization satisfied her.

Americans now consider this integration one of the hallmarks of our unique culture. Few of us realize that this breakthrough idea was promoted and funded by the wealthy daughter of a long line of respected rabbis and enterprising merchants. Gratz's idea set an example for how more good and less conflict could come to America from the stream of immigrants who arrived. They have proved to be a critical part of our economic success.

Mary Elizabeth Lange, a Haitian immigrant born in 1784, had her own breakthrough idea in 1827. Before the end of slavery, she decided that black children should be educated and that blacks could be teachers. With the approval of the archbishop of Baltimore, she founded a Catholic religious order, the Oblate Sisters of Providence, dedicated to the education of black children. She wanted them to be assets to themselves and to their country.

Lange and her mother had come to America in 1817 and eventually settled in Baltimore, a city with many French-speaking whites who had fled there during the French Revolution and many blacks fleeing Haiti's revolution. She was drawn to caring for people in need, but these activities, including religious ones, were segregated in Baltimore at the time. Only white women were accepted into religious orders. Although Maryland did not forbid the education of black children as some other states did, Lange saw that the education of blacks was extremely poor, especially that of

Catholic black children. After founding her religious order, Mother Elizabeth and her nuns founded schools with contributions from white and black members of the French-speaking Maryland community. As enrollment grew, the nuns made arrangements to secure larger and larger buildings and then took their mission to establish schools for their charges beyond Baltimore, to Philadelphia, New Orleans, and St. Louis. The order expanded its work to the Caribbean and Central America.

Mother Elizabeth's commitment to ensuring the education of black children played a critical role early in American history. Her courage in acting on her belief and engaging others to contribute to the mission created early forceful testimony to the drive for the end of slavery and the contributions that the country could expect from all who inhabit it. The Oblate Sisters of Providence are the order of nuns that educated Camille Cosby, wife of comedian Bill Cosby, who recently made a major contribution to the order, a wonderful example of giving back in gratitude. Mother Elizabeth focused on this work decades before this mission was on the agenda of Julius Rosenwald, Mother Katharine Drexel, the Rockefeller family, and countless other generous Americans.

Women's giving tackles social problems

The generosity of women has also tackled the problems of poverty, social dislocations occurring during periods of economic change, and transformations in the way medical care is delivered to patients. These gifts established new and effective ways to deal with complicated, multitiered problems. Consequently, the United States was spared potentially violent reactions to these problems. In other cases, funds already being spent had a higher, better impact as a result of these investments. In all cases, the women's philanthropy-funded solutions to highly complex and costly social problems became the standard of treatment of these challenges, transforming both our society and our economy.

One interesting example began in 1830. As the economy was shifting from largely agricultural and rural venues to the urban centers of the industrial revolution, a serious problem of great complexity arose that became more urgent during, and as a consequence of, the Civil War: family life changed dramatically. Women witnessed the devastating changes in the lives of their friends whose husbands were absent or had been killed. Widows and orphans had been more easily absorbed into farm homesteads in rural communities than was possible in the manufacturing economies in urban settings. Working outside the home was not a condition of gentlewomen, and if a woman began working, even to keep her children fed, she was recategorized as a "decayed gentlewoman." Her children could not marry in her former social tier, and her friends could not maintain relationships with her.

Women's philanthropy developed a dramatic solution to this problem. Groups of women in homes with a husband provider met to figure out how to help their unfortunate sisters. They decided to let these women's talents support their families, but not by working outside the home. Many of the widowed or abandoned mothers had needlework skills of various sorts. Others had highly specialized cooking and baking skills. The comfortably placed women decided to purchase, with their own resources, the finest materials: silks and satins and the most elegant culinary ingredients. They gave them to their widow sisters to confect as they wished and returned to gather the handiwork and sell the items in what came to be called Women's Exchanges. The makers of these elegant products received all of the profits of the sales.

Society was not offended. Households were held together. A social problem was resolved and had the added impact of teaching the managers of the exchanges how to run businesses. They ran them throughout the nineteenth and twentieth centuries in cities across the nation. Some elegant stores like Bergdorf Goodman in New York City purchased the exquisite items for resale. This new experience, shared across generations of mothers and daughters, raised expectations for additional education, for voting rights, and opportunities to pursue work for salaries (Sander, 1998). Women's

exchanges offered an opportunity for economic independence and integrity of the family and society at a time when many families would have gone to the poorhouse in countries without imaginative philanthropy.

Women's giving builds human capital

Mary Garrett had a breakthrough idea that she funded into existence. Like Anne Radcliffe and Elizabeth Lange, Garrett changed America. Mary Elizabeth Garrett was the only daughter of John Work Garrett, president of the Baltimore & Ohio Railroad, the country's first major railroad. Born in Baltimore in 1854, Garrett used her great wealth consistently to advance women's causes just as her grandfather and her father had built their financial and railroad wealth. She brought powerful vision and effective strategies to create breakthroughs that remain remarkable. In 1884 the president of Johns Hopkins University asked her if she would contribute to the campaign for the new medical school. Instead, she offered to fund the whole effort if, from opening day, Hopkins would admit women on the same basis as men. Garrett thus enabled medicine to become the first of the major professions to be open to women. With a stroke of her pen confirming the gift, Garrett saw to the enabling of women's human capital to the medical profession instead of continuing the withholding of 50 percent of the available capital to that profession. Other medical schools followed, and the legal profession made similar steps soon after. This was another step for economic gain for the country.

In 1889 with the Founding of Hull-House in Chicago, Jane Addams led one of these attacks on a complex social problem that had wide economic as well as social reform impact. She and a cohort of supporters, including Ellen Gates Starr, Louise de Koven Bowen, and Mary Rozet Smith, confronted the potentially explosive challenge of urban migration. Masses of poor immigrants were arriving in America from largely rural areas of Europe, and African Americans were fleeing the repressive Jim Crow laws in America's

South. They lived in dauntingly cramped quarters in tenement houses that lacked bathing facilities and had too few sanitary facilities; disease and poverty ran wild there. Tuberculosis decimated the population. The lack of language ability and urban work and life habits made every day a disaster for these new arrivals in America's northern cities.

Addams not only proposed centralizing support resources for these families; she and her colleagues often lived in the settlement houses. Eventually more than four hundred settlement houses offered English language lessons, work readiness and job placement, access to bathing, and help in improving health and sanitary conditions appropriate for urban life. Addams's inspired work not only relieved human suffering, but also offered a rapidly industrializing nation a large and available workforce that, for instance, built cars in Detroit and made steel in Pittsburgh.

The reforms engendered by the settlement houses included the nation's first juvenile court, the Immigrants' Protective League, the Juvenile Protective Association, and the Juvenile Psychopathic Clinic, later called the Institute for Juvenile Research. Addams and her colleagues coaxed the Illinois legislature to enact protective legislation for women and children and in 1903 to pass a strong child labor law and an accompanying compulsory education law. They expanded their efforts to reach the national dimension with the creation of the Federal Children's Bureau in 1912 and the passage of a federal child labor law in 1916. The investment in protecting and developing human capital connected the work of Jane Addams to both social and economic growth.

Caroline Phelps-Stokes, the daughter and granddaughter of highly successful businessmen-entrepreneurs, spent her own life in philanthropic activities that, paralleling Garrett's contribution to women in medicine, made a dramatic change in the education of African Americans and Native Americans in the United States. She left a substantial estate that, in 1911, founded the Phelps-Stokes Fund. She directed that the fund be focused on "the creation and improvement of dwellings in the City of New York for the poor families of the city, and for the education of Africans, African-

Americans, and American Indians, and needy white students" (Phelps-Stokes Fund, 1989).

The Phelps-Stokes Fund contributed to basic change in American society. It went beyond simply charity to create a factual basis for social policy. It commissioned studies and reports that presented the statistics needed to develop new policies. Quantitative analysis of social problems was pioneered by both Olivia Sage through the Russell Sage Foundation and by Phelps-Dodge. In 1907–1908, Sage's foundation produced and funded the first quantitative studies of poverty, and with this study, the Pittsburgh Survey, brought a professional and contemporary scientific approach to drawing attention to profound social problems. One of the Phelps-Stokes Fund's first studies, "Negro Education in the United States," completed in 1912, detailed the differences between white and black schools and outlined the inadequacies of the segregated system. It demonstrated the flaws in the effort to sustain separate but equal schools almost fifty years before *Brown v. Board of Education.* The work of the fund and of Caroline Phelps-Stokes developed human capital among African Americans and Indians and poor Americans generally. Through the dissemination of its studies, it also raised the social conscience of other Americans, who became convinced that the nation could improve its treatment of these peoples and experience a greater good in society.

The fund went beyond commissioning reports; it acted on their findings and implemented changes, most often by supporting new or grassroots organizations that carried out the work. Among many others, the Phelps-Stokes Fund nurtured the Citizens Housing Council of New York, the Boys Choir of Harlem, the Harlem Youth Development Foundation, and the Jackie Robinson Foundation. Each of these organizations is now independent and embarked on significant projects that create opportunities for minorities in both the United States and Africa.

However impressive this list of organizations, the Phelps-Stokes Fund may have made its most lasting impression with one single effort. Endeavoring to build strength in schools and colleges focused on minority students, it began supporting the best of the historically

black colleges and funding scholarships for black students to attend these schools. The nation's 105 historically black colleges and universities consist of private liberal arts colleges such as Spelman, land grant institutions such as Tennessee State University, graduate and professional schools such as Howard Medical School, and two-year community colleges. Ultimately Phelps-Stokes Fund president Frederick Douglass Patterson conceived and developed the United Negro College Fund, which became an independent entity in 1944.

Countries experiencing the alienation of the poor and of workers predicted by Marx did not have their own Jane Addams, Carolyn Phelps-Dodge, and Olivia Sage. Their poor and minority populations had few powerful advocates to invest in their well-being and upward mobility. These nations experienced the violence of the Bolshevik revolution of the early twentieth century. In America, these women's generosity contributed to a rising consciousness about the greater good served by healthy relationships across income groups and the possibilities for upward mobility for those born elsewhere or born poor or both. Women's caring for others through their financial and volunteer generosity created hope, contributed to a growing black and immigrant middle class, and enabled improvements in the social relationships across income groups. The resulting comity and upward mobility added to America's economic advances during the century.

Twentieth-century women's gifts sustain the tradition

American history is full of these examples. Katherine Dexter McCormick and Margaret Sanger took on the earliest stages of developing the scientific research that eventually produced oral contraceptives. The scientific and social complexity of this venture marks one of the twentieth century's greatest battles, which is continuing on into the twenty-first century. Mary Lasker not only funded medical research with her husband, Albert Lasker, but had the breakthrough idea to engage federal dollars into funding this

area critical to a healthy population and lengthening average life span. Candy Lightner took on the complex social problem of drinking and driving. She and her colleagues collected funds to create a national movement, Mothers Against Drunk Driving, whose cause was the wholesale criminalization of driving under the influence of alcohol.

As a final example of women's work for society and the economy, while Mary Lasker was urging the Senate, House, and president to put tax dollars into medical research, the Mothers' March of Dimes mobilized across the country. Mostly women, the March was witness to the belief that ordinary people could be part of the assault on the poliovirus. These women collected 4 billion dimes from 89 percent of the American population over a seventeen-year period from 1938 to 1954 (Carter, 1961). The laboratories at the University of Pittsburgh where the first vaccine was discovered received March of Dimes funds. But this groundbreaking effort also funded wheelchairs and iron lungs for children and gave fellowships to young scientists studying for doctoral degrees in microbiology. These "dime at a time" funds gave the nation the first massive infusion of capacity in this new field. They contributed to the creation of the dramatic dominance of the United States in medical and pharmaceutical research. These gifts continue to work for us today. The idea that citizens' generosity can change the pace of scientific research has caught on globally. Few diseases lack a group of people raising funds to advance research to reduce the impact of the condition on its sufferers.

Later-twentieth-century women like Clare Boothe Luce had their own breakthrough ideas. After her own stunning career culminated in the U.S. ambassadorship to Italy, Luce noted that too few women pursued doctorates in the physical sciences and engineering. She left a bequest to fund young women pursuing these areas to the highest levels, including undergraduate, graduate education, and full funding for the most gifted students at the colleges that hired them as professors. These fields are being transformed today because of Luce's generosity and transforming vision.

In 1998, Penny George received a diagnosis of breast cancer. Her experience healing and becoming a survivor gave her a break-through idea. Raising money for cancer research was already widely under way, but George saw a problem like these other women before her did, and she set about to address it in a totally new way. The problem was that many people needed and sought help heal-ing using methods that Western-trained doctors had no way to measure the impact of or trust. So-called alternative therapies attract millions of hopeful people and their families. She sought some herself, meditating and envisioning among others. She then decided that medical schools, researchers, and practicing doctors needed to assess and study alternative therapies both alone and in conjunction with more routine Western medical interventions. She initiated a project to bring twenty-five of the nation's premier lead-ers in medicine together. Their charge was to lay out a way to col-laborate on a new project that would begin the process of evaluating the impact of alternative therapies to achieve depend-able research data on effectiveness and safety both alone and in tan-dem with allopathic treatment.

George's continuing mission is to bring about optimum health and healing for society and individuals by creating a community of philanthropists who share a common vision and by executing four strategic initiatives that leverage their individual philanthropic efforts: changing how physicians are educated, supporting leading clinical centers to be models for change, championing physician leaders, and expanding public awareness of the importance of inte-grative medicine.

This woman philanthropist has assembled about twenty-five other philanthropists and has raised $17 million of her five-year goal of $19 million. This group has developed the Consortium of Academic Health Centers for Integrative Medicine, with member-ship up now to twenty-nine medical schools. The consortium has created a medical school curriculum built on the principles of inte-grative medicine as well as publishing an article on it in the lead-ing academic medicine journal (Kligler and Maizes, 2004). This

curriculum has been distributed to every medical school in the country, and the consortium is now evaluating its impact.

With the input of the project's pro bono partner McKinsey & Co., George's group created a clinical network of the leading centers of integrative medicine nationally to help them be sustainable when the economic drivers are all about disease. The National Institutes of Health (NIH) and the National Cancer Institute have expressed enthusiasm about the prospects for doing clinical outcomes research on integrative approaches to cancer pain, and they recently hosted a meeting for the leadership of the clinical centers and plan to help them create an NIH-funded research network. George is drafting a new chapter in the annals of medicine: research-based integrative medicine. These breakthrough ideas will benefit the greater good for all.

Upward mobility, comity, and economic growth

The breakthrough ideas already noted advanced the economy of their time by advancing the utility of human capital. In a capital market economy, the goal is to use available assets at the highest and best level possible within the most advantageous cost structure. Scholarships have given our economy millions of people who have served society at the levels of their giftedness rather than being remanded to the level in society where their parents' education, stations in society, or economic status might have left them. The process of maximizing human capital assets has offered the United States a powerful force for wealth creation. Women's generosity enabled progress long before standard social and political institutions grasped the value proposition.

Anne Radcliffe saw the advantage to the new colony in educating all its most able sons—wealthy or not. Elizabeth Lange maximized available human capital not by scholarships but by directly offering the transforming education to black children. Rebecca Gratz's work involved a minimization of personal conflict and a

facilitation of commitment of assets to America's economic growth. Jane Addams's wide-ranging social reforms reinforced the connections between justice and prosperity. Mary Garrett removed barriers to women's contributions to medicine. Garrett set the stage for Clare Boothe Luce's breakthrough idea that women could make hallmark contributions to the sciences. Penny George is exploring how expenditures for medical care can have the highest, most effective outcome in the most efficient way. Costs may be reduced and outcomes improved by the coupling of alternative therapies with standard allopathic interventions.

It is too easy for contemporary Americans to assume that certain beliefs were always a part of human cultures or always a part of our culture. History suggests differently. Some individuals have ideas that, like technological inventions, completely revise the lives of others and change the directions of the societies they touch. Women's ideas on social changes have resonated at the economic and political levels in our nation. Women were admitted to men's medical schools before they were admitted to the voting booth. Blacks were educated to become teachers before they were declared full persons in American law. Philanthropy, and particularly women's philanthropy, affected these advances in the economic and political systems.

The challenge to twenty-first century women's generosity

This knowledge of women's philanthropic history serves a profoundly important purpose if it points twenty-first-century women to the fierce challenges facing America's post-9/11, post-Katrina society. Juan Somavia, ambassador to the United Nations from Chile, stated the challenge clearly when he and his colleagues prepared the United Nations Summit on Global Social Development in Copenhagen in 1995. They asserted that a rising global consensus was emerging around democracy as the political system of choice and around some form of markets as the economic system

of choice, but they recognized that no nation, not even the United States, had developed a similarly successful social system.

Such a system would need to complement the agreed-on political and economic systems. It would need to balance competition, incentives, self-discipline, and self-reliance, on the one hand, with necessary degrees of compassion and security, on the other. No country, they repeated, had yet developed such a social system. The major challenge ahead of all people, and especially those in leadership, they said, would be to develop such a social system over the coming years.

I believe that women's philanthropy holds the power to change the social system. This work remains critical a decade since Copenhagen and more evidently unfulfilled in the light of 9/11 and Hurricane Katrina. These disasters showed the nation that the rule of law is dependent on human and social values. Without these having been previously agreed on, law has no force and cannot be counted on to maintain the kind of order that democracies hope to achieve and that market economies require. For most of America's history, women have had responsibility for the human and social values of society.

In the first decade of the twenty-first century, more women in America are making life choices for themselves and determining when, how, and where they will make their contributions in each decade of their lives. Consequently, we have immense opportunities for women to take up this challenge of helping each other and our country to develop an adequate social system designed to sustain democratic principles and capital markets. Because the job may seem daunting to many, we all need a common knowledge of the work of American women of other centuries facing other equally daunting challenges.

While a great deal of additional research remains to be done, the force of women's ways of thinking, acting, and associating emerges as a distinctive asset to the growth of an ever more humane and prosperous American society and capital market economy. The challenge to American women now is to learn and then to emulate the power of women in the past and proceed with similar brilliant

generosity to focus on drafting a sustainable social system for our political democracy and market economy.

References

Ashton, D. *Rebecca Gratz: Women and Judaism in Antebellum America*. Detroit: Wayne State University Press, 1998.

Carter, R. *The Gentle Legions*. New York: Doubleday, 1961.

Kligler, B., and Maizes, V. "Core Competencies in Integrative Medicine for Medical School Curriculums: A Proposal." *Academic Medicine*, 2004, 79(6), 521–531.

McCarthy, K. D. (ed.). *Lady Bountiful Revisited: Women, Power, and Philanthropy*. New Brunswick, N.J.: Rutgers University Press, 1990.

Phelps-Stokes Fund. *Phelps-Stokes Fund Report, 1987–1989*. Washington, D.C.: Phelps-Stokes Fund, 1989.

Sander, K. W. *The Business of Charity*. Urbana: University of Illinois Press, 1998.

Spain, D. *How Women Saved the Cities*. Minneapolis: University of Minnesota Press, 2001.

CLAIRE GAUDIANI *is a professor at the George H. Heyman Jr. Center for Philanthropy and Fundraising at New York University's School of Continuing and Professional Studies.*

Based on the author's research, this chapter gives advice to both volunteers and development professionals about better using women's unique leadership qualities.

3

Women's philanthropic leadership: How is it different?

Bonita Banducci

PHILANTHROPY IS A fast-growing industry with a culture that demonstrates and cultivates the relational leadership of women, engendering local, national, and global communities with new models of leadership. For the full power of women's contribution to philanthropy to be realized, it is necessary to articulate what this leadership looks like. By valuing and making visible women's attributes of perception, communication, and practices, we will increase their skills in working with traditional leadership and increase fundraisers' skills in working with women.

What is different about women's leadership is relational perception, communication. and practices. This chapter provides some context and understanding about this topic:

- What does *relational* mean?
- What do relational perception, communication, and practices look like in the field of philanthropy?
- What skills serve to advance the recognition and effectiveness of women's leadership in an often more individualistic world?

NEW DIRECTIONS FOR PHILANTHROPIC FUNDRAISING, NO. 50, WINTER 2005 © WILEY PERIODICALS, INC.
Published online in Wiley InterScience (www.interscience.wiley.com) • DOI: 10.1002/pf.127

Articulating that which has previously been unnamed or misinterpreted can sound dissonant—just as when we had to change our language from *fireman* to *firefighter* to make room for greater meaning and social change. There are six aspects of using the term *relational* to describe women's leadership and the paradigm model of effectiveness that shapes their perception, communication, and practices, each distinct and yet related to the others:

1. *Relational* and *individualistic* are cross-cultural terms that create a context of differences not tied to biology and allow understanding gender differences to be a doorway into understanding international cultural differences and affinities such as differences in context, time, and information flow (Hall and Hall, 1990).

2. The terms *relational* and *individualistic* are not tied to masculine and feminine, allowing adaptability for both women and men.

3. Relational psychology is a theory of human growth, augmenting "the prevailing models of adult growth and achievement [that] are based on public-sphere characteristics such as separation, individuation, and independence" with "an alternative model, called growth-in-connection, that is rooted in private-sphere characteristics of connection, interdependence, and collectivity." New knowledge comes from "relational interactions . . . where the outcome was unpredictable because it was the product of the interaction" (Fletcher, 2001 p. 31).

4. Unpredictable growth is fundamental to self-organizing, adaptive organizations (Wheatley, 2001). Relational attributes are vital for systems of organizations and communities.

5. Fernando Flores' great work in human communication distinguishes relationship as the foundation of accomplishment. Being known to others through having conversations that convey your vision, values, and commitment, as in growth-in-connection, creates new possibilities (Flores and Solomon, 2003).

6. Deciding how to allocate money in reciprocity with others expresses your vision, values, and intention and is at the heart of the new transformative philanthropy (Twist, 2003). Such relational

leadership has a transformative impact on our own lives and our national culture.

The prevailing culture of women is relational, distinguished by a constellation of competencies that have often been filtered out or discouraged in mainstream leadership (Banducci, 2005). However, not all women are relational, just as not all men are individualistic. Some women are individualistic, and some men are relational—and many people are both. It is important to identify relational people and perspectives through perceptions, communication, and practices rather than by biology.

What are relational perceptions, communication, and practices?

The relational paradigm sees the world through a lens of relationship—of knowing one another by values, vision, and commitment; connection, that is, being "other" or "we" focused; a mutuality partnership model; and perception framed by responsibility for the whole of things. This is distinct from the traditional individualistic frame of seeing the world through an "I"-centered, prioritized lens of independence. Important clues to the relational paradigm are using *we* instead of *I*, indirectness in telling someone what to do, giving a lot of context in making a point, and being focused on the needs of the prospect or donor. Philanthropy shifts from an "I am helping you [because I know what's best and I have the resources]" hierarchical framework to an "I am listening to you to hear what you see is needed [because you are making change happen]" reciprocal framework.

Relational communication is the sharing of information, the power of creating new information together, and the giving of contextual information for greater understanding, all done as a means of collaboration and empowering others. This is distinct from individualistic communication, where information is a desirable

commodity, withholding it is power, and people play devil's advocate to show the weaknesses of an idea.

Relational practices create "webs of inclusion" (Helgesen, 1990, p. 41) with a complexity of perspectives and experiences of different people, holistic thinking, and values-based decision making. These practices are distinct from creating hierarchies of status, compartmentalizing, and prioritized, linear, logic-based decision making.

Relational leaders are transformers who "get others to transform their own self-interests into the interests of the group through a concern for a broader goal." Men are more often transactors, "seeing their jobs as a series of transactions with others in which they exchange rewards for services rendered or administer punishment to inadequate performers" (Rosener, 1990 p. 120).

Relational leadership in philanthropy

At the grassroots level, the success of the Grameen Bank, founded in Bangladesh, demonstrates the effectiveness of a relational model and practices for women to bring themselves, the poorest of the poor, out of poverty (Counts, 1996). Women are lent small sums of money in a group structure in which those with funds are supported, encouraged, and held accountable with peer pressure to the other women in the group and to a set of values and practices that represent a culture of growth-in-connection within each group and among the groups in the community. The primary problem-solving unit is the group, not the individual or the bank worker. These women are not only bringing their families out of poverty; they are leading culture change by creating a framework for values-based decision making, consistent with relational culture. Women reinvest in the business, in food, and in children's education at a dramatically higher rate than men do, who often spend money on themselves, buying material goods and alcohol. The repayment rate to the bank, 95 percent, is also much higher than for men.

Women's transformational leadership shows up in grantor couples in which the woman—the transformer—is often passionate

about making a difference, taking on projects that would not otherwise happen, while the man—the transactor—enjoys negotiating, doing the deal to have others, and competing with others to give the most. "Men tend to give to enhance their own standing or maintain the status quo [as in having one's name on a building], it is believed, while women give to promote social change or help others less fortunate" (R. Newman, cited in Hall, 2004, p. 3). Women "are more likely to volunteer before giving and seek closer contacts with the charities they support" (S. C. Shaw, D. Sublett, and M. Sommerfeld, cited in Hall, 2004, p. 3). These differences should be treated as value, not liability.

Given what we know about gender differences, we ought to look through a relational lens, not an individualistic one, to assess the contribution and cultivate the leadership of women. It may take more time to make decisions about giving due to wanting to include others in decision making, as in consulting a spouse, or to formulate decisions on more complex grounds—getting and including a full picture. It is consistent with women wanting to volunteer and build a relationship with the organization she is contributing to. Women may need to be educated about philanthropy, but they like to be educated; it is part of the growth-in-connection. Again, all of these differences should be treated as value, not liability.

We must also learn to measure the power of women to bring other women into the giving of time, talent, and treasure. In the grantor domain, the spontaneous growth of giving circles demonstrates the chemistry of growth-in-connection and the relational effectiveness when women get together in groups to support a cause rather than contributing independently. An example is the workshop events in San Francisco and Los Angeles initiated by a group of professional women who partnered with the Hunger Project to explicitly link the subjugation of women and hunger. By nearly doubling the fundraising goal, these volunteers pioneered a new Hunger Project fundraising strategy for women in philanthropy. Its educational component also had a profound impact on the lives of men and women who attended.

Funding networks and alliances of nonprofits to create powerful webs of influence are being fostered by women in philanthropy. Mergers are occurring; in California, for example, the Women's Foundation of San Francisco has merged with the Women's Foundation of Southern California to create the Women's Foundation of California. The Women's Global Green Action Network addresses isolation, the greatest fear of relational people: "Women, working on the frontlines of their communities, have the same mission but often remain isolated from each other's efforts. *The Women's Global Green Action Network seeks to build the linkages that will empower these agents of change*" (Kramer, 2005, p. 3). Imagine what will be possible with this alliance.

The Hunger Project is a woman-led nongovernmental organization (NGO) that demonstrates relational principles and strategies. As part of their strategy to provide funding for what is missing that would make a difference, it connects people with services provided by other NGOs. Years ago, the Hunger Project was acknowledged by UNICEF for providing the glue to bring NGOs together on projects rather than duplicating and competing with each other. For years, according to its methodology of "Leadership from All Sectors," the Hunger Project has insisted that in all countries it works with, women have 50 percent of the representation in all project planning and that people from a diversity of economic statuses be at the table as well.

Skills to make relational perspectives, communication, and practices visible and valued

It is essential to articulate, consciously and with conviction, the effectiveness of the relational perspectives, communication, and practices that many women and some men bring to their work and to make these visible and valued. The full spectrum of philanthropy from the grantors to the grantees and their clients can cultivate, protect, and amplify this leadership whose heart is caring. For the purpose of increasing philanthropy, relational peo-

ple are often drawn to support organizations that demonstrate this leadership.

Understanding these differences—in what works, what is effective, what is competence—leads to important leadership skills:

- Partnering with people who bring a different perspective to find directions and solutions that are of greater value because of the collaboration. There are points of diminishing return, where seeing one perspective limits what is possible.
- Standing with conviction for your ideas and point of view, understanding, and therefore better addressing resistance.
- Preventing "disappearing acts," that is, the ongoing filtering out, dismissing, and not rewarding or promoting of talent, the constellation of relational competencies (Fletcher, 2001).
- As Americans, bringing this understanding into work with people of other cultures, many of which are more relational than the United States.

My greatest awakening to the need for skills to cultivate this leadership came from an interview with Carol Bartz when she was second in command at Sun Microsystems. I asked her what she contributed as a woman to the senior executive team that would not be brought to the table if she was not there. She said she could see all the ramifications of any problem or decision. The men would consider a problem, choose the highest-priority solution, and apply that solution without looking at the interrelated factors of the problem or the solution. They wanted to fight fires as they came up; she could prevent fires from happening.

She also revealed that the men thought that she was not a team player and was stalling the action and getting in the way of "the play" the CEO wanted to call. It was eye-opening to realize that her greatest contribution—seeing the complexity and all the factors that needed to be dealt with—was perceived as disruptive and not competent. It was also surprising to discover that like many other women, she did not identify this holistic way of problem solving as the difference women bring to the workplace.

I interviewed men executives about their perceptions on why women were not being promoted and found a pattern that was exemplified by one executive who answered my question with, "They just are not ready yet." I asked, "What would 'ready' look like?" He answered, "They would be competent." I pressed, "What would competency look like?" He answered, "They would be able to get right to the heart of the matter. Women are all over the place!" Carol Bartz again: talent being completely misunderstood. And yet many of the executives at that time had Peter Senge's book, *The Fifth Discipline* (1990), on their desks. One of Senge's five disciplines is the importance of "a systems way of thinking." The executives were systematically dismissing the very talent they were looking for. It is like trying to learn to speak French from a book and then hearing a native French speaker and saying "That's not French; it sounds funny."

Steps for making the differences work

There are four steps for making communication differences work and profit from getting the best of both worlds (Banducci, 2005).

Step 1: Acknowledge differences: Stop making yourself or others wrong

Assuming that there is only one right way robs us of the opportunity to bring diverse ways of thinking, especially relational thinking, to the table. The individualistic men in Bartz's story lost this opportunity. A woman may not know that her perspective is holding her back from promotions or from everyday contributions. Even worse, a woman may think that she is in one world and everyone else is in another world she has no understanding of. When this happens, she cannot fully contribute and often will leave an organization. When something is wrong, a relational person will be less likely to question another person and more likely to doubt herself: "Something is wrong with me." When something is wrong in the world of an individualistic person, that person assumes that "something is wrong with them!"

Relational people need to catch themselves when they doubt themselves and question their questioning by exploring their assumptions. Individualistic people need self-reflection on what else may be possible and explore their assumptions as well.

Step 2: Understand these differences: Get into another's shoes

Once you understand some of the basics of individualistic and relational differences, you might immediately recognize the differences playing out, or you might need to map out the basic paradigms to figure out what is going on. You might ask, "How does looking through the lens of 'who's up and who's down' [individualistic] shape one's behavior?" Or "How does looking through the lens of how we connect and build relationships [relational] shape the other?"

We can bridge the gap inventively and learn to present our perspective in the language of the other culture. This is taking the third and fourth steps of adapting and adopting—the place where creativity, genuine innovation, and true partnership can flourish.

Step 3: Adapting others to your difference

Let people know what your unique perspective is and how it can contribute to the organization. When it comes to working with complex, holistic solutions, the relational person needs to understand that complexity looks like out-of-control chaos to a linear thinker. It is therefore the job of the relational person to let the linear thinker know that she or he can help guide the group through the chaos, most likely with a collaborative approach. We are not trying to rob firefighters of their opportunities to fight fires. There will always be fires. But cutting down on the number of fires will lower the stress of the work environment and lead to greater effectiveness.

Step 4: Adopt the differences of others

Take on learning to speak the language and play the game the way others do in order to better communicate your ideas within their culture. It does not mean giving up your perspective. "I am not good enough the way I am" is coming from deficit, resulting in

a loss of sense of self, authenticity, and self-confidence. "I am speaking from my perspective into his or her culture" takes getting outside yourself without forsaking yourself. From either perspective, "I am getting outside who I know myself to be" is often transformative.

An example at work: Applying adapting and adopting

Women and men both can use these skills of adapting, adopting, and naming the unnamed in order to open up a space for different kinds of thinking, collaborating, and establishing a new model for leadership competency.

Following is a transcript of a real workplace situation from a professional training video produced by ChartHouse Learning with Deborah Tannen, *Talking 9 to 5* (1995), based on Tannen's book *Talking from 9 to 5* (1994), which demonstrates a relational practice and an idea that disappears. Tannen narrates:

A ritual that men use which women can take literally is ritual opposition.

Just as little boys when they play with their friends often spend time play-fighting much more than little girls do, as adults men often use an oppositional stance to get things done. For example, to explore ideas.

Rather than supporting somebody else's ideas, they'll try to point out the weaknesses, challenge it as a way of helping somebody explore the idea.

Leslie: "But, I'm not sure what the angle is, but I think it's really . . . it's like a trend (you know) and what . . . and what the product is that's the manifestation of that trend."

Gary: "Right, but we'd have to . . . but, doesn't that still have implication of we're going to tell you what the best way to approach this is?"

Leslie: "So, maybe it's the (you know) best sellers. The three best selling ones."

Gary: "But then . . . but, but, then we're just . . ."

Leslie: "I'm not sure this is a good idea. I'm just throwing it out."

Gary: "I know, I'm just trying to like . . . I'm just . . . I'm just trying to be devil's advocate. So, but then all we're doing is reporting that something . . . the three best sellers is simply . . . they may be the biggest rip-offs of all of them, but they just may be stupid platitudes and they've been marketed well as opposed to."

Leslie: "So, then we get some . . . some kind of expert to say what the best ones are."

Gary: "The best books on meditation. It just sort of strikes me as somewhat . . . how is somebody going to sort of say that definitively? This book really will calm you down."

Leslie: "I don't even know if that is the angle exactly. I'm not sure if that's the angle. All I'm saying is I'm sort of throwing out something . . ."

Gary: "OK."

It's very likely that Gary isn't convinced this is a bad idea. He's simply pointing out the weaknesses as a way of exploring the idea, but Leslie backs off and lets it drop, and women often will take this devil's advocate game literally and either drop it as a bad idea or even feel personally attacked.

The danger is that the company may be losing some very good ideas, potentially very productive ones, because they're dropped because of this misunderstanding of the ritual.

Devil's advocate is the only way that many individualistic people know how to support an idea. Leslie, however, is not failing to make a point; she is trying to engage Gary in teasing out an idea, to collaborate with her, give her his insight. We don't even have a name for this collaborative approach. "Why not call it 'angel's advocate'?" a student suggested. As an archetype, angels bring information and insights and initiate epiphanies.

If Leslie or Gary (or both) could recognize their differences (step 1) and understand where they are both coming from (step 2), this is a great opportunity for adapting and adopting (steps 3 and 4). Leslie could say to Gary, "I will play devil's advocate with you, but first I want you to play angel's advocate with me. It's the way I am most creative." She could teach him to bring his best thinking to the idea before poking holes in it. That is adapting your environment to provide the right action for relational effectiveness. Gary would be adopting Leslie's approach. Then Leslie could say to Gary, "Now, work with me so I can learn to play devil's advocate"—and she would be adopting a way of perceiving and communicating that was previously foreign to her.

Devil's advocates usually listen to themselves trying to find the next question to ask. Angel's advocates listen to the other person,

trying to build on what they are saying. We need the thinking and listening to by both kinds of people. Introducing angel's advocates brings a more collaborative quality to meetings and discussions, mixing it with devil's advocates to the benefit of both. An executive director of a family foundation told me that she was taught how to play devil's advocate by her father and that was very useful in defending her ideas—but she needed an angel's advocate also in order to lead the board in being creative.

Another blind assumption involves gaze. Women look directly at each other when communicating, and men look away. The same executive director realized that she had completely discounted the interest of one of the board members because he never looked at her when she talked, not realizing that this was his way of listening. Once again, both women and men have to recognize the assumptions they are making that may be shutting out valuable participation.

Naming and renaming values-based decision making

It is important to name an effectiveness or competency such as "angel's advocate." Another effectiveness that needs naming is values-based decision making. Recently a student of mine told me that her fiancé says that his thinking is logical and hers is illogical.

I suggested that she may be making her choices based on values—a different kind of logic. Naming her thinking as values-based decision making, along with some educating and articulation of values driving her thinking, might open up new possibilities in their partnership. It certainly would shift the power relationship.

Along with naming, there are instances where we have to rename to emphasize effectiveness. The Myers-Briggs personality profile has measured the statistically significant differences between men and women in the "thinking" and "feeling" dimensions: men are 56 percent logic-based decision makers and 44 percent values-based decision makers; women are 24 percent logic-based decision makers and 75 percent values-based decision-makers (Hammer and Mitchell, 1996). However, using the terms *thinking* and *feeling* has

connotations that do not paint a picture of effectiveness for women. We are actually renaming when we point out that these terms are meant to distinguish between logic-based decision making and values-based decision making and that these terms have different and positive connotations.

Values-based decision making is at the heart of the desire of women in philanthropy to make a better world, to want to make a difference for people.

New leadership and new futures

We can use the attention on measuring effectiveness in philanthropy to point out how a woman is being effective. We may not be able to measure the degree to which one relationship is more effective than another. We can measure, for example, the differences it makes for donors being listened to, engaged with, and empowered, to have women instead of men as agents for programs such as microlending banks.

A small but illustrative incident occurred at a meeting of funders in California. In response to a panel presentation, a woman funder asked, "Is it more important for women to have relationships with their grantees than it is for men?" Two men on the panel responded to the woman without addressing her question. It was Kavita Ramdas of the Global Fund for Women who got up and said, "I believe I heard the question differently from the other panelists," and then repeated the question word for word. Many in the audience burst into an applause of agreement. She indirectly pointed out how the men could not even hear the question other than through their own lens. And she responded that having a relationship with grantees is very important for most women.

Women's leadership—relational leadership—is fundamentally inclusive and transformational. It is a phenomenon of development-in-connection. What more fertile and already fruitful field is there to cultivate this partnership leadership than in the full spectrum of philanthropy?

Conclusion

This chapter has provided some examples of what women's relational leadership looks like in the field of philanthropy. I have introduced an understanding of basic distinctions and skills that allow gender and cultural differences to work together. My intention is to foster more inventive and profound collaborations among all people who work together. Demonstrating and framing the effectiveness of relational leadership in philanthropy will have the added impact of opening up traditional institutions to new ways of leading and being effective—for the greater good of all.

References

Banducci, B. *Unmasking the Gender Effect: Men and Women Building Effective Partnership in the Workplace Workbook.* Hayward, Calif.: Banducci Consulting, 2005. www.genderwork.com/publications/womeninphilanthropy.html.

Counts, A. *Give Us Credit.* New York: Random House, 1996.

Fletcher, J. K. *Disappearing Acts: Gender, Power, and Relational Practice.* Cambridge, Mass.: MIT Press, 2001.

Flores, F., and Solomon, R. *Building Trust in Business, Politics, Relationships, and Life.* New York: Oxford University Press, 2003.

Hall, E., and Hall, M., *Understanding Cultural Differences.* Yarmouth, Me.: Intercultural Press, 1990.

Hall, H. "Communicating with Women: Understanding and Applying the Differences." In A. J. von Schlegell and J. M. Fisher (eds.), *Women as Donors, Women as Philanthropists.* New Directions for Philanthropic Fundraising, no. 2. San Francisco: Jossey-Bass, 1993.

Hall, H. "Gender Differences in Giving: Going, Going, Gone?" In L. Wagner and J. P. Ryan (eds.), *Fundraising as a Profession: Advancements and Challenges in the Field.* New Directions for Philanthropic Fundraising, no. 43. Hoboken, N.J.: Wiley, 2004.

Hammer, A. L., and Mitchell, W. D. "The Distribution of MBTI Types in the US by Gender and Ethnic Group." *Journal of Psychological Type,* 1996, 37, 2–15.

Helgesen, S. *The Female Advantage: Women's Ways of Leadership.* New York: Doubleday, 1990.

Kramer, M. "Why the Need?" In *Women's Unique Role in Sustainable Development.* 2005. www.wggan.org.

Rosener, J. "Ways Women Lead." *Harvard Business Review,* Nov-Dec. 1990, pp. 119–125.

Senge, P. *The Fifth Discipline: The Art and Practice of The Learning Organization.* New York: Currency Doubleday, 1990.

Tannen, D. *Talking 9 to 5: Women and Men in the Workplace.* Burnsville, Minn.: Charthouse International Learning Corporation, 1995. Video.

Tannen, D. *Talking from 9 to 5: How Women's and Men's Conversational Styles Affect Who Gets Heard, Who Gets Credit, and What Gets Done at Work.* New York: Morrow, 1994.

Twist, L. *The Soul of Money: Transforming Your Relationship with Money and Life.* New York: Norton, 2003.

Wheatley, M. J. *Leadership and the New Science: Discovering Order in a Chaotic World.* (2nd ed.) San Francisco: Berrett-Koehler, 2001.

BONITA BANDUCCI *is president of Banducci Consulting and a founding faculty member of the Women Leaders for the World Program of Santa Clara University's Global Women's Leadership Network.*

Philanthropic giving of both time and money is increasingly an important part of the expectations of the role of businesswomen. Women in the corporate world are emerging as some of the most generous and creative new philanthropists.

4

Women executives and business owners: A new philanthropy

Cynthia R. Jasper

AMERICAN BUSINESSWOMEN have made substantial contributions to philanthropic endeavors throughout the history of the United States. In fact, Madam C. J. Walker, an African American woman born in 1867, who established a cosmetics and hair care company and became the first female African American millionaire, donated generously to causes related to African American education and well-being. In the early 1900s, Sydnor Walker brought her expertise in teaching and working for the American Friends Service Committee to the Laura Spelman Rockefeller Foundation, where she established the idea of building a strong relationship with donors so that they continue to give (Walton, 2005). This idea is still common today.

In more recent years, Darla Moore, a co-owner of a multibillion-dollar investment company, generously gave $25 million to her alma mater, the University of South Carolina, which chose to name its business school after her (Hall, 2005). These women are famous examples, but businesswomen in general are becoming increasingly

NEW DIRECTIONS FOR PHILANTHROPIC FUNDRAISING, NO. 50, WINTER 2005 © WILEY PERIODICALS, INC.
Published online in Wiley InterScience (www.interscience.wiley.com) • DOI: 10.1002/pf.128

active in philanthropy. As women's wages and their roles in the corporate world rise, so too does their philanthropic activity. According to the U.S. Census Bureau, "The number of women who make at least $75,000 a year annually more than quadrupled from 1980 to 1995" (Hall, 1997, p. 1). They have been active in volunteer work as well as increasingly donating money to support various philanthropic causes. In addition, businesswomen are establishing more and more foundations to serve their philanthropic giving.

Philanthropic activity is often an integral part of the roles and expectations associated with businesses in the United States. Many U.S. companies strongly support or even require philanthropic activities related to various positions within their companies. Women business owners have been especially responsive to giving both time and money to various philanthropic causes.

This chapter focuses on the role businesswomen play in philanthropic activity. Increasingly, society expects women business owners and executives to volunteer in charitable organizations and also to contribute financially to them, just as much as men do. Women have embraced this role by contributing portions of their income as well as starting their own foundations in order to make and distribute wealth to causes that are important to them. Their efforts are giving new meanings to the role of businesswomen as philanthropists.

Volunteering

Volunteering, an important aspect of American society, has long been associated with women; however, in recent years that pattern has been changing since many women have begun to enter the workforce. Nevertheless, women are more likely than men to both volunteer and donate to charity. Although women donate less, the percentage of income that they do donate is the same as men's.

A study conducted by the National Foundation of Women Business Owners (1996) examined whether women business owners volunteer more or less than the average woman, whether these

women encourage their employees to volunteer more or less, and what types of activities these women engage in. The study indicates that women business owners volunteer more compared to other adults and other business owners. According to this study, 78 percent of women business owners spend time volunteering, while only 48 percent of all U.S. adults, 51 percent of all women, and 56 percent of all business owners do so. Women business owners between the ages of forty-five and fifty-four volunteer at the highest rate. In addition, those with a higher level of education and those who are married donate more. This study found that both single and married women business owners have relatively high rates of volunteering, with 72 percent of single businesswomen and 78 percent of married businesswomen volunteering.

Many business owners volunteer for more than one cause. In fact, 28 percent of women business owners volunteer for two charities, 13 percent volunteer for three, and 9 percent volunteer for four or more (National Foundation for Women Business Owners, 1996). In addition, while women who own a business and have children may seem unlikely to volunteer, they actually volunteer more, with 58 percent of these women volunteering for more than one charity.

The study also aimed to find out what types of activities women business owners are involved in. The findings indicate that women donate time and money to community-related, education-related, and health-related charities; the arts; and religious charities; a smaller number donate to the environment-, sports-, and youth-related activities. The percentages are as follows: activities, 65 percent; education-related activities, 35 percent; religious charities, 28 percent; health- or disease-related charities, 21 percent; the arts, 19 percent; sports, 9 percent; the environment, 8 percent; a professional organization or activity, 7 percent; women/girls/youth-related activities, 2 percent; or another organization, 15 percent (National Foundation for Women Business Owners, 2000).

Finally, the study examined whether women business owners encourage their employees to volunteer. The study found that a

large share of women business owners encourage their employees to do so. Fifty-nine percent of women business owners encourage their employees to volunteer, and 12 percent support their employees' volunteerism financially (National Foundation for Women Business Owners, 2000).

The study also found that the volunteer level of business owners had an impact on their support and encouragement of their employees' volunteering. For example, 66 percent of women business owners who themselves volunteer also support their employees' volunteering, while only 33 percent of women business owners who do not volunteer support their employees' volunteering (National Foundation for Women Business Owners, 2000).

Financial contributions

Increasingly, women are making monetary contributions as well. As women's wages rise, so does their ability to donate to various philanthropic causes. A study conducted by the National Foundation of Women Business owners (2000) examined women business owners' giving patterns, causes they support, reasons for giving, and the recognition they expected.

Women business owners contribute financially. Thirty-one percent contributed five thousand dollars or more per year, which includes 15 percent who donate ten thousand dollars or more. These numbers are rising, with 52 percent of women business owners citing a rise in their giving levels (National Foundation for Women Business Owners, 2000).

The study found a correlation between giving money and volunteering. Those who gave the most also volunteered the most. For example, a woman who gave $10,000 or more a year volunteered an average of 22.4 hours per month. Women business owners who gave between $5,000 and $9,999 volunteered 15.9 hours per month, and those who gave less than $5,000 gave 7.2 hours per month (National Foundation for Women Business Owners, 2000).

The study found that women business owners often take on leadership positions in their philanthropy. Women business owners are more likely than men to participate in leadership roles during their volunteer hours, which include serving as a chair of a special event or serving on a board. Forty-six percent (46 percent) of women respondents frequently do one of these activities (National Foundation for Women Business Owners, 2000).

In addition, this study noted that 76 percent of both women and men business owners reported making financial contributions to charities through their businesses. Nine percent of women business owners contribute $10,000 or more each year to charitable organizations as a business donation, while 13 percent of women business owners make financial contributions of between $5,000 and $9,999 annually to charities through their businesses. Fifty-four percent of women business owners make business contributions of less than $5,000 a year (National Foundation for Women Business Owners, 2000).

Many business owners have similar giving patterns in both their business and personal lives. Only 13 percent of women business owners contribute at a higher level as individuals than through their businesses, while 9 percent of women give at a higher level through their business contributions than they do personally (National Foundation for Women Business Owners, 2000).

Many women business owners contribute out of a sense of social responsibility (53 percent), and 8 percent give to advance their business practice. Women business owners are motivated to contribute to philanthropic causes because they feel that it is the right thing to do (36 percent), they have an interest in a specific cause (34 percent), or they want to give back to the community (22 percent) (National Foundation for Women Business Owners, 2000).

Women business owners are careful in their decisions about which organizations to support financially. The most important factor when deciding whether to give is whether the organization is well run (94 percent). In addition, 89 percent of women business owners feel the need to donate to causes that they are passionate about (National Foundation for Women Business Owners, 2000).

The way an organization is run has an important impact on women business owners' desire to contribute. In fact, the way they are asked to donate has one of the biggest impacts, with 59 percent noting that this affects their decision. Women prefer not to be pushed into giving and prefer working with someone who is pleasant (National Foundation for Women Business Owners, 2000).

Women business owners want to be recognized for significant charitable contributions, although a majority (55 percent) prefer not to be recognized at all. Thirty-two percent say that they would like to be recognized for significant charitable contributions in some manner, for example, a thank-you letter (10 percent), being included in a listing with other donors (9 percent), or having a building or program named after them (1 percent) (National Foundation for Women Business Owners, 2000).

High-net-worth women business owners (those with assets of more than $1 million) are even more likely to give, with 30 percent described as very engaged in philanthropy, while only 12 percent of women business owners are in general (National Foundation for Women Business Owners, 2000).

Fifty percent of high net-worth women contribute $10,000 or more annually. High-net-worth women business owners are more likely to serve on a board or advisory group as compared to all women and men business owners. Ninety-four percent of high-net-worth women say they serve in this capacity sometimes or very frequently (National Foundation for Women Business Owners, 2000).

A famous example, the Committee of 200, is a group of women entrepreneurs that was formed in 1986. A study conducted by the National Foundation of Women Business Owners and Merrill Lynch (National Foundation for Women Business Owners, 1999) examined the giving patterns of these women. Overall findings indicated that members of the Committee of 200 volunteer and that over the previous five years, the time these women devoted to volunteering increased. Committee of 200 members spend approximately nineteen hours per month volunteering. And 54 percent of committee members donate over $25,000 annually to charity. In fact, there are very few Committee of 200 members

who do not donate time (only 4 percent report never volunteering or donating money), and none report never making a monetary donation. In the five years before the report was published, volunteering rose 44 percent and financial contributions rose 71 percent among these women.

The study also indicates that when compared to women executives, women business owners are more involved in their philanthropic endeavors. The study shows that 35 percent of women business owners say that they are "very involved" in many volunteer activities, while only 18 percent of women executives are equally involved (National Foundation for Women Business Owners, 1999). Their giving behavior is similar, with 28 percent of business owners describing themselves as "active and engaged philanthropists," while only 16 percent of executives describe themselves this way (National Foundation for Women Business Owners, 1999, p. 3).

Women who give

It has been theorized that women have an effect on a corporation's commitment to giving. For example, a study conducted by Robert J. Williams (2003) looked at 185 Fortune 500 firms between 1991 and 1994 to see if there was a relationship between the number of women serving on corporate boards and the extent of charitable giving within these firms. The study found a link between the number of women on corporate boards and the amount of giving. Corporate boards with a higher percentage of women are more likely to engage in charitable contributions.

In addition, there are many individual women in corporate America who use their money and influence to advance causes that are important to them. Studies indicate that as women become more successful, they contribute more time and money than other women. Also, businesswomen are more likely to thoroughly consider why they give and assess their motives for giving. For instance, Helen Johnson-Leipold, who serves as the chair and CEO

of Johnson Outdoors and Johnson Financial Group, both divisions under the S. C. Johnson Company, is active in philanthropy and founded Next Generation Now, which works in the areas of child development and family support (http://www.scjohnson.com/family.fam_our_hle.asp).

Another philanthropist also concerned with children and families is Pleasant Rowland, creator of the American Girl doll collection, the product line of American Girl, originally known as Pleasant Company. She gives generously to various causes, including several institutions in the Madison, Wisconsin, area. Every year American Girl donates merchandise to the Madison Children's Museum, which sells this merchandise. The profits from this annual benefit sale have raised over $8 million for the museum. She also supports Pleasant Company's Fund for Children, a foundation that provides grants for children's programs to enhance children's education in the arts, culture, and environment. This includes the establishment of the Aldo Leopold Nature Center, a natural site to promote environmental education for elementary school children. In further support of children throughout the country, American Girl has donated more than 300,000 books to various nonprofits. At the global level, American Girl is involved with the Kids in Distress Situations organization that assists children in need throughout the world (http://www.mattel.com/about_us/Comm_Involvement/ci_pleasant.asp).

In addition to these philanthropic activities, Pleasant Rowland and her husband, W. Jerome Frautschi, created the Overture Center, a state-of-the-art facility for the creative arts in Madison, Wisconsin, and its endowment fund. She contributed generously to her alma mater, Wells College, in Aurora, New York. Her contributions helped to renovate part of the town of Aurora, thus helping to support the Wells College mission of assisting in the town's economic development (http://www.wells.edu/whatsnew/wnnwar41.htm). Sara Martinez Tucker, who chairs the Hispanic Scholarship Fund, uses her business skills from working in the corporate world for years to ensure that Hispanic students have an opportunity to attend college and complete their degree. She began the project

with $3 million a year to give to one thousand needy Latino students. Tucker launched a marketing campaign and talked to corporations, and she has expanded the project to $30 million divided among seventy-five hundred students per year. She continues to raise money with the goal of increasing the number of Hispanics in the United States earning a college degree to 18 percent, up from 11 percent currently (Taylor, 2005).

Mildred Robbins Leet, a businesswoman successful in the real estate industry, has continually been active in philanthropy in various sectors, including education, health, international development, and women's issues. As a young woman in her twenties, Leet cofounded the United Cerebral Palsy in 1948. Among her many philanthropic accomplishments is the establishment of TrickleUp, which she founded with her husband, Glen Leet, in 1979. TrickleUp, an international nonprofit organization, helps some of the world's poorest people establish their own businesses and bring them out of poverty. So far more than 500,000 people have been helped through this program, with over 100,000 businesses started (http://www.greatwomen.org/women.php?action=viewone&id=205).

Debbie Bricker has also tried to leave her mark on society. Born to two high school dropouts, she earned a teaching degree and then began a corporate career. She was fired from her first job, but that only inspired her to work hard and start her own company. Bricker gives between $500,000 and $750,000 to Chicago nonprofits. Her battle with a brain tumor showed her what was important in life and inspired her to donate to charity. Currently, Bricker teaches a leadership class for a preparatory school of the Chicago Public Schools (Reed, 2004).

Foundations

These examples demonstrate the increasing trend of women to use their money to advance the causes they care about and to influence society. There are other women who have started

foundations to leverage support for their causes and exert an even greater influence on society. In recent years, various American women business leaders have created foundations that not only advance particular causes but also encourage and contribute to the growth of women's philanthropic giving.

Two American businesswomen, Patricia Miller and Barbara Bradley Baekgaard, founded the Vera Bradley Company, which designs luggage for women, in 1982. They also launched the Vera Bradley Foundation for Breast Cancer to fund research to eliminate breast cancer. So far $4 million has been raised, including the completion of two major endowments to the Indiana University School of Medicine to support the Vera Bradley Chair in Oncology and establish the Vera Bradley Center for Breast Cancer Research. The Vera Bradley Foundation raises money in several ways. The main fundraiser is the annual Vera Bradley Golf and Tennis Classic. In addition, funds are raised through Ribbons for Life Events, New Hope product sales, donations from Vera Bradley sales representatives and retailers, general donations, the Friends of the Foundation Outlet Sale Day, and the Tickled Pink Toast & Tour (www.verabradley.com).

Eileen Fisher began a women's clothing company twenty-one years ago following a career in interior design. Her clothing is simple yet elegant—"professional enough for the office yet relaxed enough for the weekends" (Pofeldt, 2003). Fisher prides herself in creating an environment that is pleasant for her employees to work in. She shares 10 percent of pretax profits with her employees and gives each a $1,000 education benefit and a $1,000 wellness benefit that can be spent on massages, spa visits, and gym equipment. The company offers classes in yoga, tai chi, and stress reduction. Fisher extends her beliefs in caring for others in the surrounding community through her philanthropic work. She supports programs that aid women's health and well-being and women's independence and empowerment. Fisher also supports organizations that give women access to high-quality health care to help women ensure that they will have healthy lives. She works to help low-income women gain access to health care and education and to

make personal choices needed to help them gain control of their lives and get out of poverty (Pofeldt, 2003).

Catherine Muther, who decided to use her expertise in the business world to help others, founded Three Guineas Fund in 1994. Muther invested $2 million of her own money to establish the fund as a 501(c) grant-making foundation. The foundation's primary goal is to work to ensure economic equality for women and girls. The foundation has many values that work to ensure this goal is met. First, it seeks to build relationships with the people who give to the organization. Next, the fund invests in start-up companies and organizations with little capital so that the investment has a greater impact.

The Three Guineas Fund recognizes that there is not just one aspect to the solution to ensuring equality for women and girls, so it works to cover all aspects, including health care, literacy, self-esteem, and labor. Currently, the Three Guineas Fund supports Co-Abode House Sharing, an Internet resource that aids single mothers; GirlSource, which supports exceptionally high rates of high school graduation and college enrollment for girls; the Lower East Side Girls Club, which started the Sweet Things Bake Shop and the Sweet Things Café; and the National Women's Law Center, which works to realize Title IX's promise. As of January 2005, the organization has pledged to give grants totaling $200,000 for the next two years, including $60,000 to the National Women's Law Center, $60,000 to Co-Abode, $30,000 to GirlSource, $30,000 to the Lower East Side Girls Club, and $20,000 to Social Fusion for MicroFusion (http://www.3gf.org/index.html).

Anita Roddick, owner of the Body Shop, began the Body Shop Foundation in 2000, which works in the areas of human and civil rights as well as animal and environmental protection. These ideals are also reflected in the business practices of the Body Shop. Since 2000, the Body Shop has given a biannual Body Shop Human Rights Award. The first award was given to help 250 million children forced into child labor; it worked to ensure that these children had an education and to bring them out of poverty. These grants have assisted organizations that support human and civil

rights and animal and environmental protection. They have funded organizations that promote social change and increased awareness of public issues. The Body Shop Foundation also works to aid organizations that would not receive funding otherwise. In 2002, it gave $300,000 in awards to be divided by four groups to aid people in finding housing (http://www.thebodyshopinternational.com/web/tbsgl/values.jsp).

Corporate training

An examination of twenty Web sites of Fortune 500 companies indicates that few include information about volunteering and philanthropic giving. Few sites demonstrate an expectation that company executives will be involved in their communities, support charitable causes, volunteer, or make financial gifts to nonprofit agencies. Yet posting information about philanthropic activities on company Web sites and providing training on philanthropy for women executives have become imperative given the recent growth in philanthropic activity by U.S. businesswomen.

Conclusion

In recent years women have begun to give more, both in volunteering their time and giving monetarily to charitable causes. This increase is due to a rise in women's wages. As their wages have increased, women have realized that they can truly make a difference with their pocketbooks. They have also realized that they can join together and pool their money to make even larger contributions by establishing foundations. As women's wages continue to rise, how will their charitable giving patterns change? What do philanthropic organizations need to do in order to attract women to volunteer and give to their organizations? These are questions that these organizations must continue to ask if they are to continue to gain women's time and financial support.

Organizations need to understand how to interact with women business owners and executives. This includes being sensitive to the ways that women are approached to volunteer and contribute financial resources. Women prefer pleasant interactions and not to be pushed into giving time or money to an organization. Findings also indicate that women give to organizations that they are passionate about and feel will make a difference, as well as to organizations that appear to be well managed. Organizations should strive to meet these women's needs and communicate frequently with women regarding how their philanthropic activities are being used.

It is imperative that companies educate women about the expectations for philanthropic activity associated with the role of business executives. An initial survey of company Web sites indicates that this education is not being addressed. There is a need for increased training and education for both women owners and executives regarding the expectations and processes of philanthropic giving within the corporate world.

References

Hall, H. "Cultivating Philanthropy by Women." *Chronicle of Philanthropy*, July 10, 1997, pp. 1–3.

Hall, H. "Women's Foundation Appears in the Chronicle of Philanthropy." 2005. http://www.womensfoundation.org/newsroom2.asp.

National Foundation for Women Business Owners. *Giving Something Back: Volunteerism Among Women Business Owners in the U.S.* Silver Spring, Md.: National Foundation for Women Business Owners, 1996.

National Foundation for Women Business Owners. *Philanthropy Among Business Women of Achievement: A Summary of Key Findings.* Silver Spring, Md.: National Foundation for Women Business Owners, 1999.

National Foundation for Women Business Owners. *Leaders in Business and Community.* Silver Spring, Md.: National Foundation for Women Business Owners, 2000.

Pofeldt, E. "The Best Bosses, The Nurturer: Eileen Fisher." *Fortune Online.* Oct. 1, 2003. http://www.fortune.com/fortune/smallbusiness/managing/articles/o,15114487551,00.html.

Reed, C. L. "From Sexism Victim to Multimillionaire Tune." *Chicago Sun Times Online.* 2004. http://www.suntimes.com/special_sections/powerful_women/philanthropy_bricker.html.

Taylor, C. "Sara Martinez-Tucker." Aug. 13, 2005. http://www.time.com. time.nation/printout/0,9916,1093653,00.html.

Walton, A. *Women and Philanthropy in Education*. Bloomington: Indiana University Press, 2005.

Williams, R. J. "Women on Corporate Boards of Directors and Their Influence on Corporate Philanthropy." *Journal of Business Ethics*, 2003, *42*, 1–10.

CYNTHIA R. JASPER *is chair of the Department of Consumer Science at the University of Wisconsin–Madison and the Vaughan Bascom Professor in Women and Philanthropy.*

The author discusses new research on married couples' giving and makes predictions about married women's decision-making trends.

5

Married couples' charitable giving: Who and why

Eleanor Brown •

SINGLE MEN AND WOMEN differ in their charitable behavior (Andreoni, Brown, and Rischall, 2003). What happens, then, to charitable behaviors when men and women marry? How does a couple reconcile partners' differing interests in deciding how to spend their income, on charity as well as in other areas? The data suggest that it matters for philanthropy whether decisions about charitable giving are made jointly or delegated to one member of the couple. In a recent survey, couples who decided jointly on how much to give reported that they gave away 3.4 percent of household income; couples in which one partner made decisions gave away 2.9 percent of household income (Toppe, Kirsch, and Michel, 2002). The data further suggest, as does economic theory, that economic clout within marriage matters for the way money is spent.

In this chapter, I review and extend the literature on charitable giving by married couples. I begin by describing how economists view decision making within households in order to identify the circumstances that influence partners' bargaining power when conflicts arise. I then review recent trends in the economic positions of men and women that are likely to affect the clout they bring to

discussions about how to spend household income. Next, the chapter turns to what we know about gender differences in charitable behavior and about charitable giving in married couples.

The picture that emerges from the data is one in which married women's influence over their families' charitable giving is growing. As married women's earnings, and their potential earnings should they choose to increase their time in the labor market, increase, women's voice in the disposition of charitable giving grows at home. Charitable organizations may wish to pay attention to these trends as they decide to whom in a couple they should pitch their requests for financial support; wives today may be taking a more active role in decision making than past experience in fundraising suggests. This is particularly good news for charitable organizations in those service areas, such as health care, that appear to receive more and bigger donations when the wife is in charge.

Decision making within the household

In thinking about how couples reach spending decisions, economists have considered several basic possibilities. Each model of decision making imagines a different level of cooperation between partners, and each has distinct implications for the relative authority of husband and wife.

Unitary preferences (income pooling)

The simplest way of looking at a multiperson household imagines that it makes decisions as if it were a single individual. Perhaps couples achieve perfect harmony and think as one. Alternatively, one member of the household may have dictatorial control, either altruistic or tyrannical, over resources. In this case as well, the household thinks as one. In these models, it is enough to know how much money comes into the household; regardless of who earns a paycheck, the money will be spent according to the one set of tastes that matters. This class of models is known as income-pooling models.

NEW DIRECTIONS FOR PHILANTHROPIC FUNDRAISING • DOI: 10.1002/pf

This implication of the perfect harmony or dictator model does not hold up to empirical scrutiny, however. Using Canadian data, researchers found that child care expenditures rise with the wife's income but not with the husband's, even when both spouses work full time (Phipps and Burton, 1998). Another test of the income pooling model came when the United Kingdom changed the manner in which child welfare payments were made. In the late 1970s, the U.K. switched from a tax break administered as reduced withholding from the father's paycheck to a welfare check mailed to the mother. The change reduced the take-home pay of a father of two by about 6 percent, increasing the mother's income by that amount. If family incomes were pooled and then spent according to a single set of tastes, this adjustment in the route through which income reached the household should have had no effect on household expenditures. In fact, in families with two or three children (the original welfare policy did not apply to families with one child), expenditures on men's clothing fell and expenditures on clothing for women and children rose when income was transferred "from the wallet to the purse" (Lundberg, Pollak, and Wales, 1997). Other studies in a variety of cultures have reached similar findings (Thomas, 1990).

Cooperative bargaining

Other models take the point of view that there is some conflict between the partners' preferred spending patterns: the wife might prefer that a little more be spent on her clothing, while the husband might prefer that a little more be spent on his own clothing. Given that partners care about each other's well-being, economists tend to think of this as caring conflict, each partner wanting the other to reach the highest level of well-being consistent with his or her own achieved level of well-being. Restated in the language of economists, we expect households to spend their money in ways that are Pareto efficient. For example, if the husband would be equally happy with an extra hundred dollars of clothing or of tobacco and if the wife would be happier seeing her husband better dressed but indifferent to his tobacco consumption, the couple

would never choose to spend the extra hundred dollars on the husband's tobacco habit. In this fashion, the assumption of Pareto efficiency gets us a long way toward predicting household expenditures: out of all the ways to spend money that would make one partner, say the husband, equally well off, we predict that the couple will prefer the one that is better for the wife.

We are left, then, with one final step: predicting the relative levels of well-being that husband and wife will enjoy. One factor to consider is each individual's threat point: if the household does not provide at least the level of well-being that partner could achieve by leaving the household, the partner can credibly threaten to leave. This threat translates into bargaining power in the household. These threat points can be taken as the starting points, and bargaining is then an issue of how to divide the surplus produced by the marriage. For example, the partners could spend money so as to make each person gain equally from the marriage. The solution of the famous game theorist John Nash is to maximize the product of the partners' gains from marriage (Lundberg and Pollak, 1996).

Noncooperative (separate spheres) behavior

Leaving the marriage is not the only possible threat. One could stay married but cease to cooperate. In other words, the threat point is not how well off one would be outside the marriage, but how well off one would be within the marriage if spouses ceased to consult one another on their spending choices. This is known as a separate spheres arrangement. Notice that when the threat point is internal to the marriage, it is no longer how well off one could be outside the marriage that matters. For example, an accomplished lawyer who moves with her spouse to a state in which she has not passed the bar might have significant bargaining power if the credible threat is to leave the marriage, but rather less power if she is to remain in the marriage where her earning power is substantially reduced (at least by commuting costs). If the threat of noncooperation is credible, then we expect to see some marriages dissolving not into divorce, as we would expect with external threats, but into

noncooperation. Control over spending in this case would depend strongly on how much income each partner brings to the marriage, and spending patterns would no longer be predicted to be Pareto efficient.

What does all this imply for the question of who in a household has influence over charitable giving? The greater a partner's threat point is, the greater the command is over resources; the greater a partner's threat point is relative to that of the spouse, the greater the share of household resources commanded is. Current earnings have been seen to influence spending. Education is a strong predictor of earnings power, as is labor market experience; both serve to raise threat points. The presence of young children in a household has generally been taken to reduce a mother's willingness to leave a marriage or to throw herself full time onto an ambitious career path.

Women have made great strides in the labor market, both in absolute terms and in relation to men, in the past quarter-century. Among workers who worked full time, year round in 2004, women earned seventy-seven cents for every dollar men earned; although this is far from representing equality, until 1980 that figure had for decades fluctuated around a norm of about sixty cents on the dollar (DeNavas-Walt, Proctor, and Lee, 2005). Models of household decision making suggest that the influence of wives over spending decisions will have increased with women's earnings. From 1981 to 1996, the proportion of working wives who outearned their working husbands rose from 16 percent to 23 percent (Winkler, 1998). Gains in employment and earnings have been greatest among wives of high-wage men (Juhn and Murphy, 1997), implying that these changes are most important among the higher-income families that dominate charitable giving (especially giving to nonreligious causes). There are, however, some indications that women's presence in the labor market is not inexorably rising on all fronts. The labor force participation of mothers with infants has been falling since 1998. In 2003 alone, the labor force participation rate for married mothers of infants fell by 1.8 percentage points to 52.9 percent (U.S. Department of Labor, 2004). Similarly, the rates for mothers with children

under age eighteen have been falling since 2000, standing at 70.4 percent in 2004 (U.S. Department of Labor, 2005).

Gender differences in charitable behavior

Wives' increasing influence over household resources may be of little consequence to charitable giving if in fact men and women behave similarly when it comes to charity. Ways to address this question empirically include looking at differences in the charitable bequests made by men and women, and differences in the behaviors of single men and women, or men and women in situations in which they are acting without reference to a partner, as, for example, in experimental situations.

There is evidence to support two general hypotheses about gender differences in giving behavior. First, men seem more responsive to measures of the personal costs associated with giving. Both survey data and experimental data suggest that men are more sensitive to the tax benefits associated with giving (Andreoni, Brown, and Rischall, 2003; Andreoni and Vesterlund, 2001) and may be more sensitive to variations in their levels of income as well (Andreoni, Brown, and Rischall, 2003). A second difference is that women tend to spread their charitable giving across more categories of recipients (such as the arts, social welfare, and education) than do men. This difference has been noted in survey data on charitable giving (Andreoni, Brown, and Rischall, 2003) and in tax data on charitable bequests (Joulfaian, 1991). One unifying interpretation of these differences is that women are more egalitarian in their giving, while men are more strategic. For example, Andreoni and Vesterlund (2001) find that in experiments in which the subject is asked to divide a pot of money between himself or herself and another person, at varying rates of exchange (for instance, every dime taken away from oneself might translate into two dimes or, alternatively, one nickel, for the other person), men are more likely to maximize the value of the pot, either keeping it all for themselves or giving it all away, whereas women will calculate how much to give away in

order for themselves and the other person to end up with equal amounts of money. Similarly, women's observed tendency to support a broader array of charities might be interpreted as an inclination to weigh more equally competing requests for support, whereas men may be rewarding "the best" options more heavily. Men are also more likely than women to decline to support any charity at all (Rooney, Mesch, Chin, and Steinberg, 2005).

Finally, Andreoni, Brown, and Rischall (2003) look at the types of charitable organizations supported by husbands and wives. Their work is based on the 1996 household survey of charitable behavior conducted for INDEPENDENT SECTOR in which the question is asked, "Who in your household is considered most involved in deciding which charities your household will give to?" (p. 114), to which respondents replied that the wife, the husband, both jointly, or someone else in the household was most involved. The authors examined the probabilities of giving to various kinds of charities, conditional on who in the household made the decision. For a typical family (white, churchgoing, income of $39,785 and a marginal tax bracket of 15 percent, one child, a forty-five-year-old husband, and a forty-three-year-old wife), the following differences in the probabilities of making contributions were statistically significant:

- All charities: Taking all charities as a whole, couples deciding jointly were less likely to make any contribution than were couples in which the husband decided.
- Health organizations: The likelihood of a household's making a contribution to a health organization was significantly higher if the wife decided than if either the husband or the couple jointly was in charge.
- Education: The likelihood of a household's making a contribution to an educational organization was significantly higher if the wife decided than if either the husband or the couple jointly was in charge.
- Religious organizations: The likelihood of a household's making a contribution to a religious organization was significantly higher if the wife decided than if the couple decided jointly.

- Adult recreation: The likelihood of a household's making a contribution to adult recreation was significantly higher if the husband decided than if the couple decided jointly.

Categories for which there was no significant difference in giving according to who had decision-making power were human services, environment, public/society benefit, youth development, private community foundations, and international/foreign.

There were also differences in the predicted amounts given, depending on who in the household had control over the decision making:

- Health: As was true of the probability of making a donation of any size, the amount given to health organizations was greater if the wife rather than the husband or the couple jointly was the decision maker.
- Human services: The amount given to human services was greater if the wife rather than the couple jointly was the decision maker.
- Private/community foundations: The amount given to foundations was greater if the wife rather than the couple jointly was the decision maker.

Note that in the predictions for how much is given to charities of different types and to charity as a whole, there are no instances in which the amount given differs depending on whether it is the husband or the couple who is in charge. One might suspect that this means that when the couple decides together, the outcome is not very different from what the husband would have chosen. This suspicion is borne out in a statistical regression describing the choices of couples deciding jointly as a combination of the choice that the household would have made were the man in charge and the choice it would have made were the woman in charge. Andreoni, Brown, and Rischall (2003) find that jointly reached decisions are best described as 68 percent of what the man would choose plus 26 percent of what the woman would choose. In this sense, husbands are

seen to be roughly two and a half times as influential as their wives in charitable decision making when couples decide jointly how much to give.

Given their limited influence over the jointly determined outcome, the good news for married women in the INDEPENDENT SECTOR data is that 28 percent of households reported that the wife was the principal decision maker when it came to charitable donations. The likelihood of the wife's having authority over decision making was greater when the wife was at least as well educated as her husband and was also greater if her earnings exceeded his. These findings are consistent with economic models of bargaining power within the household.

Decision making and charitable giving in the Center on Philanthropy Panel Study–Panel Study of Income Dynamics

Recently data have become available that eventually will allow replication of some of the analysis done by Andreoni, Brown, and Rischall (2003). The 2003 wave of the Panel Study of Income Dynamics (PSID), a long-established panel data set begun in the 1960s and known for the high quality of its data, queries charitable giving and includes a question for married couples on who makes the charitable decisions. Because the survey did not elicit information on who would have been involved in decision making from those households that did not in fact make charitable contributions, the data do not allow one to see how the assignment of decision-making authority affects the decision to give. Among households that do give, however, the PSID data provide a chance to compare the distribution of decision-making authority with that found in the 1996 INDEPENDENT SECTOR data.

Respondents in the PSID had four choices in describing decision-making authority within the household. As in the INDEPENDENT SECTOR data, respondents could report that the authority lay primarily with the husband, primarily with the wife, or that the two

decided jointly. A fourth option, that both partners made decisions but that they did so separately rather than jointly, is also allowed for in the PSID. The distribution of decision-making modes is reported in Table 5.1. As can be seen in the last row, by far the most commonly reported mode of decision making is collaborative, reported by three-quarters of the sample. Another 15 percent report that both partners are involved in charitable giving but that they decide separately. Just over 10 percent of couples report that only one member of the couple decides; among these, wives are more than twice as likely as husbands to be the decision maker. Collaborative decision making seems especially prevalent in households with a Hispanic head, among whom it is nearly universally the reported choice, and households in which the head has more education. Collaborative decision making is less prevalent in older households, where separate decision making is reported by more than a fifth of all couples; one interpretation is that as people grow older, they learn more about charities and come to have strong preferences. Families with a black head of household are also especially likely to report separate decision making.

Table 5.1. Decision making on giving in households

	Husband Decides	Wife Decides	Couple Decides Jointly	Couple Decides Separately
Education				
Head not high school graduate	3.6%	7.3%	72.2%	17.0%
Head high school graduate	2.1	7.3	82.7	7.9
Head college graduate	1.2	9.5	81.0	8.3
Race/ethnicity				
White	3.8	7.2	74.7	14.2
Black	2.0	8.8	68.0	21.1
Hispanic	—	—	97.1	2.9
Age				
Household head over age 50	2.8	7.2	67.5	22.5
Household head age 35–50	4.0	6.8	76.5	12.7
Household head under age 35	2.2	8.6	79.6	9.7
All contributing households	3.3	7.3	74.2	15.3

The prevalence of joint decision making reported in the PSID is striking: 89 percent of couples report that both partners participate, much higher than the 53 percent reported in the INDEPENDENT SECTOR data. It is worth remembering that the INDEPENDENT SECTOR data include information on decision making even from households that choose not to make charitable contributions. Perhaps the lower incidence of joint decision making is attributable to households that are not motivated to give, in which there is little reason to believe that both partners would insist on participating in decision making.

The high level of participation by both partners observed in the PSID suggests that among couples who make charitable donations, both husband and wife are usually interested in charitable giving. This is exactly the circumstance in which economic models of intrahousehold resource allocation tell us that partners' bargaining power matters. As women continue to make strides in the labor market relative to men, their voice in charitable giving is predicted to grow. If married mothers continue their trend toward a more traditional role, as seen in their decreasing labor force participation rates, we may see a widening divide between the influence wielded by wives who remain childless and those who interrupt their careers to raise children.

References

Andreoni, J., Brown, E., and Rischall, I. "Charitable Giving by Married Couples: Who Decides and Why Does It Matter?" *Journal of Human Resources,* 2003, *38*(1), 111–133.

Andreoni, J., and Vesterlund, L. "Which Is the Fair Sex? Gender Differences in Altruism." *Quarterly Journal of Economics,* 2001, *116*(1), 293–312.

DeNavas-Walt, C., Proctor, B., and Lee, C. *U.S. Census Bureau, Current Population Reports, P60–229: Income, Poverty, and Health Insurance Coverage in the United States: 2004.* Washington, D.C.: U.S. Government Printing Office, 2005.

Joulfaian, D. "Charitable Bequests and Estate Taxes." *National Tax Journal,* 1991, *44*(2), 169–180.

Juhn, C., and Murphy, K. "Wage Inequality and Family Labor Supply." *Journal of Labor Economics,* 1997, *15*(1), 72–97.

Lundberg, S., and Pollak, R. "Bargaining and Distribution in Marriage." *Journal of Economic Perspectives,* 1996, *10*(4), 139–158.

Lundberg, S., Pollak, R., and Wales, T. "Do Husbands and Wives Pool Their Resources? Evidence from the United Kingdom Child Benefit." *Journal of Human Resources*, 1997, *32*(3), 463–480.

Phipps, S., and Burton, P. "What's Mine Is Yours? The Influence of Male and Female Incomes on Patterns of Household Expenditure." *Economica*, 1998, *65*(260), 599–613.

Rooney, P., Mesch, D., Chin, W., and Steinberg, K. "The Effects of Race, Gender, and Survey Methodologies on Giving in the US." *Economics Letters*, 2005, *86*(2), 173–180.

Thomas, D. "Intra-Household Resource Allocation: An Inferential Approach." *Journal of Human Resources*, 1990, *25*(4), 635–664.

Toppe, C., Kirsch, A., and Michel, J. *Giving and Volunteering in the United States: Findings from a National Survey, 2001.* Washington, D.C.: INDEPENDENT SECTOR, 2002.

U.S. Department of Labor. "Labor Force Participation of Mothers with Infants in 2003." *Monthly Labor Review Online*, Apr. 22, 2004. http://www.bls.gov/opub/ted/2004/apr/wk3/art04.htm.

U.S. Department of Labor. "Labor Force Participation of Mothers and Fathers." *Monthly Labor Review Online*, June 10, 2005. http://www.bls.gov/opub.ted.2005/jun/wk1/art05.html.

Winkler, A. "Earnings of Husbands and Wives in Dual-Earner Families." *Monthly Labor Review*, 1998, *121*(4), 42–48.

ELEANOR BROWN *is the James Irvine Professor of Economics at Pomona College.*

The stewardship of wealth is key to the growth of many family foundations. What is women's important role in this trend? How is women's leadership affecting family philanthropy?

6

The dynamics of women and family philanthropy

Ellen E. Remmer

TWO OF THE MOST significant trends in the world of philanthropy today are the rapid growth of family philanthropy and the increased importance of women in philanthropy. This chapter addresses the intersection of the two trends and how they affect and influence one another. I propose that for the most part, the intersection is positive and reinforcing of both the growth and character of philanthropy as well as the health and well-being of women and their families. However, I also raise some caveats about the feminization of this work and pose a number of questions that I believe warrant further inquiry and research.

Family philanthropy

Family philanthropy is rapidly growing in both the United States and abroad. According to various estimates prepared by the Council on Foundations, the Foundation Center, and the National Center for Family Philanthropy, there are an estimated thirty thousand

NEW DIRECTIONS FOR PHILANTHROPIC FUNDRAISING, NO. 50, WINTER 2005 © WILEY PERIODICALS, INC.
Published online in Wiley InterScience (www.interscience.wiley.com) • DOI: 10.1002/pf.130

to forty thousand family foundations in North America today, a number that has grown by over a thousand per year since 1990, twenty-five hundred per year since 1999, and is projected to grow by as many as five thousand new entities per year in the near future.

Annual giving by family foundations is estimated to be about $12 billion on an asset base of approximately $195 billion (Foundation Center, 2005), and family foundations grew from less than a quarter of the membership of the Council on Foundations in 1992 to 40 percent in 2002. The Internal Revenue Service reports that bequests to foundations (many of which will be family controlled) accounted for 42.8 percent of all bequests, or $6.32 billion, in 2003 (Joulfaian, 2005).

Organized family foundations tell only part of the family philanthropy growth story. We know that a considerable amount of family giving takes place through direct gifts to nonprofit organizations and through other giving vehicles, most notably donor-advised funds housed at organizations such as Community Foundations, Jewish Federations, and nonprofit gift funds offered by commercial investment companies. According to the *Chronicle of Philanthropy*, which conducts an annual survey of gift funds, the assets of ninety of the nation's largest donor-advised funds grew from $3 billion in 1995 to more than $13 billion in 2004 ("Growing Assets and Concerns," 2005). Family philanthropy also takes place through various charitable lead and remainder trusts, gifts of life insurance, and even through family businesses.

The potential for continued growth of family philanthropy is immense. In 2001, there were 2.2 million individuals in North America whose net worth exceeded $1 million (excluding residences), and 18,000 individuals with net assets of $30 million or more (Merrill Lynch and Capgemini, 2001). The fact that over 90 percent of all business enterprises in North America are family owned, as are 35 percent of Fortune 500 companies, suggests a vast potential reservoir of family driven philanthropy. Despite the growing importance of family philanthropy, there is surprisingly little factual knowledge about the origins, operations, and character of the family philanthropy world. There is no legal definition for a

family foundation; however, the Council on Foundations characterizes it as "a private foundation in which the donor or the donor's relatives plays a significant governing role" (http://cof.org). The National Center for Family Philanthropy, which studies and provides resources to all family philanthropy regardless of the vehicle, considers family philanthropy as "giving by a family through any of a number of options, including family foundations, community foundations, foundations tied to a family business, gift funds, banks, religious or ethnic federations, and collaboratives of donors" (http://www.NCFP.org). Many observers tend to use the term primarily, although not exclusively, to refer to intergenerational family giving. Certainly, what uniquely separates family philanthropy from other collective giving experiences is that family-related systems, dynamics, histories, and motivations come into play.

Motivations for family philanthropy

Most of what we know about family philanthropy motivation is anecdotal, although a few studies are beginning to address this topic in a more rigorous manner.

The motivations of donors are not simple, and they often evolve. A recent study of thirty family foundations that endured over multiple generations found that the primary motivation for these foundations were, in order of frequency, tax savings (identified by thirteen foundations), a philanthropic agenda (identified by twelve foundations), and family closeness and legacy (identified by ten foundations) (Gersick and others, 2004). Yet these foundations were the ones that endured, and certainly a tax motivation is hardly the recipe for continuity. Evidence that family issues may become even more important is demonstrated in a survey that asked family foundations with living donors, "What might inspire you to allocate even more dollars to the foundation?" The largest response by far, at 39 percent, was that "donors see first hand that the foundation is an effective way to pass on philanthropic values" (Association of Small Foundations, 2005, p. 12)

Through my consulting experience and exposure to hundreds of family philanthropies, I suggest the following as some of the most common (and typically overlapping) reasons donors decide to involve other family members in their philanthropy:

- Pass on philanthropic values and a spirit of giving to the next generation.
- Bring the family closer together, especially as they become geographically separated.
- Keep the family together after the sale of a family business.
- Establish or continue a family legacy.
- Share personal philanthropic interests and experiences.
- Teach the next generation about being effective donors.
- Pass on the stewardship of wealth to the next generation, but not pass on direct wealth, for fear of stunting motivation and achievement.
- Involve family members who are not otherwise involved in a family business.

Historical reviews of family philanthropy focused considerably on its role in establishing a legacy for a family. I believe that the recent growth of family philanthropy is tied much more to its role as a tool for financial and moral parenting. The families that I see are eager to use philanthropy as a way to articulate and act on shared and altruistic family values and to model responsible use of wealth. The legacy that donor parents are most interested in leaving is a next generation with good civic and moral values, using philanthropy as a tool. Because there has been a proliferation of more accessible and manageable family philanthropy vehicles, such as donor-advised funds, this tool is now available to many families.

A survey cited by the National Center for Family Philanthropy (2003) indicated that 82 percent of affluent parents want their children to know that philanthropy is important. A 2000 Cone/Roper Charitable Children Survey indicated that 85 percent of Americans agree that children should be introduced to charities by the age of

thirteen, and more than 90 percent believe that parents are pivotal for getting children involved (Cone, 2000).

Family philanthropy in practice: No one size fits all

An oft-quoted phrase in the family philanthropy field is, "You've seen one family foundation, you've seen one family foundation." Certainly the variation among family foundations in terms of what they look like and how they operate is so diverse that it is hard to categorize them. The variation is clearly influenced by such complexities as the personality and objectives of the donors; the personalities of other family members; family culture, traditions, and dynamics; the generational distance from the founders; the context within which the philanthropy operates (for example, a family business, small town or large city); and the strategic philanthropic choices made by the family.

Some of the primary differences that I have seen in how family philanthropies operate are along the following qualities.

Control: Autocratic versus inclusive or democratic

Probably the most widely recognized difference among family philanthropies, this characteristic refers to the stereotypical patriarch or matriarch who "invites" family members into the philanthropy but retains all control. The autocrat's interests and style dictate what the philanthropy funds and how it operates; and although family members may be asked to participate in discussion or present funding ideas, the autocrat retains decision-making control. At the opposite end of the spectrum is the family philanthropy that includes many family members and operates as a collective democracy. As Alan Alda (1995) described his family foundation, "It's maddeningly democratic. One person, one damn vote!" (p. 3).

Objectives: Family togetherness versus individual interests

When a family philanthropy is launched with the primary objective of strengthening family bonds, the decision-making process is generally collective, and the grant making often reflects a focus

on one or more issues arrived at through family consensus. Other family philanthropies emphasize supporting individual members' participation in philanthropy, with the objective of teaching them to be good stewards of wealth and enabling them to act on their personal passions. There are many hybrid models that seek to serve both goals.

Culture: Family versus formal

Some family philanthropies go to great lengths to maintain a culture of interaction that is personal and informal and reflects the fact that this is "just family." These philanthropies truly make decisions around the kitchen table and communicate their decisions to grantees through personal interactions. Others emulate the practices of independent foundations with more formal and professional modes of communication and operations. While this can often be a function of foundation longevity, growth stage, or, most important, whether the family has hired staff, it is not always the case.

Perspective: Internal versus external

While somewhat related to the preceding issues, this quality refers to whether a family's philanthropic choices are based primarily on a narrow band of family input or whether the family draws extensively on external resources for advice and partnerships. An external orientation may be reflected in governance (for example, there may be nonfamily board members) or in grant-making style, with externally oriented families more visibly participating in community and partnering with others. For some families, an internal perspective can be a function of their discomfort with wealth, a need for privacy, or simply lesser philanthropic engagement.

Women and family philanthropy

Some of the questions that I seek to address in this chapter are the following:

- How do women become involved in family philanthropy? As donors, partners with their spouses, as inheritors? Are there any discernible trends?
- What roles do women typically play in family philanthropy—in formal roles such as board members or staff or in informal roles?
- What are women's leadership styles in family philanthropy? How do their roles in family systems influence their leadership styles? And based on this, do women make a distinctive contribution to family philanthropy?
- What is the impact on the women themselves of their involvement in family philanthropy?

How women become involved in family philanthropy

This question is a difficult one to get a handle on and suggests one possible research strand. The first question is whether women are most likely to come to family philanthropy as the founding donor, as partner to the donor, or as heir who works with her own children, siblings, or other relatives. The second question is when they are not the donor, what role do women play in the decision to launch a family philanthropy? Can we predict whether women are more or less likely to launch a family philanthropy than men?

Given women's comparative economic disadvantage over history, it is undoubtedly true that men have been the largest financial donors to enduring family philanthropic institutions. Even as recently as the middle of the twentieth century, a study of thirty family foundations indicated that 90 percent of their leaders were male (Gersick and others, 2004). I would hazard that it is likely today, as marriages have become more egalitarian, that women as partners play a larger role in the decision to launch a family philanthropy. Moreover, as more women make substantial incomes, earn their own wealth, and become the stewards of the family's wealth on their spouse's death, they will have significantly greater opportunities to initiate family philanthropies.

Women are certainly the leaders when it comes to leaving significant charitable bequests, a fact that is typically attributed to the greater likelihood of being the surviving spouse. Thus, while women

made up 49.3 percent of deaths, 45.1 percent of estate tax decedents, and 60 percent of the donor population in 1995 (Eller, 2001), we also know that the majority of female tax decedents were widows and male tax decedents were married. I believe that women are increasingly leaving bequests to family philanthropy even when they predecease their male partners. For example, Susan Buffett, who died in July 2004 (her husband, financier Warren Buffett, is still alive), left most of her estate of $2.6 billion to the Buffett Foundation and to foundations created by each of her three children ("The Top Givers," 2004). Since more than 40 percent of all bequests went to foundations in 2003, it is likely that women are responsible for launching or contributing to many family giving enterprises. Female next-generation heirs may also start family philanthropies or become the stewards of larger foundations on the deaths of their parents.

One opportune time for the formation of a family philanthropy happens on the death of the first spouse, either because a bequest is made to a family foundation or because more family members may become involved in the family's overall financial situation and estate planning. There may be a financial windfall due to insurance payments or the sale of a family business. (Of course, for some, it can be a financial crisis, as the income stream from the person who died is eliminated.) Because the surviving spouse is more likely to be a woman, she is the decision maker when it comes to further estate planning and the determination of whether to put resources into a family philanthropy today or in the future. My mother was in just such a position in 1988 and with the encouragement and support of her children, formed the family's foundation. Through The Philanthropic Initiative's consulting practice, we have seen a number of women who gained more control over wealth as a result of either a death or divorce and chose to allocate significant portions to family philanthropy. I believe that research on the needs and opportunity to work with widows of wealth as well as divorcees would yield some intriguing possibilities.

Much has been speculated, and only a little good research conducted, about whether gender affects generosity in terms of both participation in philanthropy and size of gifts. The mythology has

evoked pictures of prosperous and adventurous male entrepreneurs who give large amounts of money, knowing they can replace their fortunes, and prosperous and cautious female widows who give parsimoniously, fearing the gradual erosion of their financial security. However, recent research conducted by Indiana University's Center on Philanthropy found that on an income-adjusted basis, single women were in fact the most generous donors, followed by married couples, with single men bringing up the rear (Rooney, Mesch, Chin, and Steinberg, 2004). The authors of this study have speculated about whether this indicates that women actually socialize men to become givers.

Women's roles in family philanthropy

The literature on how gender affects the roles of women in family philanthropy is primarily limited to survey data drawn from the membership roles of the national foundation membership groups. The Council on Foundations membership surveys (corporate, community, and private) show a steady growth in the percentage of females as board members, from 22.6 percent in 1982 to 35.8 percent in 2004. Among family foundations, a separate category identified only in recent years, women have played a significantly larger governance role, holding approximately 44 percent of the board seats during the entire period, 1997 to 2004 (e-mail from J. Kroll, Council on Foundations, to the author, 2005).

The explanation for this larger role for women in the governance of family philanthropies is unknown, but one theory is that families have a smaller pool of candidates from which to pick board members, given that 42 percent of family foundations have boards composed exclusively of family members (Council on Foundations, 2001). Another possible explanation is that women are often given a role in the family philanthropy as a way to involve them in a family enterprise, while the men work in the family business. It may also be that women are given greater opportunity to opt into the governance of a family foundation than of a community, corporate, or independent foundation, where business or social status plays a larger role.

The philanthropy profession has become increasingly feminized over the past twenty years, with women now holding nearly 70 percent of all professional foundation staff positions. Women's representation in professional staff positions at family foundations is slightly lower (72.6 percent) than at other foundation types, although still significant (Council on Foundations, 2004). In our consulting practice, we have noticed a fairly common practice of hiring next-generation females as family philanthropy staff. I believe that the field is at a stage where employment in philanthropy is fast becoming traditionally female, with the attendant risks of marginalization and undercompensation.

Another possible explanation for the dominant role women play in philanthropy employment and governance might be found in their attitudes toward money. Fredda Herz Brown, a psychologist and family business adviser, suggests that women look at money from the perspective of what it can afford them to do, while men tend to look at money as a measurement of their success. She is currently undertaking a research study to examine more closely the different ways that women view and use their wealth (Brown, Jaffe, and Rosplock, 2005).

Women's leadership styles and contribution to family philanthropy

It is impossible to talk about women's leadership styles and contributions to family philanthropy without addressing their role in family systems. Traditionally, women have been responsible for the care and nurturing of children and the elderly, maintaining family relationships, and making sure that others' needs are filled before taking care of themselves. Whether women took on these roles, and the personality characteristics and behaviors that help them successfully fulfill these roles because of nature versus nurture, is an age-old discussion. It is important only to note that these behaviors and roles, while certainly in a state of flux today, are still deeply established norms and traditions.

Based on these norms, one would speculate that the mother might be the parent more interested in engaging the children in

family philanthropy based on her interest in moral parenting. A survey of high-net-worth banking clients conducted in 2002 for Citigroup Private Bank supports this notion. It showed that women were almost twice as likely as men to agree with the phrases, "It's important for others in the family to be involved in charity" (40 percent versus 21 percent) and "It is important to teach kids that affluence brings responsibility" (61 percent to 37 percent) (Citigroup Private Bank, 2002, p. 2).

Another interesting question is whether women lead family philanthropies differently than men do. Is their style of interaction with family members or grantees distinctive? Again, we tread the dangerous waters of stereotyping, but nonetheless I will venture that there are some differences, and many of them can be positive when it comes to family philanthropy.

Primary among these, and affirmed by a number of observers from different fields, is that women are more likely to use a participative and inclusive leadership style. From an international study of women's leadership, we learned that "women . . . tend to use an interactive leadership style in which they not only encourage others' participation but also attempt to enhance other people's sense of self-worth and to energize followers" (Rosener, 1990). A handbook on family systems notes that "adaptability has probably been the major skill required of women" (McGoldrick and Carter, 1998, p. 33). Family business literature states that "some management consultants report that women business owners listen better and act on what they hear, whereas men tend to think they don't need advice" (Nelton, 1998, p. 217). And Gersick and others' study of thirty enduring foundations (2004) reported, "The inclusion of women seems to have a significant impact on the grantmaking process, especially if a woman is in the leadership position. . . . They looked for support from the group. They were more accommodating and better able to tolerate multiple agendas. They may also have been more in touch with different branches of the family, and more inclined to inclusion across branches and generations" (p. 133).

It may be that women tend to use these styles because, having been denied positional power, they have developed an approach

reliant on networks. Nonetheless, a research study in the family business field showed that participative leadership styles have the best outcomes in terms of both financial success and family (Sorenson, 2000). Based on my experience helping new family philanthropies succeed, I agree that a participative leadership style is more likely to be a satisfying and successful mode for a family philanthropy.

Impact on women of family philanthropy involvement

Through our consulting practice, it has been a pleasure to witness the positive effects that deep philanthropic engagement can have on an individual's sense of purpose, connection, and satisfaction with life. I have also seen how profoundly fulfilling and enjoyable it can be for family members to work together on a shared philanthropic endeavor. Family philanthropy may provide its participants with diverse and expanded networks in the community; it can provide a meaningful bridge between wealth and self-expression; within a family, it can become a platform on which individuals carve out new roles for themselves. For family members who take a leadership role in their philanthropy, it can be a positive, life-altering experience. For women who traditionally have had fewer avenues open for self-actualization, philanthropy has provided opportunity.

However, family philanthropy is not easy. In addition to learning how to become a grant maker, the leader of a family philanthropy must often navigate the world of sometimes tension-filled family dynamics and family politics. That leader, often a woman, can be caught in the middle, and instead of experiencing personal growth, she may feel relegated to the position of family negotiator or, worse, scapegoat. Moreover, in a family that also has a family business, the woman's philanthropy role may be marginalized.

Conclusion

This chapter has looked at two important trends in philanthropy—the increased significance of women in philanthropy and the

growth of family philanthropy—and addressed the implications for women, their families, and the field of philanthropy. I believe there is exciting potential in the intersection of these two trends, especially as they take place in the context of the intergenerational transfer of wealth and the proliferation of philanthropic vehicles that make family philanthropy accessible to more families. Women are increasingly in a position where they will drive how much of the intergenerational transfer of wealth goes to social use. As a result, there is tremendous opportunity to:

- Encourage women to become the catalysts for family philanthropy.
- Support women who are leading or participating in family philanthropy.
- Learn from the experience of both men and women about what makes for successful transmission of philanthropic values and energy within a family.

Finally, I suggest that there are important research needs that will help us take advantage of these opportunities. A number of questions emerged during my research that I believe merit further exploration:

- How does gender—and its relationship to parental roles and couple dynamics—affect the decision of whether to launch a family philanthropy?
- How do women of different age cohorts view and participate in family philanthropy? Do postboomers have different motivations? Different leadership styles?
- How do women with different relationships to wealth—earned, married, inherited—view and participate in family philanthropy?
- What is the impact on widows and divorcees of launching a family philanthropy? What is the opportunity?
- What trade-offs do women face, and how do they negotiate them, between finding self-actualization in philanthropy, serving as the protector of family happiness and togetherness, and achieving philanthropic impact?

References

Alda, A. "Giving Well." Speech to the Council on Foundations Family Foundation Conference in Initiatives, Boston, 1995.

Association of Small Foundations. *Foundation Operations and Management Survey 2004/2005.* Washington, D.C.: Association of Small Foundations, 2005.

Brown, F. H., Jaffe, D., and Rosplock, K. "A Proposal for Survey Research on Women and Wealth: Emerging Leadership as Older Women Control Wealth." Unpublished manuscript, Philanthropic Initiative, 2005.

Citigroup Private Bank. "Family, Philanthropy Top Priorities for Ultra-Wealthy." Press release, Aug. 5, 2002.

Cone. *Cone/Roper Raising Charitable Children Survey.* Boston: Cone, 2000.

Council on Foundations. *Trends in Family Foundation Governance, Staffing and Management.* (4th ed.) Washington, D.C.: Council on Foundations, 2001.

Council on Foundations. *Grantmakers Salary and Benefits Report.* Washington, D.C.: Council on Foundations, 2004.

Eller, M. B. "Charitable Bequests: Evidence from Federal Estate Tax Returns." *SOI Bulletin,* Spring 2001, p. 175.

Foundation Center. *Key Facts on Family Foundations.* Washington, D.C.: Foundation Center, 2005.

Gersick, K., and others. *Generations of Giving: Leadership and Continuity in Family Foundations.* Lanham, Md.: Lexington Books, 2004.

"Growing Assets and Concerns." *Chronicle of Philanthropy,* Apr. 28, 2005. http://www.philanthropy.com.

Joulfaian, D. "Basic Facts About Charitable Bequests." Washington D.C.: U.S. Department of the Treasury, Mar. 2005. Mimeo.

McGoldrick, M., and Carter, E. A. *The Expanded Family Life Cycle: The Individual Family and Social Perspective.* Needham Heights, Mass.: Allyn and Bacon, 1998.

Merrill Lynch and Capgemini. "World Wealth Report." 2001. http://ml.com.

National Center for Family Philanthropy. *Family Philanthropy: What We Don't Know.* Washington, D.C.: National Center for Family Philanthropy, 2003.

Nelton, S. "The Rise of Women in Family Firms: A Call for Research Now." In J. H. Astrachan (ed.), *Family Business Review.* Boston: Family Firm Institute, 1998.

Rooney, P., Mesch, D., Chin, W., and Steinberg, K. *Race and Gender Differences in Philanthropy: Indiana as a Test Case.* Indianapolis: Indiana University Center on Philanthropy, 2004.

Rosener, J. "Ways Women Lead." *Harvard Business Review,* 1990, *68*(6), 119–125.

Sorenson, R. "The Contribution of Leadership Style and Practices to Family and Business Success." In J. H. Astrachan (ed.), *Family Business Review.* Boston: Family Firm Institute, Sept. 2000.

"The Top Givers." *Chronicle of Philanthropy,* Nov. 29, 2004. http://www.philanthropy.com.

ELLEN E. REMMER *is a vice president of The Philanthropic Initiative.*

Women face complex challenges as they move through their philanthropic journey—financial resources being a major one. As women become more informed and work collaboratively, a better society will be created.

7

Women philanthropists: Leveraging influence and impact as change makers

Tracy Gary

Let the women set the noble example. Let circles of philanthropy be formed throughout the length and breadth of the land. Let them educate themselves as to the needs of existing conditions. Let sound reasoning and a good heart govern their actions. Let their best efforts and their noblest impulses guide them to do the right with all their might in this coming millennium. It is my firm belief that women have this mission to fulfill. For as Emerson says, "What is civilization without the power of a good woman?"

Cecilia Lichtenstadter Borg, New York City, 1800
(Shaw-Hardy, 2000, p. 61)

Learning about finances and philanthropy is as important to the empowerment of the women of our generation as voting was for our grandmothers at the beginning of the last century, and driving a car was for our mothers at the middle of the century!

Tracy Gary, San Francisco (1980)

NEW DIRECTIONS FOR PHILANTHROPIC FUNDRAISING, NO. 50, WINTER 2005 © WILEY PERIODICALS, INC.
Published online in Wiley InterScience (www.interscience.wiley.com) • DOI: 10.1002/pf.131

> Giving intentionally to inspire and create a better
> world, now becomes women's collective call.
>
> Tracy Gary, San Francisco (2005)

WOMEN AND GIRLS' independent and collective financial, philan-
thropic, and leadership expression are the tipping points of the
times. We examine quotations from the past and history and rec-
ognize just how far we seem to have come and how much
women's history has inspired and can inform us. On the surface,
advancements for women and girls that we have experienced in
the past century have been nothing short of extraordinary. While
women of previous generations have made change, this is the first
generation of women who have funded our own and collective
dreams for society with substantial contributions. It is also the
first generation that has effectively used legislation to gain our
rights and ensure at least some progress on the march to equal-
ity. Money and women's shifting to philanthropy have been key
to that success. Women's philanthropy and investing in socially
responsible investments, women-owned businesses, and women-
financed candidates have shown us multifaceted options for the
expressions of women's leadership and concerns. We must now
step up with even greater harmony and capacity if we are to
achieve our highest potential: a more civil society.

A web of women's funds, women's giving circles, and women
donor networks are now covering the globe and casting hope
through their existence. Never before have women funded at such
generous and impressive levels not only to women and girls' pro-
grams, but to other programs that inspire their family and personal
generosity. Adding this figure to the number of women donors who
have and are giving millions during their lifetimes to their pas-
sionate concerns or honored obligations to programs like Girls Inc.
or the YWCAs, to local battered women's shelters, to the Global
Fund for Women, or to their universities or religious organizations,
we have nothing short of a revolution in the making. Giving cir-
cles and engagement in women's giving have become the "hip and
cool" thing to do.

As the first and second generations of women from middle- and upper-income U.S.-based households have joined the wage earners of working-class and selected professional women, we now have a mass movement of two generations of women willingly expressing that we are and want to be investors in change making.

In spite of this, we know that we are far from our goal of having a sustainable, just, and healthy world that creates a future that will work for everyone. How best then might we replicate the successful leadership and accomplishments of this first wave of women's financed philanthropy, and leverage our success so that women's impact does in fact create a trajectory that guides us from the malaise, corruption, wars, and neglect of the early turn of this twenty-first century?

Catalyzing change in women's giving

To catalyze more consciousness about women's core values and to achieve a world that works better for more people, how might we build on the qualities and the influence of the foundation of this movement of women and girls? Can we fully understand what has motivated and propelled their success or breakthroughs?

It seems key to analyze what forms of creativity, concern, and capital have helped to create and spark this exceptional wave of relative generosity. Has it been leadership? Has it been the media's support to expose new needs? Or has it been the deepest collective concern that we as a planet are off course for survival?

We can see that many forms of capital have shaped this movement of hope. It is women's courage capital, creative capital, and wisdom capital, offered by every woman from her experience in her family and community, that have joined with social and financial capital of the times to reinforce women's positions of leadership in philanthropy. Philanthropy gives women a platform and a place of leadership in a world that still largely has not permitted women to fully lead, especially behind the doors where a great deal of money or power still is stored. The highest echelons of business and

government are still positions of power guarded by men. But how amazing that in my life span, I have moved from a world dominated by stay-at-home, one-income families for at least middle- and upper-income families to a world in which women seek the highest office and will undoubtedly achieve it in our lifetimes.

Can we permit new possibilities for our collective future through focused and intentional cultivation or transplanting the roots of our successes as we mentor across generations? Will the next generation take what has been laid out as a form from which to work, that is, a more democratized, collective form, and help to rebalance the more private forms of self-indulgence possible in an overcapitalized world? Is it shared values, worldview, or the regenerative qualities of gratitude that have catapulted our faith in women and girls now to lead us to greater hope? Or are we deluding ourselves about our balance sheet, and only able to hold hope instead of falling into reluctant denial or acceptance of a more dismal fate for our world? Just how powerful and influential are women, and are women in fact using our power? And who are the heroines who have inspired our audacious possibilities?

Making a difference in communities

I have spent over one hundred days a year over the past twenty-five years on the road in all fifty states and fourteen countries with members of the Women's Funding Network and leaders from the Women's Philanthropy Institute, spreading and helping to cheer on the movement of women gathering to make a difference in their communities. Each day is filled with events, hundreds annually, that convene women, as we have done for years, to examine a community issue or problem and to celebrate the usually quiet persistence and leadership of some exemplary women and girls who have gone the extra mile in their communities to make the world a better place. What in the 1970s were living room-sized gatherings, each time I return there is a larger and larger group. Most major cities and universities now have a women's fund and a university with at

least an annual event honoring women in the community or some form of women's philanthropy, and hundreds, if not thousands, rush to get tickets to enable a seat or sponsorship. We have moved what was once a circle of women who gathered for quilting, or discussing books, or sharing child care, or investing, to expanded intergenerational and more diverse circles that are excited to share and influence each other about projects in their communities or some collective endeavor.

When we ask women, "Why give?" and "Why give to women and girls?" many of them say, "Because giving grows empathy and good listening and engagement skills." "The world needs us to care. We can see now that our security is not going to be taken care of by others." "We have so much; we must pass some of it on, to help others." "Women are the only way that communities grow." A woman is more likely than a man to start a child care center or to gather others to improve the water system or playgrounds. We know that developing the culture of giving makes healthier individuals and communities. In communities that have a women's foundation, giving circles, a United Way, a Black United Fund, a social change fund, workplace giving alternatives, and fraternities and sororities as well as service clubs like the Rotaries, or Links in full swing, there is a hope and effectiveness that is unstoppable.

The world of possibilities ·

If we consider women's giving as a tool for evaluating our balance sheet of assets and liabilities in progress for women and girls, we might examine the number of women worldwide who now know that owning property is key. Consider that just 150 years ago, women were not permitted to own property in the United States. Consider how wages for women have changed and jobs that were once impossible for any woman to consider are now fully open for women professionals. Consider finances, medicine, law, business, and politics. Expanded scholarships for women by women and

supportive women have enabled more women to go to graduate and professional schools than at any time in previous history. Women globally are stepping forward or have pushed their way to be recognized as leaders, so that their families and humanity can be preserved.

What is apparent is that the world of possibilities has opened to women and girls thanks to some diligent legislation of the last half of the twentieth century. But it has also been leaders like Marie Wilson of the White House Project and the Ms. Foundation, Ellen Malcolm of EMILY's LIST, and Anne Firth Murray and Kavita Ramdas of the Global Fund for Women who by their sheer persistence have made a path for women to be leaders at the governing tables of all countries.

No women have been more in the media than these but for Oprah Winfrey. This media star and entrepreneur has herself expanded her giving and her abilities to join with public policymakers and the law to show her daily viewership of millions that giving will produce changes in communities. This is the power of women's philanthropy today. We are breaking barriers and making change.

Consider philanthropy and the signs of progress for women and girls. In the last thirty years, we have seen the following trends:

- Women have moved from the margins of the philanthropic industry to some of its industry leaders. In fact, women make up 52 percent of foundation CEOs, 72 percent of program officers, and 31 percent of board members of foundations (Council on Foundations, 1980).
- Women give a larger percentage of their earnings and a larger percentage of their legacy gifts than men to charities (Rooney, Mesch, Chin, and Steinberg, 2004).
- Girls in the United States and globally are increasingly educated about obtaining their financial independence. Girl Scouts, USA, and Girls Inc. provide training about finances and philanthropy to their young female members.
- Over one hundred women's foundations have been established that exclusively work to empower women and girls and to shift

society through root-cause-focused giving and leading that make an impact (www.wfnet.org).

- Women, alone, as part of a couple, or as part of an estate, have invested more than $3 billion in establishing and funding new foundations, according to Jankowski Associates of Frederick, Maryland.
- Women's way of giving is being emulated around the world in collective giving circles and donor circles, pioneered as models by women in the end of the twentieth century (www.women-philanthropy.org).

In short, the greatest contribution of the women's philanthropic movement has been our spirit to deepen, diversify, and democratize philanthropy.

Moving forward for greater progress

Yet our moral and financial balance sheets inform us that we must propel ourselves for even greater progress. The forces of destruction or favoritism exclude and deter the progress that the promise of democracy should inspire. While the number of private foundations continues to increase and philanthropy is on the rise, so is an unacceptable level of inequality. The faces of that inequality, some of the faces of poverty in our own backyard and of blatant discrimination, came to the fore, exposed and raw through the exodus and the victimization of the residents of New Orleans and the Gulf Coast.

For once our media showed us what a community becomes when more than 35 percent of its residents are poor and neglected. Women and children remain at two-thirds of those in poverty. Our work to redistribute money, power, and skills has not been accomplished. In fact, due to tax policy that at the beginning of the twenty-first century favored corporations and the wealthy, the position of the poor in America made the raising up of all women and girls nearly impossible.

In spite of our efforts to spread and enhance philanthropy, the gap between the rich and poor appears to be widening. Our giving has been for the most part decorative and has not required much sacrifice for most. The great news is that more can and must be done. We have barely begun the redistribution of money and power. Although the quality of most of our lives is more than sufficient—how many clothes, how much stuff, how much travel, how much money for "security" is enough—far too many suffer at our unconscious, collective indulgences.

In 2001 the richest 5 percent of American households controlled over 59 percent of the country's wealth (United for a Fair Economy, 2001). It was not always this way. Moreover, charitable giving to change—projects that support underprivileged communities and take on the root cause of issues—is on the decline. With government clearly not as responsive or willing to direct its tax dollars back to the communities most in need, the mandate for philanthropy that has an impact becomes even more important.

The work of philanthropy and women's leadership in philanthropy for the foreseeable future is not only to encourage giving but giving to lift our nation and our world's poor through pursuing answers about the source for and the answers to this great economic and resource divide. Can we not through taxation, philanthropy, and mentoring lift the quality of life for many while barely changing our lifestyles? Would living with 10 or 20 percent less of our excess, or giving 5 to 10 percent more, not catapult a greater good? It is the average woman who is the leading consumer in America who must take us back to reason. If each of us gave more, wasted less, and shared more, we would in fact achieve greater sustainability for the world. This must be our call as we move ahead as a force for good.

Women as change makers

Women giving must now become women as change makers. Let our circles be expanded to include those more diverse who are not

yet at our tables. In 1999 a foundation was founded that put under its banner of collective giving many of the women's funds and social change funds. These were foundations that practice community-based giving. Changemakers, as this public foundation is called (www.changemakers.org), sees that giving has a greater impact and achieves a deeper consideration for the root cause of problems when we gather together, rather than when we are just donors in one circle or activists in another or business leaders in another.

Community-based giving is achieved when donors, activists, and community leaders gather to examine what the needed priorities are in a community or region or for a population and then together seek the answers to those problems as a team and get them financed or get business and policymakers to make needed shifts in the interest of the whole of a society. This is a democratized form of giving and requires us to ask, "Who is not at our table who should be represented?" Healthier communities and a more sustainable world will occur when we engage those most affected by our decisions. This meshing of classes and races and differences will change the world from its current silos of power or desperation. Women innately understand this form of collective and democratic decision making and have greater tolerance for the deep respect and listening that it requires. We must demonstrate the results of community-based giving by showcasing change making throughout the land.

Women change makers provide even more hope. In the next decade as trillions of dollars transfer between the generations, many new philanthropists, foundations, and trusts will likely emerge. Is it possible to tap this rising community and help them commit to be angels of a cultural and global agenda of change? Can we urge every woman to live and leave her legacy with intention? Can we create a world that works for everyone?

We must draw our hope and inspiration from the achievements of women with supportive men and families. We see the potential in entrepreneurship or economic development for the masses. We are advancing in global technologies and have made advances in math and science in order to do so. Women now make up the majority of those enrolled in U.S.-based higher learning, specifically,

undergraduates, law, and medical students. We have in the face of enormous conservatism cracked open a diverse and accepting women's spirituality movement. And we will have seen more women presidents of varied institutions in my lifetime than in previous collective histories.

We are at a helix of renewal, birth, new beginnings, and innovation. We are also at the edge of death, hospicing the old ways and the effect of leaders who perpetrate destruction and war, global warming, weapons of mass destruction, corruption, terrorism, and neglect of the needs of the poor, the disenfranchised, and the environment. This is not the world we want. Peter Karoff (2005), founder and chairman of the Philanthropic Initiative, has said, "The world is at a pivotal point, poised between a downward spiral and extraordinary renewal."

The agenda that lies ahead

So how then can we take such a clear message and use the tools we have before us to propel that extraordinary renewal? I see philanthropy, the act of giving of our time and money for the public good, as the greatest place of leverage for women and girls for our time. While business and politics are seats that hold powerful impact, the vast majority of women and girls and citizens globally have the capacity to give and mobilize change from the grassroots up. It is time for us to stop waiting for our political leaders to make changes that are within our reach.

The agenda for women as change makers must then be well informed. What I have learned from the hundreds and thousands of women and girls whom I have witnessed is wisdom on these matters, as follows:

• Women must know their values and vision and what they hope to change or preserve during their lifetime. Designating our three top values and the issue areas that we want to fund and want our families or community giving circles to fund enables a focus that is

imperative for humanity. This kind of focus enables greater impact and results.

• Women must become money mentors. We must learn about money management, the workings of the checkbook, stock and real estate markets, credit, loans, and banking, and learn more about leveraging. We must not let credit card debt get out of hand. Although we have made progress as women in learning the language of money, we are still one step removed from the core of power of money in many situations. We may have moved from secretary to treasurer, but we still do not control the larger investment portfolios in our families, universities, foundations, communities, or government. Until we share what we do know more broadly, we will not have confidence about what we own, owe, and have capacity to therefore give.

• Women must plan for retirement and put aside money early. The teachings of compounded interest should be understood and taught to every woman and girl and family we can reach.

• Women must know our earning power and go for what we deserve. Hire a coach, practice negotiating, get support from mentors and friends, but we must not let ourselves be paid less than we are worth. Family leave policies are a big step, and so too are men sharing in the responsibilities of caregiving. We must understand the economic impact of women caregiving on our long-term personal economies as on our philanthropic capacities. Just as giving circles have spread, the twenty-first century will enable women to hang on to their economic lives while caring for others through the formalization of care teams, in which primary caregivers are relieved every day or two by those who come in for half-days to provide for at least part-time work for the working head of the family.

• Women must lead families and communities so that leadership and giving have more impact. A giving plan, a family philanthropic mission statement, and dedication to volunteerism are key. We must know what the average giving and household income or assets are for our position and privilege, know what we have to offer and the many ways we have to give, and offer it freely. Giving motivations must move from consideration of supporting our

friends or honored obligations to more transformational motivations, such as considering upstream solutions or what root cause or prevention strategies will foster change or support life sustainability. Supporting passionate and truly effective organizations becomes mandatory in the age of giving with an impact.

• We must know where we are on the economic scale and give or pay our fair share. For example, a family with an income of $135,000 or more after taxes is in the top 5 percent in the United States and the top 1 percent in the world (Citizens for Tax Justice, 2000; Karoff, 2005).

• We must expect our government to do its fair share well and know what the most likely share that is and what it really will do. Should not the people devastated by 9/11 or on the Gulf Coast during Hurricane Katrina have hoped for or expected greater security? We must use the political process to advocate for and state our vision and our beliefs and compel officials to vote for our rights and our collective responsibilities to uplift and propel the poor out of poverty.

• We must ask for guidance for our actions in dialogue and in silence. The inner life of reflection multiplies our capacities for mindful service and leadership when coupled with the outer life of action.

• We must become deliberate and compelling leaders and fundraisers. Board leadership, fundraising keys to success, working cross-class and cross-race, diversity, and commitment to partnership are examples of this point. We must get over our discomfort of asking for money and become donor partners to our favorite organizations. We should raise and leverage thousands, if not millions, of dollars during our lifetimes if we are committed seriously to make these critical changes.

• We must leverage all we have done during our lifetimes by living and leaving our legacies with enormous intentionality. Imagine the impact ahead with women establishing foundations, lead and remainder trusts, expanding women's funds and circles, and endowing funds for universities, scholarships, and political advocacy and research organizations. Where bake sales once existed as women's

work, millions of dollars will be directed simply by each of us intentionally having annual giving plans and making legacy gifts to the organizations and leaders with whom we are mission partners for a more just society.

Women who are informed and collectively have a vision and then put the full spectrum of their resources to use are unstoppable. Let society permit the culture of generosity and gratitude to replace the culture of greed, fear, and war. And let women continue boldly this powerful rebalance toward love.

References

Citizens for Tax Justice. "Summary and Analysis of George W. Bush's Tax Plan Updated August 2000." Aug. 2000. http://www.ctjh.org/html/gush0800.htm.

Council on Foundations. *Grantmakers Salary and Benefits Report.* Washington, D.C.: Council on Foundations, 2003.

Gary, T. "Women Donors Emerging." Speech presented to the annual meeting of the Women's Foundation, San Francisco, 1980.

Gary, T. "From Quilting Bees to Giving Circles: How Women Are Changing the World." Speech to the More Than Money and Resourceful Women conference, San Francisco, 2005.

Karoff, P. "The World We Have—a Balance Sheet HPK Draft." Sept. 1, 2005. http://www.theworldwewant.org.

Rooney, P., Mesch, D., Chin, W., and Steinberg, K. *Race and Gender Differences in Philanthropy: Indiana as a Test Case.* Indianapolis: Indiana University Center on Philanthropy, 2004.

Shaw-Hardy, S. *Creating a Women's Giving Circle.* Indianapolis: Women's Philanthropy Institute, Center on Philanthropy, Indiana University, 2000.

United for a Fair Economy. "Responsible Wealth Training Materials." 2001. www.faireconomy.org/research/wealth_charts.html.

TRACY GARY *is a philanthropic and legacy adviser to Changemakers and Inspired Legacies.*

A powerful new vehicle for women as philanthropists has exploded across the nation. An outgrowth of quilting bees and book and investment clubs reflect women's growing economic power and concern for their communities.

8

Giving circles: A powerful vehicle for women

Jessica Bearman, Buffy Beaudoin-Schwartz, Tracey A. Rutnik

We founded our model in the mid '90s to address the growing new donor group of women emerging in the new millennium. We wanted to create a multiplier effect by "giving together," allowing each individual dollar to be leveraged for greater impact than if it was given alone. In the mid 2000s, I feel this potential even more urgently. Women will surely stand to inherit at least one half of the coming implosion of good fortune. My hope is that we will be ready in greater number to use this good fortune for the greater good. Giving Together is one way to learn and grow!

<div align="right">
Colleen Willoughby, President
Washington Women's Foundation
</div>

PHILANTHROPY IS OFTEN seen as a lonely enterprise of the very wealthy. The traditional image of the philanthropist is one of the solitary magnate: an impeccably dressed elderly white man sitting alone at his large desk carefully writing large checks to the worthy charities of his choice: the hospital, his alma mater, the symphony.

**WILEY
InterScience®**
DISCOVER SOMETHING GREAT

NEW DIRECTIONS FOR PHILANTHROPIC FUNDRAISING, NO. 50, WINTER 2005 © WILEY PERIODICALS, INC.
Published online in Wiley InterScience (www.interscience.wiley.com) • DOI: 10.1002/pf.132

But increasingly, philanthropy is taking a new form. Imagine instead a multigenerational, multiethnic group of twenty women meeting monthly in a living room. Over a potluck dinner, they hold spirited conversations about their community's environmental needs. They host speakers from nonprofit organizations that are dedicated to promoting clean air, clean water, green space protection, and sustainable agriculture. Each woman has contributed two thousand dollars to a common fund. After listening to a range of speakers, considering where their money might have the biggest impact, and requesting proposals from four organizations, the women make two grants of twenty thousand dollars to small nonprofits.

Over the course of the year, these women follow the progress of their grantees. They participate with their families in several volunteer events sponsored by their grantees, including a tree planting, a stream clean-up, and a letter writing campaign. At the end of the year, they host a celebratory luncheon where the grantees report on their work to an audience that includes the twenty women, as well as many other invited guests who might serve as donors in the future.

Women are coming together to give collectively—agreeing on the cause, issue, or organization to support and directing their giving accordingly. This form of highly participative philanthropy is called a giving circle.

What is a giving circle?

Sometimes described as a social investment club, a giving circle is a pooled fund, often hosted or sponsored by a charitable organization such as a community foundation, through which members make grants together. Circles are typically organized around a particular issue or area of interest and are considered a high-engagement form of philanthropy because donors engage in collective decision making and educational activities. The circle's grant-making functions—

which may include issuing a formal request for proposals, proposal review, and site visits—offer an enriching and rewarding philanthropic experience. This participatory process, combined with the increased impact of pooled charitable dollars, has strong appeal to many donors, particularly to women. This chapter focuses on women's giving circles, although giving circles are not exclusively a female phenomenon.

Part of what makes giving circles special is their flexibility. They range from intimate twelve-person groups that meet in a living room to four-hundred-person organizations with their own nonprofit status. They can be highly structured, with formal committees and by-laws, informal communities that get together for periodic potluck dinners, or tightly knit groups that make all decisions by consensus. Although all circles require a financial contribution, the giving level also varies widely, from less than a dollar per day in some circles to up to twenty thousand dollars and more in others. Whatever their shape, size, and structure, giving circles share common characteristics. Angela Eikenberry (2005) has identified six major characteristics of giving circles:

1. Ask donors to pool their funds.
2. Give away resources such as money and time.
3. Educate members about philanthropy and issues in the community.
4. Include a social dimension.
5. Engage members in volunteering in the giving circle or with nonprofits.
6. Maintain their independence by not affiliating with any one particular charity [p. 118].

The idea that giving circles maintain their independence from any particular charity is particularly important, since many nonprofit organizations, universities, and other entities invite donors to join donor circles, which are fundraising vehicles for the organization.

The emergence of giving together in women's philanthropy

In their current iteration, giving circles seem like a fairly new phenomenon, dating back to the early 1990s. However, collective philanthropy—individuals united through the act of giving—has a strong history in the United States and internationally through voluntary fraternal or mutual benefit societies. These traditions, brought to the United States from home cultures and strengthened by necessity, shaped our country's civic culture.

Giving circles gained prominence in philanthropy during the 1990s as a result of several factors: the rise of new donors and high-net-worth individuals who sought engaging ways to give back to society, the increasing desire by individuals to have a greater voice in and ownership over their charitable giving, and women's increased ability to give money and desire to do so in a collaborative manner. The individuals who initiated and embraced shared giving and attracted press attention were instrumental in helping further the trend.

The Ms. Foundation for Women and the Global Fund for Women were early advocates for donor circles (Clohesy, 2004). One of the first circles, Women's Voices, was created in 1992 by the Ms. Foundation for Women in conjunction with the Center for Policy Alternatives. The success of that fund prompted the creation of additional donor circles within women's philanthropic funds, such as the Democracy Funding Circle in 1996 by the Ms. Foundation for Women, which requires an annual gift of twenty-five thousand dollars. The United Way expanded on its de Tocqueville Society, created in 1984 to increase the giving patterns of major donors through gifts of ten thousand dollars or greater, with the creation of the National Women's Initiatives in de Tocqueville and Leadership Giving. Although these early donor circles were largely grounded in donor education and fundraising within their respective institutions, they broke new ground in collective giving.

The Washington Women's Foundation (WWF), founded in 1995 by Colleen Willoughby, was the seminal force in the modern

giving circles movement. With four decades of experience as a donor and volunteer and a strong interest in women's leadership, Willoughby observed a disconnect between women's financial capacity and their confidence to invest in major ways when they were approached as donors. After a challenging campaign to raise $1 million for Campfire, which Willoughby jokes was raised "quarter by quarter," she was determined to change this picture. Willoughby created a new model for strategic pooled giving to engage, educate, and empower women as philanthropists.

The WWF's distinctive model encourages women to be bold donors individually and collectively. Each member gives twenty-three hundred dollars annually for a period of five years. Members contribute one thousand dollars to a pooled fund from which the circle makes its large impact grants. Each woman makes an individual gift with the second one thousand dollars to up to three nonprofits of her choice. The remaining three hundred dollars supports educational programming for members. Promoting the idea that "we may not all individually be wealthy women, but we hold great wealth in common" (Washington Women's Foundation, 2002, p. 3), the foundation's unique model quickly attracted press attention and requests by many for assistance in replicating the concept elsewhere.

Although WWF was featured in papers ranging from the *Seattle Post Intelligencer* to the *Washington Post* and *Los Angeles Times* and nonprofit publications such as the *American Benefactor,* it was a 1998 article in *People* magazine, "Charity Belle: Colleen Willoughby Helps Women Give Money Away," that helped incite the proliferation of the giving circle concept (Miller and Kelley, 1998). Many women's giving circles began as a result of the *People* profile of WWF and the publication of its handbook, *Something Ventured: An Innovative Model in Philanthropy* (Washington Women's Foundation, 2002), which outlines the steps WWF took to establish its foundation. Indeed, Sondra Shaw-Hardy, widely recognized as one of the leading experts on giving circles, noted that she was inspired to create her own circle after reading the *People* profile. Working with the WWF as a model, Shaw-Hardy developed her Three

Generations Giving Circle, which requires a thousand dollar gift annually for two years.

Concurrent with this trend in women's philanthropy, the burgeoning dot-com economy produced many millionaires—and multimillionaires—virtually overnight. Relatively young and often visionary, many of them began exploring opportunities for putting their new-found wealth and business sense to good use, and not always in the fashion of traditional philanthropists.

Against this backdrop, Paul Brainerd, former Aldus Corporation president, founded Social Venture Partners (SVP) in 1997. Not content with traditional giving, the founders aspired to build a philanthropic organization using a venture capital model, where participants could actively nurture their financial investments with guidance and resources. Participants pool contributions of fifty-five hundred dollars a year for two years, which is invested in a select group of nonprofit organizations. The SVP model has spread widely; there are now twenty-two SVP affiliates in North America and many other giving circles whose structure reflects SVP's influence.

Giving circles today

In little more than a decade since the creation of one of the first formal donor circles for women, giving circles have emerged as a popular and effective way to marshal philanthropic resources, engage donors, and build community. A national scan of giving circles and shared giving by Rutnik and Bearman (2005) identified more than 220 giving circles in thirty-nine states plus the District of Columbia. Overlapping research conducted at the same time by Eikenberry (2005) found 188 circles. Although it may never be possible to get an accurate count of giving circles due to their informal nature, it is evident that they are widespread and changing the way that many women think about giving.

Giving circles range in style and operation from the very informal "parties for a purpose" to highly organized, professionally

hosted and managed circles, which are more like charitable foundations in operation and appearance. Eikenberry (2005) suggests a simple typology: small groups, loose networks, and formal organizations. Each category of giving circle has distinct characteristics. Circles in the small group category tend to have thirty or fewer donors who share decision-making power through a consensus decision-making process or by voting. The focus of these intimate circles is on social networking and educational activities. Giving circles that take the form of loose networks generally involve a core group of organizers who create opportunities—events or parties, for example—for other individuals to become involved on a regular basis. Finally, formal organizations are giving circles characterized by their structure, which entails a board or steering committee and additional committees responsible for different aspects of the circles' work. These giving circles are generally larger, require higher giving levels, and usually have staff support.

Many giving circles are connected to the existing nonprofit and philanthropic infrastructure. Most have a connection to an institutional host: a community foundation, other public foundation, a nonprofit, or a university. Host organizations may simply hold the circle's funds, but they often provide administration and staffing. When a circle is hosted, the host charity takes care of all grant administration and asset management and generally charges a fee for these services. Not all circles choose to be hosted. In fact, some, such as the Everychild Foundation in Los Angeles, choose to remain independent by setting up their own 501c(3) nonprofit organization. Some smaller circles may decide instead to have each member write an individual check, dispensing with the need for an institutional host or nonprofit status altogether.

Several giving circles, like SVP and WWF, have created replicable models that can be transplanted to new locations. Impact 100 was founded in 2001 by Wendy Hushak Steel as an independent 501(c)3 organization dedicated to improving Cincinnati by collectively funding significant grants to charitable initiatives. The giving circle recruited more than one hundred women, each of whom

gave a thousand dollars. Since then, Impact 100 has spread to additional cities, including Pensacola, Florida, and Indianapolis, Indiana.

A powerful vehicle for women

Giving circles are particularly attractive to women who are eager to create change by joining together to invest their social, intellectual, and financial resources. Sondra Shaw-Hardy and Martha Taylor's research indicates that women are motivated to give for six primary reasons, which they call the "Six C's of Giving": (1) to *create* something; (2) to bring about *change*; (3) because they have *connected* with a cause, organization, or institution; (4) to be part of a larger effort in *collaboration* with other women; (5) to be part of a longer *commitment* to the cause; and (6) to have fun and *celebrate* (Shaw and Taylor, 1995).

Giving circles are well positioned to tap into these reasons for giving and to satisfy the hunger that many women feel for meaningful engagement in community. The power of the collective, the connectedness of the circle, the new relationships that participation brings, and the opportunities for skill building and education resonate with potential members. By pooling their resources, participants can achieve a more significant impact with their charitable giving than they would as individuals, another important factor for women.

Circles usually begin as small, informal groups whose members share a desire to learn more about philanthropy as a vehicle for social change, leverage the impact of their charitable contribution, connect substantively with the communities and causes they care about, and participate in a network of people who share similar interests and values. Although most giving circles are started by a motivated catalyst or group of close friends, they almost always branch out to include women beyond the founders' immediate friends, maximizing informal social ties that build community and

expand networks. Giving circles often grow rapidly as the news spreads through word-of-mouth and local media. The concept resonates strongly with women who are seeking opportunities to become involved in their communities.

Benefits of giving circles

Giving circles bring value to the community in the form of grant dollars and informed, engaged donors and volunteers. Women involved in giving circles assert that the greatest benefit is to the giver, as giving circles provide donors with opportunities to learn, share, and grow as philanthropists and community leaders. There are four central benefits to giving circles: they provide grant making and other support to the community, allow donors to learn together, cultivate philanthropists, and build community.

Grant making and other forms of support

Grant making is where a circle's activities translate into money to address community needs. Giving circles support a variety of issues, with the top being youth development, women and girls, human services, and mental health and crisis intervention. The circles identify organizations to fund through a variety of strategies, including suggestions from members, a formal request for proposals process, recommendations from the host organization, and funding organizations that are in the news or well known locally. Some research issues and organizations use the Internet.

Women in giving circles give more money and time to nonprofits in their communities beyond their contribution to the giving circle. They report that their members give additional money directly to the nonprofit organizations that the circle funds or considers. Members donate their time and talent in addition to their treasure, participating in organized volunteer activities, becoming involved in board-level activities, and providing additional fundraising support to nonprofits.

Many giving circles are leaving a lasting legacy by retaining funds for a larger philanthropic fund or endowment. Others grant all of their funds each year but structure their circle so that the circle itself is continually refreshed by new funds, leadership, and energy.

Learning together

Learning is a significant part of each giving circle—whether an implicit or, more commonly, an explicit, purpose of the circle. Circle mission statements often reflect this goal. Here are two examples of mission statements:

> "Women for Wise Giving is an alliance committed to the advancement of philanthropy and to educating and inspiring women to become philanthropic leaders."
> "Discovery is a group of women formed to provide education related to informed philanthropy, to inspire women to become leaders in philanthropy, and to demonstrate the impact of philanthropy on the projects and programs of the university."

Giving circles educate their participants about issues, the community's nonprofits, group process and leadership, and philanthropy and grant-making practice. Learning opportunities may include a grant-making training curriculum, educational speakers and workshops, or other avenues for education such as distribution and discussion of reading materials. For example, Dining for Women creates fact sheets profiling what life is like for women living in the country on which the group is currently focusing its giving. Many giving circles invite nonprofits to speak directly to circle participants, as a way to help the circle make decisions or to keep donors up to date on the nonprofits' activities and the community's needs. Loose networks may limit their educational programming to asking nonprofits to speak briefly about their mission and programming to the assembled donors. For many participants, participation in a circle gives them an opportunity to learn about philanthropy and grant making primarily by doing.

Cultivating philanthropists

Many women's giving circles have a deliberate goal to cultivate philanthropists. Often the donation level is set as a stretch gift and is frequently the largest single donation that members have ever given. To that end, circles often pursue an underlying agenda to help members realize the power of philanthropy and their place at the table.

Many members of giving circles are new to philanthropy, particularly organized philanthropy. According to Eikenberry (2005), these individuals seem to be increasing their giving and adding new money to philanthropy. She notes that there is substantial evidence to suggest that participating in a giving circle increases donors' level of and commitment to giving.

Building community

Giving circles emerge from a philanthropic impulse first and foremost. Another significant benefit of giving circles, and what seems to keep many donors engaged over the long haul, is the chance to engage more deeply in community—both the community of donors and the community in which they live. Many giving circles' founders and participants echo the sentiments expressed by Cathy Lange, current president of the Angels' Network: "It is . . . part of my mission to be of service in the community. This was a way that I could do it that I would enjoy, and I could get connected to organizations that do an incredible amount of work to make a difference" (Rutnik and Bearman, 2005, p. 14).

Giving circles provide an opportunity to build a community of like-minded women while engaging meaningfully in the community. Circle participants, founders, and staff talk about their circles in terms of fun and bonding, but also of shared values. Colleen Willoughby and Emily Parker of the WWF theorize that their members come to the circle for the impact on community, but they stay because of the community of women and the chance to contribute in an intellectually stimulating way (Rutnik and Bearman, 2005). Circles capitalize on the community-building appeal by providing opportunities for members to socialize, network, and learn together.

Starting a giving circle

The key to the success of a giving circle is strong leadership and a commitment to learning about giving through a group process. This combination of leveraged financial and social capital, collaboration, human resources, and spirit define giving circles and make them a uniquely satisfying giving vehicle for women. The following guidelines for starting a giving circle will assist circle founders in building the foundation to develop and sustain a healthy giving circle. (For more detailed information, visit the Giving Circles Knowledge Center: www.givingforum.org/givingcircles.)

Step One: Set goals and structure for the giving circle

Bring the group together for a first meeting and begin the process of setting goals and structure. Start with four to five women as the initial leadership body—women whom others want to partner with to learn, engage, network, socialize, and make grants.

There are several decisions that this group can make in the early phases of the giving circle, including funding focus, size of the circle, size or range of financial contributions, time commitment, and decision-making process.

Step Two: Mission and commitment

Once the group sets up regular meetings, it is a good idea to establish a mission, set meeting guidelines, agree on common goals and objectives, and name the group. All members of the group can be given the opportunity to work on tasks. Creating a rotating chair, designating a treasurer, and setting up committees or work groups will build the common purpose. It is not too early to consider how to nurture both current and future circle leaders, so the commitment and passion for the circle's growth and development can be sustained in the future.

Step Three: Where to place collective dollars

It is recommended that all members make a financial commitment to the giving circle at the start of each year. There are options for

where circle members' money can sit and there are benefits to each depending on the circle's needs, experience, and structure:

- Open a joint bank account. Check with a professional adviser on the tax implications for starting a joint bank account giving circle.
- Establish a donor-advised fund at a community or public foundation.
- Write individual checks to the chosen nonprofits once donations have been determined.

Step Four: Establish an issue or focus area for contributions

This step may take some time and discussion to determine because the circle must choose a process to find common areas of interest. Define the geographical area where the group will seek out potential organizations or service providers.

Step Five: Create smaller work groups for giving circle tasks

Once the focus is established, having members of the group volunteer for particular tasks will build personal commitment and interest in the work of the giving circle. These smaller groups can investigate to learn which nonprofit organizations are doing the best work in the circle's field of interest.

Step Six: Develop a process and criteria for determining who will receive contributions

This is an ideal assignment for a committee. This process can be as simple as choosing a recipient organization based on information gathered and then writing a check to that group, or as involved as reviewing written applications, visiting the organization's headquarters or project area, or asking for a presentation. The circle needs to consider these questions: What are the criteria for determining who receives funding? Will we review grant applications? Will we visit specific organizations? What kind of a report will we want at the end of the project period from the recipient of these funds?

Step Seven: Develop and define a partnership with the recipient of the grant award

The circle may choose to offer additional assistance to grantees. Members of the circle may want to volunteer for an organization that they have funded. Web development, finances, program planning, legal work, and mentoring are some examples of ways members might get involved.

Step Eight: Review potential recipients for donations or visit nonprofits

Conducting site visits with potential grantees can be enormously helpful in the grant-making process. This is the time to ask questions, get clarification about anything that was not clear in the proposal, and see organizations in action.

Step Nine: Make grant awards

Immediately following the group's decision, alert the recipient of these intentions, letting it know when it can expect a check. It is good practice at this time to let organizations that will not be funded know of the decision.

Step Ten: Evaluate the impact of the giving circle

Be sure to take the time to examine the short-term and long-term goals of the giving circle on an annual or other regular basis. This will help develop satisfaction with the work the circle is doing and show how its contributions have made a difference to the nonprofits funded and the donors engaged.

Make philanthropy fun!

Many giving circles find that members value the social interaction almost as much as the philanthropic achievements of the circles. Make social events a part of the circle programming, volunteer together, and consider hosting family-friendly activities. Strength-

ening the social bonds among members can help retain members, make the learning and giving process enjoyable, and sustain a healthy and meaningful circle of givers.

References

Clohesy, S. *Donor Circles: Launching and Leveraging Shared Giving*. San Francisco: Women's Funding Network, 2004.

Eikenberry, A. "Giving Circles and the Democratization of Philanthropy." Unpublished doctoral dissertation, University of Nebraska, 2005.

Miller, S., and Kelley, T. "Charity Belle: Colleen Willoughby Helps Women Give Money Away." *People Magazine*, Nov. 30, 1998.

Rutnik, T., and Bearman, J. *Giving Together: A National Scan of Giving Circles and Shared Giving*. Washington, D.C.: Forum of Regional Associations of Grantmakers, 2005.

Shaw, S., and Taylor, M. *Reinventing Fundraising: Realizing the Potential of Women's Philanthropy*. San Francisco: Jossey-Bass, 1995.

Washington Women's Foundation. *Something Ventured: An Innovative Model in Philanthropy*. Seattle, Wash.: Washington Women's Foundation, 2002.

JESSICA BEARMAN *is the deputy director of the New Ventures in Philanthropy Initiative of the Forum of Regional Associations of Grantmakers.*

BUFFY BEAUDOIN-SCHWARTZ *is the communications director for the Association of Baltimore Area Grantmakers.*

TRACEY A. RUTNIK *is the director of Practice Development for the Fannie Mae Foundation.*

This chapter explains the dramatic fundraising results that can occur by involving women as volunteers, donors, and leaders.

9

Women's volunteerism and philanthropy at Princeton University

Michele Minter

IN THE SPRING OF 2005, three alumnae from Princeton University's class of 1980 came up with a plan to encourage their female classmates to support the class's twenty-fifth reunion annual fund. Eager to see women contribute generously, they worked with university staff members to organize a day on campus. The day's events, which featured meetings with Princeton's president, Shirley M. Tilghman, faculty members, and senior administrators, included discussions of the importance and impact of the annual fund. The results were outstanding: 100 percent of the attendees made gifts to the annual fund, totaling $585,389, plus an additional $200,000 in new pledges for the endowment.

That same spring, a second group of alumnae organized an effort to help Princeton's Office of Career Services respond to students' requests for corporate site visits and mentoring support. The alumnae had learned about these needs while talking with students on campus. Sixty students participated in site visits in three locations, and the success of the project has led to plans for its continuation.

What do these two efforts have in common? The leaders of each project had attended a February 2005 conference sponsored by

Princeton University's Women in Leadership Initiative. During that on-campus gathering, alumnae had learned about opportunities and challenges throughout the university, became motivated, and then put their interest and enthusiasm to work on Princeton's behalf. For the alumnae described above, the Women in Leadership Initiative had accomplished its goal: to connect women to Princeton University and then help them become leaders.

Launched in 1998 in conjunction with the twenty-fifth anniversary of coeducation at Princeton, the Women in Leadership Initiative is an ongoing effort to expand Princeton University's volunteer and donor base. The initiative is a distinctive model for two reasons: it places equal value on volunteer engagement and philanthropy as integrated components of leadership and actively works to encourage both, and it is a highly flexible model that serves as an entry point to engage women and then directs the resulting enthusiasm and energy toward other university programs and needs. Unlike many other philanthropic programs, Princeton's model does not seek to build an ongoing membership cohort; rather, it acts as a pass-through that educates, engages, inspires, and ultimately facilitates other forms of alumnae interaction with the university. In the words of its mission statement, "Princeton University's Women in Leadership Initiative offers alumnae the chance to reconnect with the intellectual excitement of today's University, collaborate with other Princetonians as volunteers, decision-makers and role models, and to organize their talents and resources to benefit the University." The initiative has been uniquely successful in attracting the attention of women who were not otherwise engaged at Princeton.

The Women in Leadership Initiative has four main tactical components. Through the initiative, alumnae are working with Princeton to:

- Organize events at the University and elsewhere that are of special interest to women.
- Provide opportunities to engage all alumni with the University and communicate those opportunities.

- Identify and develop alumnae for leadership roles.
- Increase alumnae giving and participation.

The Women in Leadership Initiative is a true partnership between Princeton and its alumnae. Its mission, structure, and strategies result from careful collaboration between volunteers and university staff to construct a program that bridges alumnae interest and university priorities.

Asking questions, developing a plan

There are significant demographic differences between Princeton alumni from older classes and those admitted later, from approximately 1970 to the present. The university's decision to admit women in the late 1960s, coupled with an increased interest in diversification of the student body, resulted in new challenges to traditional methods of engagement. Since it is often at the time of the twenty-fifth reunion that Princeton alumni begin to assume leadership roles as volunteers and donors, the years of the Anniversary Campaign for Princeton (1995–2000) represented a watershed moment for the university. During this period, for the first time, alumnae began to pass their twenty-fifth reunions and increasingly demonstrated the professional expertise, volunteer experience, and philanthropic inclination to assume leadership roles in university governance and fundraising. During this period, Princeton decided to evaluate strategies for engaging alumnae, with an awareness that their needs and interests might be slightly different from those of older alumni from all-male classes. Successful fundraising programs targeted at women at peer institutions such as Harvard provided initial evidence that a focus on alumnae could provide fruitful fundraising outcomes (Kaminski, 1999).

It is important to note that even as Princeton began to consider ways to enhance the alumnae experience, women were already playing an important role in the university's fundraising success. In fact, 74 percent of all alumnae participated in the Anniversary

Campaign for Princeton, surpassing participation rates from male alumni in the same class years. Several alumnae distinguished themselves as fundraising volunteer leaders. It was clear that further involvement by alumnae would only enhance Princeton's effectiveness.

The effort that would become the Women in Leadership Initiative began with an event for alumnae held in New York City in 1998. Designed as an experiment in reaching women who were potential donors, this unprecedented event drew an unexpectedly strong response. Two prominent alumnae agreed to serve as hostesses, and the evening was organized as a group conversation about the role of alumnae in the Princeton community. Women attended in a much higher proportion than was typical for coed events, and they expressed great enthusiasm for the opportunity to think and talk together about Princeton's future. The success of the event suggested that the time was ripe to offer expanded programming for Princeton alumnae. The key leaders in the development of a larger, ongoing initiative were Anniversary Campaign volunteers Nancy Peretsman, the New York City chair, and Janet Clarke, cochair of the Anniversary Campaign for Princeton. Encouraged by these volunteers and with the support of the development staff, the Women in Leadership Initiative entered a cultivation and fact-finding phase. As the staff member who coordinated those efforts, I had the good fortune to participate in the initiative from its inception.

During 1999, focus group luncheons were held in ten cities: New York, Boston, Chicago, Atlanta, Seattle, Princeton, Philadelphia, Washington, Dallas, and Houston. More than four hundred women attended. A group of female trustees and emeritus trustees helped plan the luncheons and refine the discussion topics. These gatherings allowed Princeton to collect anecdotal information about alumnae perceptions of Princeton, philanthropy, and volunteerism, while offering participants a meaningful forum in which to contribute their ideas. The lunches provided alumnae with the chance to connect around issues of common interest and communicated a strong message of collaboration and leadership. As the invitation to the focus groups' lunches stated, "It is now twenty-

five years since the graduation of Princeton's first fully coeducational class. This anniversary is more than symbolic, because it is traditionally at the 25th reunion that alumni begin to assume key leadership roles in the Princeton community. Since Princeton today has an undergraduate student body that is 50 percent female, it is our collective responsibility and obligation to become part of this leadership."

In addition to a wealth of information, the focus group lunches provided an ideal means to engage key alumnae, for whom serving as hostesses or discussion leaders created a chance to work more closely with Princeton staff members.

The focus group findings provided Princeton staff members with invaluable insights about how its alumnae viewed their experiences as volunteers and donors. The key findings are summarized below.

Attitudes about volunteer service

- There was a strong consensus that information about volunteer opportunities was not always easily accessible.
- Most alumnae enjoyed women-only gatherings, and most expressed eagerness for more opportunities to connect with other Princeton women. There was also a desire to be full participants in all university programs on a coed basis.
- There was greater interest in substantive programs such as community service and faculty lectures than in social events.
- Alumnae felt that volunteering was made difficult because of time constraints, especially when trying to balance their careers and parenting.
- Alumnae who were not in close proximity to campus were eager for more ways to connect with Princeton.
- There was a perception that the university expressed greater appreciation for financial contributions than for volunteer service.

Attitudes about philanthropy

- Most alumnae agreed that their philanthropic support results from substantive involvement with an organization.

- While alumnae acknowledged the importance of unrestricted support, they wanted to know how their gifts are used. This was expressed both as a desire to allocate their gifts and as an interest in increased stewardship that illustrated the impact of their support.
- The alumnae strongly agreed that they did not generally value public recognition for their giving. They did, however, value personal recognition.
- There was a strong consensus that alumnae were not as enthusiastic as their male counterparts about interclass competition as a motivation for fundraising.

Informed by the focus group findings, volunteer leaders and development staff members identified and adopted three operating principles for the nascent Women in Leadership Initiative. First, we believed that all alumni would benefit from new models for enhancing volunteerism and philanthropy. Although focused on women, the Women in Leadership Initiative offered Princeton the chance to experiment with an outreach model that might also be applicable to other diverse alumni cohorts. Second, it was clear that alumnae deeply valued their connection to and collaboration with other Princetonians. They were particularly interested in events that would allow them to interact with other women and with female students. Creative use of events and contact with students were likely to strengthen ties to the university as a whole. Most important, for many women, philanthropy is both integrally linked to and grows out of involvement. Enhancing opportunities for meaningful alumnae participation in the life of the university would be a critical tool to increase giving. The focus group findings helped to make it clear that the best way for Princeton to accomplish its fundraising goals was to expand its efforts beyond a strict philanthropic emphasis. The resulting theme of leadership was a natural one; it allowed us to build a holistic program that sent a powerful inspirational message.

From the outset, it was determined that the Women in Leadership Initiative would not replace Princeton's regular gender-

neutral fundraising and volunteer recruitment efforts. Rather, it would complement those efforts where appropriate by providing an additional resource to enhance the alumnae experience.

Designing a distinctive model

In 2001, a steering committee of alumnae was appointed. Chaired by Nancy Peretsman, an emeritus trustee and investment banker, the Women in Leadership Steering Committee provides oversight for the initiative's activities. As defined by the committee's charter, its members advise on strategic planning for the initiative, serve as advocates and spokespeople on behalf of alumnae to the university's administration and trustees, and work with staff to organize regional and on-campus events for alumnae. The steering committee members also help to raise funds for Princeton by assisting with solicitation and cultivation calls and by identifying new prospective donors. The committee members are encouraged to lead by example in providing financial support for the university.

In 2002, under the leadership of Brian McDonald, vice president for development, and with the active participation of the steering committee, a five-year strategic plan for the Women in Leadership Initiative was developed. This document articulated a structural model for the effort, identified key tactical components, and established metrics. As part of the planning process, staff members conducted extensive benchmarking of women's philanthropy programs at other colleges and universities. In some areas such as events, the strategic plan incorporated ongoing approaches that had evolved organically since 1998. In other areas, the plan established best practices for a Princeton-specific model. For example, the strength of Princeton's annual fund program suggested that a formal link between that program and the initiative would be beneficial.

The resulting strategic plan was designed to reflect Princeton University's distinctive relationship with its alumni body and leverage its centralized fundraising operation. A key decision was the creation of a pass-through structure focused on education,

cultivation, and stewardship rather than choosing the more traditional model of a membership organization. As defined in the strategic plan, the Women in Leadership Initiative would capitalize on alumnae interest in interacting with other women to draw them in, provide education and fellowship that would strengthen a connection to Princeton, and encourage the alumnae to spin off to reengage with the university more broadly. Rather than promote collaborative gifts or establish an expectation of ongoing interaction, the Women in Leadership Initiative would allow each alumna to develop her relationship with Princeton in the way that best suited her interests and abilities. Steering committee chair Nancy Peretsman comments, "One of the most gratifying aspects of the Women in Leadership Initiative is that it reaches each woman in a personal way. For those alumnae who have been actively engaged with the University, the chance to interact with other bright, thoughtful women enhances their experience. For alumnae who were not closely connected, the Women in Leadership Initiative makes them feel welcome and appreciated."

During this planning phase, Princeton University created a graphic identity for the Women in Leadership Initiative, which includes an attractive logo and other visual elements. This graphic identity has allowed us to brand our efforts through special stationery, brochures, and even wristwatches.

Implementation and impact

The strategic plan identified four tactical components for the Women in Leadership efforts. Although these components are so interconnected that it is difficult to separate them into neat categories, each plays an important role in helping the initiative achieve its mission.

Strengthening engagement

The first tactical focus is to organize events at the university and elsewhere that are of special interest to women. As Sondra C. Shaw

and Martha A. Taylor (1995) observed in their influential study of women's philanthropy, women are particularly drawn to opportunities to connect with each other. Princeton's alumnae respond enthusiastically to women-centered events. They welcome opportunities for socializing and professional networking. They are deeply interested in the experiences and perspectives of the women who currently attend Princeton, and we have made both undergraduate and graduate students an integral part of initiative programs. Princeton's informal polling suggests that many of the women who come to Women in Leadership events are motivated primarily by the opportunity to connect with fellow participants.

The Women in Leadership Initiative's most successful tool is an annual conference, launched in 2001. This conference, which is purposely limited to forty attendees, brings alumnae to campus for two days of panel discussions, meetings with students, and special courses taught by faculty members. The conferences are designed to showcase the full spectrum of issues and opportunities that might be of interest to alumnae. Past sessions have included a panel discussion on life/work balance led by a *New York Times* reporter, candid discussion with women students about their social lives, and a private conversation with Nobel Prize–winning novelist Toni Morrison. In recent years, a conference highlight has been dinner with President Tilghman at her residence. Alumnae consistently respond to follow-up surveys with positive feedback; they tell us that they feel enlightened and motivated by their conference attendance.

Choosing the guest list for the conferences is a challenge. Princeton has resisted the temptation to increase the size of the conference, believing that intimacy is critical to the special nature of the experience. The guests are selected for both their past involvement as leadership-level volunteers and donors and for their potential. Each year there is some emphasis on invitees who are on the cusp of their major reunions, which typically provides a boost to annual fund results. Great care is taken to explain the necessity to rotate the invitation list, but nonetheless, every year there are alumnae who express disappointment that they cannot participate repeatedly.

The Women in Leadership Initiative works to find a balance between exclusivity and inclusivity. The annual on-campus conference is exclusive, with an emphasis on philanthropic and volunteer leaders. Regional events enable the initiative to engage a wider group of alumnae. The initiative sponsors an average of three regional events each year, often featuring a university faculty member, senior administrator, or prominent alumna as a speaker. A tool kit of sample materials, including sample invitation wording, follow-up letters, and handouts, is made available for staff members to customize so that each event will have a local flavor. Over two thousand alumnae have participated in at least one Women in Leadership event, which have taken place in fourteen cities across the country and internationally. In major metropolitan areas such as New York City, Women in Leadership events have become a tradition.

Great care is taken to optimize the strategic value of each regional event. Which local alumna could be substantively engaged with Princeton if asked to serve as hostess? Would a faculty member be a compelling speaker, or would local women be more interested in a program on volunteer service? Would a small dinner promote intimate conversation, or would a large reception encourage more mingling? Each event shares a common emphasis on the Women in Leadership mission, but the model is designed to provide maximum flexibility.

Strengthening involvement

The Women in Leadership Initiative's second tactical focus is to provide opportunities to engage all alumni with the university and make sure that alumni are informed of those opportunities. One of the most useful and commonly expressed insights from the focus groups was that many alumnae were not volunteering more because they lacked understanding of the opportunities available to them. This sparked the creation of a brochure, "Getting Involved at Princeton," that is distributed at every Women in Leadership event on and off campus. It lists a variety of opportunities to participate as a volunteer, with names, telephone numbers, and e-mail addresses of relevant contacts. The brochure can be customized to reflect

local interests. For example, in preparation for a Women in Leadership event in Atlanta, "Getting Involved at Princeton" will be adjusted to include names of contact people for the Atlanta regional Princeton association and admissions committee.

Every Women in Leadership conference includes a session designed to highlight volunteer service opportunities, and some regional events have featured panel discussions about how to become more involved with Princeton. In addition to printed materials and presentations, development staff members are available to consult with alumnae who would like to think about ways to increase their participation. As a result, staff members have discovered numerous alumnae with special capacity to support the university as donors and volunteers and have matched these distinctive women with opportunities for engagement. Through information provided by the initiative, alumnae have become involved with their local admissions committees, academic advisory councils, Career Services, and many other university programs.

The Women in Leadership Steering Committee itself has become a particularly effective addition to the university's portfolio of volunteer offerings. Although the committee is limited to a membership of twenty-four, its regular conference calls and meetings have united experienced volunteers with promising younger volunteers to accomplish an important mission.

As the initiative has evolved, a new challenge has emerged. Many alumnae, responding enthusiastically to the exhortation to get involved, have made it clear that they would like to volunteer for Princeton through a Women in Leadership–endorsed activity. This desire for branded Women in Leadership volunteer programs is understandable but risky, since it could end up competing with rather than leveraging existing university volunteer programs. The steering committee continues to consider and experiment with methods for meeting alumnae interest without the need to generate new programs.

It is worth noting that the goal of involving alumni more broadly in the life of the university is purposely not a gender-specific goal.

During the strategic planning process, the steering committee members felt strongly that one of the exciting aspects of the Women in Leadership initiative was its potential to serve as an innovative model for the ways in which Princeton engages its diverse constituent cohorts. All alumni can benefit from new models for enhancing volunteerism and philanthropy.

Strengthening leadership

Closely linked to the emphasis on increasing involvement is a third focus on identifying and developing alumnae leaders. Women in Leadership seeks to be inclusive in offering all alumnae access to information about its activities, but its goal is to develop leadership in donors and volunteers. Therefore, its primary focus is on cultivating and stewarding leadership-level gifts and volunteer service. A two-pronged structure of on-campus conferences and regional events provides broad-based participation opportunities as well as more elite experiences for a smaller group.

The steering committee membership exemplifies leadership: its 2005 membership includes five trustees, four emeritus trustees, and the past president of the Alumni Association. The overlap between the steering committee and the university board of trustees is a source of pride, since steering committee service has helped to engage and showcase many promising alumnae leaders. The steering committee includes many women who have achieved professional distinction; its membership includes four members of *Fortune's* list of the fifty most influential women in American business. In 2002, the Women in Leadership Initiative was mentioned in several newspaper articles reporting on the $30 million gift of steering committee member and eBay CEO Meg Whitman to support Whitman College, a new residential complex. The steering committee also includes many women who have chosen to focus on their families and on community leadership rather than a career. By selecting a wide range of role models to serve on the steering committee, the initiative tries to embody all of the ways in which Princeton women can lead by example.

Strengthening philanthropy

The fourth key component of the Women in Leadership strategy is to increase alumnae giving and fundraising participation. Princeton's alumnae are generous: their participation rate as donors consistently surpasses that of men in their classes. Among alumnae with identified capacity to give at leadership levels, evidence suggests that strengthening involvement with Princeton has been instrumental in increasing their philanthropic support. For example, an internal study comparing alumnae who attended at least one Women in Leadership conference to a control group of similar alumnae who were invited but did not attend found that women who had participated in a conference gave, on average, nearly three times as much to the annual fund as the control group of non-attendees during the same period. The conference attendees gave more than twenty times as much for endowment and other capital fundraising projects than their control group counterparts during this period.

As well, alumnae who have become motivated by their Women in Leadership experience often become more active as fundraising volunteers. In the example described in the introduction, the women of the class of 1980 chose to translate their enthusiasm for Princeton, enhanced by their Women in Leadership experience, into a fundraising effort for their twenty-fifth reunion.

To cite another example, during the Anniversary Campaign for Princeton, staff members identified an alumna who serves as CEO of a Fortune 500 company. After initial attempts at engagement by staff members failed, Women in Leadership steering committee chair Nancy Peretsman agreed to reach out. The CEO took that telephone call and soon agreed to co-host a Women in Leadership event. One year later, she joined Princeton's board of trustees. When pledging a significant capital gift shortly after, she explained her hope that it would serve as a model for other alumnae giving. Another female trustee immediately offered to match the pledge, and a third alumna joined in as well. Overall, the three women's seven-figure commitment represented an increase of more than fivefold over their total previous giving.

The Women in Leadership Initiative motivates alumnae philanthropy through a positive emphasis on collaboration and community. Success in these areas is detailed in the *Women in Leadership Report to the President*, an annual publication that profiles Princeton women and showcases volunteer service. The report also includes the names of all alumnae who have given at leadership levels during the previous fiscal year. Since each reunion class defines the leadership gift level differently (based on the age of the alumni), this publication recognizes many women as leaders. The *Report to the President* includes a running list of alumnae who have given cumulative gifts of fifty thousand dollars or more since 2002, and many women have told us that they aspire to be included on that list.

At the time of the strategic planning process in 2002, we considered whether a collaborative gift or giving circle model might work for Princeton. After exploring this notion with some of our key alumnae donors, we reached the conclusion that Princeton women liked to maintain philanthropic independence. Many were deeply involved in annual fund activities; others were intrigued by specific university fundraising efforts. The flexibility of the Women in Leadership model allows alumnae to connect with the university individually and in the manner that most resonates for them personally.

Looking ahead

As the Women in Leadership Initiative enters its ninth year, it has outgrown its first strategic plan. Under the leadership of its newly appointed chair, university trustee and Time Warner executive Karen Magee, the steering committee will consider the future of the initiative with an eye to extending its effectiveness long into the future. Although tactics may evolve to reflect the initiative's growth, the core program will likely remain constant.

Why does the Princeton model work? It uses women's interest in engaging with other women to connect them to Princeton. It values both involvement and philanthropy. It grooms leaders. And

it does so within a flexible structure that encourages each woman to act on her enthusiasm in a personal manner. Princeton University is committed to enhancing the experience of all its alumni, and the Women in Leadership Initiative offers one way to engage the women who make up an increasingly important part of the alumni community, often reaching those not otherwise engaged. Princeton's alumnae have responded enthusiastically to the initiative. They welcome opportunities to connect with other women. They feel a deep sense of obligation to serve as role models and mentors to female students, and they want to guarantee that Princeton continues to excel. In the words of President Tilghman, "The Women in Leadership Initiative has been a remarkable partnership between the University and its alumnae. Princeton will continue to reap the benefits of its alumnae's leadership for generations to come" (personal communication to the author, 2005).

References

Kaminski, A. "The Hidden Philanthropists." *CASE Currents*, Feb. 1999, pp. 20–25.

Shaw, S. C., and Taylor, M. A. *Reinventing Fundraising: Realizing the Potential of Women's Philanthropy.* San Francisco: Jossey-Bass, 1995.

MICHELE MINTER *is director of development at Princeton University and founding coordinator of Princeton's Women in Leadership Initiative.*

Many programs that work at universities and colleges to successfully engage more women as donors can be applied to any other nonprofit organization.

10

Women's philanthropy programs at coeducational colleges and universities

Jeanie Lovell

A GROWING NUMBER OF coeducational colleges and universities are seeing the untapped philanthropic potential of alumnae donors. In response, some institutions have established women's philanthropy programs in order to educate and engage more women as leaders and donors. This study compares existing alumnae initiatives at a variety of coeducational institutions, ranging from large public research universities to small private liberal arts colleges, in order to identify effective models and components. The conclusions from this study will be useful to institutions of all sizes that want to engage their alumnae more actively and help these women reach their full potential as philanthropists.

The interviews cited in this chapter were conducted as part of a 2004 thesis study that examined women's philanthropy programs currently under way at coeducational institutions in order to identify effective components for a model that can be applied and implemented at Luther College, a four-year, private, coeducational liberal arts institution located in Decorah, Iowa. The study also included an extensive literature review and two focus groups: one with Luther College alumnae and one with the Luther College Alumni and Development staff.

Alumnae giving in higher education

The success of fundraising programs at colleges and universities relies in large part on the generosity of graduates of their institutions. According to Judith E. Nichols in her book *Pinpointing Affluence in the Twenty-First Century* (2001), male and female "alumni provide nearly 40 percent of contributions at both colleges and secondary schools" (p. 10). Therefore it is important for institutions of higher education to pay particular attention to the changing demographics of this primary donor constituency.

The National Center for Education Statistics reports that U.S. college and university enrollment of both sexes has increased in the past three decades. But women's enrollment has increased at such a pace that the proportion of undergraduate men and women is nearly the reverse of what it was thirty years ago. In 1970, 56 percent of the students who earned bachelor's degrees were men and 44 percent were women. By 2001, women were 56 percent of undergraduates nationwide (Bickel, 2002, p. 34).

More than a decade before, in the early 1990s, higher education began taking notice of alumnae donors. In "Alma Maters Court Their Daughters," a 1991 article in the *New York Times*, author Anne Matthews wrote:

Many campus administrations have long assumed that "donor" primarily means "male donor." No more. As alumnae move into prominence and power in business and the professions (often becoming, in the process, major giving prospects), their views on college philanthropy are creating bewilderment, even alarm, on many campuses. The reasons why women give, or refuse to give, or give sporadically, or donate to one institution attended but not another are proving far more complex than previously believed—and far different from the giving decisions of their male counterparts [p. 73].

One year later, the *Chronicle of Higher Education* noted:

Many colleges and universities, eager for new sources of support and aware that women represent an untapped donor market, are beginning to court their daughters in the same way they have pursued their sons: aggressively.

They are setting up special fund-raising programs to woo female donors and are paying much closer attention to the views of alumnae about their institutions [McMillen, 1992, p. A31].

Without a doubt, this was a formative period in which fundraisers began to take serious note of women's potential as donors in their own names. The media attention directed at the successful fundraising efforts of women's colleges in the early 1990s prompted comparisons of alumnae support at coeducational institutions. Data showing less support by women graduates of coeducational colleges and universities were viewed by some as a warning sign. Select institutions recognized this as an opportunity and began looking for new ways to engage and involve their alumnae as donors and leaders.

The women's philanthropy movement as a whole gained momentum throughout the 1990s, which sparked a growing number of coeducational institutions to implement philanthropy initiatives designed to involve more alumnae. Today more and more institutions are seeing the potential of women's philanthropy to higher education. According to M. Ann Abbe, "As the forces of education and career choices, business acumen, accumulation of wealth and charitable attitude converge, women possess a greater capacity to make major contributions to universities than any time in our history" (2001, para. 19). Yet the creation of a women's philanthropy program is still a relatively unexplored idea among the vast majority of U.S. colleges and universities.

With the exception of the handful of coeducational institutions whose women's philanthropy programs received significant media attention in the 1990s (for example, UCLA, the University of Wisconsin-Madison, Colgate) or have been highlighted more recently by the Council for Advancement and Support of Education (CASE) or the Women's Philanthropy Institute, little published documentation is available regarding the impact of women's philanthropy programs at coeducational colleges and universities. Yet a growing number of colleges and universities are implementing alumnae initiatives and exploring ways to involve more women

as donors and leaders at their institutions. Interviews conducted as part of a thesis study of women's philanthropy programs (Lovell, 2004) sought to learn from some of their collective experiences.

Interview findings

To gather firsthand information regarding the benefits and challenges of establishing a women's philanthropy program, telephone interviews were conducted with development representatives from eight coeducational colleges and universities from throughout the United States: Denison University (Ohio), Iowa State University, Mount Mercy College (Iowa), Purdue University (Indiana), South Dakota State University, University of Mississippi, University of Tennessee, and University of Wisconsin-Madison. Of these eight, five were founded as coeducational universities (several of which were land grant institutions), two were founded as men's universities, and one was founded as a women's college. All eight institutions currently enroll men and women.

Each of the institutions interviewed currently has an established women's philanthropy program. Information reflects a full range of program histories, spanning from two to seventeen years. The oldest program, founded in 1988, is at the University of Wisconsin-Madison, which was the first coeducational institution to create a major gift organization for women. Three of the institutions interviewed established their programs in the mid-1990s, and four have programs that have been begun since 2000.

All college and university representatives who participated in the telephone interviews were asked a series of open-ended questions focused on the women's philanthropy programs at their respective institutions. The interviews provided a snapshot of eight unique programs at different stages of implementation. The participants shared detailed feedback specific to their respective programs, which offer a full range of models that could be applied at other institutions.

In order to present the findings, each question is listed with a narrative summary of the participants' responses.

• *What is the mission/purpose of the women's philanthropy program at your institution? What are the primary goals of your women's philanthropy program?* In defining the mission or purpose of their respective women's philanthropy programs, all institutional representatives stated that educating women about finances, raising their awareness about philanthropy, and identifying and encouraging women as leaders are primary program goals. Several also said their programs seek to inspire and motivate women to think more broadly about major gifts and to increase giving by women donors. Some representatives cited additional goals of providing networking opportunities for women of all ages and seeking women who can be role models in philanthropy. One institution also includes a leadership mentoring program as a key part of its women's philanthropy initiative.

The women's philanthropy programs at all eight of the institutions are open to all women associated with the college or university: alumnae, faculty, trustees, spouses, and friends of the institution. Two universities stated that their women's philanthropy programs serve primarily alumnae, but all women are welcome to participate.

• *Briefly describe the women's philanthropy program at your institution including an overview of the key components (e.g., meetings, mailings, seminars, minimum donation, annual celebration).* All institutions stated that they hold educational seminars or forums for women on topics such as finance, estate planning, or leadership. Often these seminars are part of an annual event hosted on their respective campuses. The scope of participation ranges from 40 to 350 participants. Many programs feature primarily women speakers at their seminars and events. One institution indicated that its founding group mandated "women teaching women" to increase women's comfort levels.

All of the institutions interviewed have a steering committee, board, or council that meets at least once annually to advise their

women's philanthropy programs. The memberships range from ten to thirty-three members. Some advisory groups meet as many as four times each year; most meet only once or twice annually.

The financial expectations associated with the women's giving programs vary significantly. Mount Mercy College and South Dakota State University have giving circles that require gifts at a level of five hundred dollars annually. At the University of Wisconsin-Madison, the women's philanthropy program encourages all alumnae giving but focuses on major gifts of twenty-five thousand dollars or more to the area of the donor's interest. The council has an annual collaborative giving project to support women on campus and a Women's Leadership Fund. The University of Mississippi is the only institution to request dues for membership; it also receives corporate and foundation grant support for the program's annual operating budget and its endowed scholarship. Several institutions, including Denison University, indicated that they do not have specific solicitations as part of their women's philanthropy programs, but use the programs as a cultivation tool to encourage women to consider more major gifts.

Marketing and communication efforts vary among the institutions. While two universities noted sending regular newsletters to highlight women's impact, other institutions use their existing alumni publications to publicize the women's philanthropy program and spotlight women as donors and leaders.

Iowa State University and the University of Wisconsin-Madison noted that they conduct in-house staff training regarding gender sensitivity as part of their women's philanthropy programs.

• *What was the biggest challenge in establishing a women's philanthropy program at your institution?* According to the interviews, one of the biggest challenges in establishing a women's philanthropy program was getting the administration and top leadership to buy in to the concept of a program focused on women. One representative indicated that some people within her institution were initially concerned about discrimination and feared that women would be "belittled" by the segmenting. Another representative stated that her institution's biggest challenge was overcoming the internal and

external skepticism of the need for such a program aimed at women. One person said some individuals within her university doubted a women's philanthropy program could raise significant blocks of money, which has since been disproved.

Several institutions noted the challenges of staffing and managing a women's philanthropy program. According to Debra Engle, vice president for development at Iowa State University Foundation, its biggest challenge has been "determining how to share responsibility and make sure it is a coordinated, collaborative effort," so it is not just one staff member doing everything. Determining the financial success of the program can also be a challenge, according to Martha Taylor, vice president of the University of Wisconsin Foundation, Madison, who said it is difficult to trace "credit" for the money raised to the women's philanthropy program in particular.

Another big challenge, according to the interviews, was getting women to think differently about their own giving. One institution stated that older women had the capacity to give but were afraid of having financial advisers "jump on them" when they have limited financial background. Acknowledging generational differences, one university indicated the ongoing challenge of "trying to appeal to young and old" within one program aimed at women.

• *What has been the most positive outcome?* Several institutions commented that the most positive outcome of their women's philanthropy programs is the women's response in terms of their giving and involvement. The University of Wisconsin-Madison said one positive outcome is "the new donors we have brought into the fold." South Dakota State University said its program has "unearthed women who were wanting to get involved." Denison University noted that several women are now members of the university's highly selective board of trustees.

According to Engle, one of the positive outcomes of the women's philanthropy program at Iowa State University is "seeing women step up in leadership positions and taking their role in philanthropy much more seriously," which has resulted in "larger, more-focused gifts." Purdue University and Denison University

also noted that many women have made major gifts as a result of their involvement, citing gifts of $1 million or more from participants in their women's philanthropy programs. At Mount Mercy College, women have experienced "joy in allocating money and seeing what it could do" as part of its giving circle, which the college said is the most positive outcome of its women's philanthropy program.

Many institutions also noted the positive outcomes involving campus awareness and gender sensitivity. Iowa State University noted a cultural change with the "sensitivity of men looking at family philanthropy, not just who is sitting in the corporate office." The University of Tennessee said its most positive outcome was the "realization that we need more women involved." Taylor also acknowledged the "level of awareness by the dean and colleagues who really supported the concept of involving women on advisory boards" as a positive outcome at the University of Wisconsin-Madison. At South Dakota State University, "collaborating with women across campus for a common goal" has been a plus as well.

For the University of Mississippi, the leadership mentoring program that is part of its women's philanthropy initiative is the most positive outcome.

• *Have there been outcomes that you would consider "problematic" or "negative"? If yes, what are they, and why do you consider them problematic or negative?* Responses to this question varied considerably. Three institutions said getting people to recognize the need for a program was somewhat problematic initially. "Dealing with the perception of women's giving and why it's necessary to have a separate group" was a challenge, according to one university. Another representative noted that her institution had gotten "a few complaints that it was 'all women,'" although men are welcome to attend program events. Cheryl Altinkemer, senior director of development at Purdue University, said the development community is "interested intellectually, but action may take some time. Education and success [of the women's philanthropy program] get their attention."

One university expressed concern that the development staff "go at alums with so many asks, we may be shifting allegiance rather

than expanding on top of current commitments." Another institution shared frustration with how to get the word out and encourage women to participate in a women's philanthropy program. The difficulty of having a common agenda for women of diverse backgrounds and generations was also noted.

Staffing was identified as problematic by one representative, who said the women's philanthropy program is labor intensive and acknowledged that women donors "need lots of attention."

One of the eight institutions interviewed said there were no "problematic" or negative outcomes resulting from the establishment of its women's philanthropy program.

• *Did you receive any criticism for targeting women? Please explain.* None of the institutions interviewed reported any direct criticism for targeting women with a women's philanthropy program. Some representatives indicated that they did experience skepticism about the need for a women's philanthropy program, but felt *criticism* was too strong of a word.

One person said that while none of the women were negative about the concept, some questioned if it was good to separate men and women donors. Another representative said she had fielded similar concerns from some of her development colleagues who were concerned about targeting by gender.

One university pointed out that generation makes a significant difference, noting that "many fifty-year-olds don't want to segment." The representative added that a women's philanthropy program "is not for everyone" but is another way of involving potential donors.

• *Have you experienced a growth in alumnae giving (dollars and/or participation) as a result of the women's philanthropy program?* While most institutions interviewed acknowledged that it is hard to quantify and pinpoint giving to a particular program, all thought their women's philanthropy programs have resulted in some level of growth in giving among their alumnae. One university noted growth particularly at the "largest-end capital gifts," where, after removing couples, now almost half of their top one hundred donors are women. Most of these gifts were bequests, yet the university anticipates it is "likely to

see more women making outright gifts" in the future. Another institution said its program had experienced growth in giving and participation, saying it had found "new donor pockets" and "opened a new market segment" for the university.

Two institutions commented that because they split gifts between couples (attributing a portion of the gift to both wife and husband), it is more difficult to track giving directly resulting from involvement with their women's philanthropy programs. One university said that it is a struggle to answer the question of growth and that perhaps institutions need to find a new way to get at the issue of program success. According to Martha Taylor, the challenge is how to establish a direct line of credit to know what gifts resulted from the women's philanthropy program. Given the multiple contacts and multiple involvements most donors have with an institution, there is typically not one particular incident that is solely responsible for a gift.

Some of the newer programs said it is too early to tell if there has been growth in giving, especially since women generally take longer to become major donors; however, one representative predicts there will be a growth in giving because the women's philanthropy program has "struck a chord with some women who weren't donors before." Another university representative emphasized that it is best to view a women's philanthropy program as a "long-term thing, not an annual review."

• *What words of wisdom would you offer to institutions considering a women's philanthropy program?* All representatives were very encouraging and highly recommended establishing a women's philanthropy program. They offered a full range of advice in response to the closing question on words of wisdom. Their comments appear under the general categories that emerged as themes:

Goals and expectations

"Have realistic expectations—this requires a longer process."
"Start small—the program will require huge time and effort."
"Tailor the program to your institution."

"Know your institution's culture."

"Evaluate as you go."

"Be clear about purpose and goals."

"Look at women's giving and benchmarking to determine goals."

"Determine how to show the program has made a difference; gather baseline data on women's giving to show a change has happened."

Staffing and budget

"You don't have to spend a lot of money to start a program; don't go extravagant."

"Have a budget on which to operate."

"Be sure to have staff to handle the program; will need a full-time staff person ('staff champion') devoted to the initiative; very rewarding and very labor intensive."

"Must be able to manage the volunteers; an all-female group can be harder to manage because they want more accountability."

To begin planning for a women's philanthropy program, those interviewed recommended establishing a committee or starting with a small planning group. One representative suggested identifying a core group of ten to twenty women to gather ideas. Getting the right people involved (staff, leadership, and volunteers) was also noted. Several institutions emphasized the importance of having a diverse group, including younger members and minorities. It was also recommended that each group be approached differently.

Regarding institutional buy-in, several institutions interviewed noted the importance of having the endorsement of leadership, with support from the highest levels. Others emphasized the need for buy-in from colleagues and raised awareness across the institution. One representative acknowledged, "There is a huge learning curve."

Finally, regarding presentations and events offered as part of a women's philanthropy program, several of the institutions interviewed noted the importance of including breakout sessions and

networking time to get women talking. Women want sessions to be interactive and want to be able to ask questions. According to one representative, the best presenters are those who want to interact with the women, not lecture them.

Summary of recommendations

Based on the findings of this study, it is evident that women's philanthropy programs can and do have a positive impact on fundraising at coeducational institutions.

While most women's philanthropy programs share some basic components, many different models are being implemented nationwide. Budgets, staffing, and participation all vary considerably, depending on the size of the institution and the scope of the program. It is clear that in order to be effective, a women's philanthropy program or initiative must be tailored to fit the institution's culture.

Plan first

The key to success seems to be to begin with comprehensive planning. It is evident that an institution must clearly define goals and thoroughly plan before launching a women's philanthropy program. The importance of proceeding slowly in order to educate people and build necessary support for the concept was emphasized by those interviewed.

Build institutional buy-in

As noted in the interviews, overcoming internal and external skepticism can be a major challenge that must be addressed up front. According to the institutions interviewed, it is important to have both the endorsement of leadership and buy-in from colleagues. Gaining support from the highest levels of administration helps to convey the importance of having a program or initiative aimed specifically at women donors.

Start small

Unlike the major universities, which have larger staffs and greater financial resources to support a comprehensive program aimed at women's philanthropy, smaller institutions may be better served by beginning their efforts on a smaller scale as part of existing fundraising programs. This idea of starting small was supported by comments from some of the newer women's philanthropy programs, including South Dakota State University and Mount Mercy College.

Gather data

As recommended in the interviews, institutions need to do a formal assessment of giving trends before moving forward. It is likely that both the administration and alumnae will want to see data that demonstrate a need for a women's philanthropy program and evidence it will work. Many of the institutions interviewed suggested using baseline data to help define the goals and purpose from the beginning. Future data comparisons will help determine if the program is a success.

Educate, educate, educate

Education will be imperative to the successful implementation of women's philanthropy initiatives. Insights shared in the interviews affirmed the importance of educating the development staff, alumnae and other women participants, and the institution as a whole about women's philanthropy.

According to the interviews, women who choose to participate in women's philanthropy programs do become more engaged, involved, and invested. The challenge is to find compelling ways to encourage alumnae and other potential women donors to participate so they will be educated about finances and philanthropy.

Discuss gender bias

The institutions interviewed cited varying viewpoints at their respective colleges and universities regarding questions of gender

difference. Most ranged from enthusiasm to skepticism. Some people see a real need for programs aimed at women; others view these same programs as unnecessary. Although the interviews did not address the history of gender bias in traditional fundraising programs and in society as a whole, these issues are worthy of future discussion in order to educate people about their potential implications for fundraising initiatives.

Acknowledge generational differences

As noted in the interviews, developing programs that appeal to women across generations can be challenging. This study concludes that programming associated with a women's philanthropy initiative must be tailored to appeal to multiple age groups in order to relate to women at different life stages.

Conclusion

Women's philanthropy will play an increasingly significant role in the future of colleges and universities. Coeducational institutions in particular must recognize the growing potential of alumnae giving and nurture relationships that engage more women as leaders and donors in their own names.

Through specific programs and initiatives aimed at educating and empowering women, institutions of higher education can broaden their donor bases and increase philanthropic support. According to the interviews, women's philanthropy programs have been well received by the women who participate. The impact in terms of both involvement and investment is positive and worth emulating. Learning from the successes and challenges experienced by existing women's philanthropy programs, this study affirms the role of women's philanthropy and encourages more coeducational colleges and universities to explore ways to realize the untapped potential of women philanthropists.

References

Abbe, M. A. "Converging Forces Enhance Women's Philanthropy." Abbe & Associates, Mar. 1, 2001. http://www.philanthropy-solutions.com/Articles/thearticles.asp?ID=13.

Bickel, K. "Alumnae: In Numbers Too Big to Ignore." *CASE Currents*, Mar. 2002, pp. 34–38.

Lovell, J. M. "Women's Philanthropy Programs at Coeducational Colleges and Universities: Exploring the Concept at Luther College." Unpublished master's thesis, Saint Mary's University of Minnesota, 2004.

Matthews, A. "Alma Maters Court Their Daughters." *New York Times*, Apr. 7, 1991, pp. 40, 73, 77.

McMillen, L. "Many College Fund Raisers See Alumnae as Untapped Donors." *Chronicle of Higher Education*, Apr. 1, 1992, pp. A31–A32.

Nichols, J. E. *Pinpointing Affluence in the Twenty-First Century.* Chicago: Precept Press, 2001.

JEANIE LOVELL *is director of corporate and foundation relations and campaign codirector at Luther College in Decorah, Iowa.*

Women as donors, board members, and nonprofit executives serve programs and projects that affect women and girls and have the opportunity to build a world that is generous, just, diverse, and equitable for all its members.

11

Women, wealth, and endowed philanthropy: Trends and innovations in foundations

Kimberly Otis, Katherine Jankowski

THIS CHAPTER INTRODUCES the nonprofit organization Women & Philanthropy, discusses the trends affecting the future of women and girls and philanthropy, presents three arguments in support of women and girls, and highlights the new directions of four foundations oriented to women and girls.

Women & Philanthropy

Women & Philanthropy was founded in 1975 and incorporated in 1977 by staff and trustees working in foundations and corporate philanthropy, including leaders who remain a strong voice in the field today, such as Susan Berresford, Jing Lyman, and Jean Fairfax. Women & Philanthropy has always included men in its leadership.

NEW DIRECTIONS FOR PHILANTHROPIC FUNDRAISING, NO. 50, WINTER 2005 © WILEY PERIODICALS, INC.
Published online in Wiley InterScience (www.interscience.wiley.com) • DOI: 10.1002/pf.135

Its purpose is to increase corporate and foundation funding to women and girls.

Now is a pivotal time for Women & Philanthropy to examine questions surrounding leadership and charitable dollars, and we have begun the process with a new theory of change, strategic planning, and funding from major foundations such as the W. K. Kellogg Foundation, the Ford Foundation, and the Mott Foundation. Our new mission is to leverage the power of women and girls in creating a just and peaceful world. In our future work, we will focus on educating, mobilizing, inspiring, and leading philanthropy to better empower diverse leaders, while also building an infrastructure to strengthen the connections between diverse leadership and giving patterns for women and girls.

Women & Philanthropy has nearly six hundred members and over eighty institutional partners. These include representatives of private and family foundations, community foundations, women's funds, corporate foundation, and individual donors. A new category for membership includes academic centers, such as the Institute for Research on Gender at Stanford University, a similar one at the University of Michigan, and the Wellesley Centers on Women. Women & Philanthropy has included these institutions because they provide scholarships and thereby are grant makers. These academic centers also provide much value to the organization's research base.

Trends affecting the future of women and girls

After eighteen months of research and regional meetings, Women & Philanthropy released a report entitled *Making the Case for Better Philanthropy: The Future of Funding for Women and Girls* (Pease, 2004). The report, based on the findings of a team of consultants— Katherine Fulton, Stephanie Clohesy, Katherine Pease, and Brigette Rouson—looks at several important international and domestic trends that will have special significance for the status of women and girls as well as the future of philanthropy.

Power and vulnerability

Terrorism and political tensions create security concerns, and women are among the most vulnerable in wartime, especially to rape, kidnapping, and forced displacement, while they also have a limited role in the military decision-making process. This contradiction is even more dramatic with the increase in all forms of terrorism versus negotiation and diplomacy, which women tend to favor.

Globalization, wealth, and technology

For some women, globalization will provide economic opportunity and increased opportunities to achieve autonomy. The scientific community will also see a small but growing number of women scientists gain positions of influence. But for the great majority, globalization will perpetuate low living standards and few opportunities. Globalization may lead to increasing gaps, while women still make only seventy-seven cents for every dollar that men make. Globalization will also continue to increase the numbers of trafficking victims and slavery for prostitution and sweatshops, the vast majority of whom are women.

Fundamentalism

Tensions between secular society and the religions are increasing in many regions around the world, including in the United States. As fundamentalists gain more influence, women will lose influence. A powerful example is the irony of the new Iraqi constitution, where women stand to lose their rights, and thereby influence.

Health and bodily integrity

Women are uniquely vulnerable to HIV/AIDS because of biology as well as socialization. In poorer countries, women are often denied access to information on family planning. In the United States, the lack of universal health care takes a particular toll on women's lives, especially African American women's lives. Indeed, women between the ages of forty-six and sixty-four are twice as likely to lack health insurance as men (Pease, 2004). The

diverse factors and complexities influencing and affecting women's lives must be addressed in a holistic way.

How funders look at gender

There are three major arguments that address trends in giving for women and girls: fairness, effectiveness, and human rights. The fairness and justice argument continues to be compelling for many grant makers. Mistaken assumptions about equity, as well as donor fatigue and competing identities of race, sexual orientation, and disability, make the argument difficult to tackle.

There is much resistance to the fairness argument, based on the erroneous notion that the United States has achieved gender equality. For example, the Title IX mandate, which prohibits sexual discrimination in any educational program, has had great successes: the percentages of law and medical degrees awarded to women have increased sharply since its inception. However, the mandate has not erased inequalities, and some groups are today arguing that it be dismantled. In the international domain, the fairness argument is also powerful. Glaring discrimination still exists: women live in poverty, sex-selective abortion is a problem in many areas, and gender discrimination persists.

In terms of the effectiveness argument, some funders have a near obsession with metrics to evaluate and quantify social change, but few of these metrics include gender, race, class, and other important variables. The effectiveness framework shows how if we want to be effective on poverty and AIDS, or leadership development—indeed any program area—we must look at gender. A new book, *Effective Philanthropy: Organizational Success Through Deep Diversity and Gender Equality* (2005), by Molly Meade of Tufts University and Mary Ellen Capek, formerly of the National Council for Research on Women, shows how funders need to be aware of the following:

- Disproportionate impact on women and girls, such as poverty, where women and girls are more likely to be in poverty

- Differential impact, for example, how biology affects women with HIV/AIDS differently than it does men
- Different gender roles—how funders need to take into consideration roles such as women as caregivers and needs for child care
- Different socialization, revealing the need for different approaches, for example, with leadership development

Women & Philanthropy (W&P) is launching a gender analysis project to develop a gender impact statement and other tools for funders. This project is based on the concept of an environmental impact statement and success of the use of gender analysis internationally, such as with the World Bank. W&P will provide a valuable tool for incorporating gender concerns for more effective grant making.

Finally, the human rights framework helps funders look at women's lives in a holistic manner and connects issues such as education, poverty, environment, and justice. Human rights concerns are measurable with documents such as the Beijing Platform for Action and the United Nations Declaration for Human Rights. Grant makers are applying such standards in their portfolios both internationally and domestically. A valuable recent Ford Foundation report, *Close to Home* (2004), looks at using a human rights framework in domestic funding through several case studies.

Trends in philanthropy

Contemporary philanthropy is characterized by two major themes: growth and diversification, on one hand, and effectiveness, on the other. Today there are more than sixty thousand foundations in the United States, and one-third of these have been created since 1996. The field of philanthropy continues to grow as the gaps between rich and poor increase, providing more incentives for new foundations. New vehicles are being created, such as women's funds, venture philanthropy funds, and giving circles. There are also many smaller foundations that are not staffed and run by trustees. Foundation staff and donors are becoming increasingly diverse, and there

are new academic centers, media, and consulting groups to support and inform these new actors. Funders' networks are another growing resource for knowledge and inspiration: there are now more than three hundred networks in the United States compared to only thirty-five in 1980 (Pease, 2004).

Aside from increasing diversification, the major trend in philanthropy is a focus on effectiveness. Donors are no longer interested only in writing checks; measuring outcomes and results have become increasingly important. Ever since September 11, 2001, and the negative response that philanthropy received over the disbursement of the enormous amount of money raised, scrutiny by the public, the media, and Congress is on the rise.

Changing landscape of new funding sources

We live in a time of unprecedented wealth creation with a burgeoning philanthropic spirit, evidenced by the growth in the establishment of new foundations, the women's funding movement, the community foundation movement, the creation of donor-advised funds at for-profit organizations, a general awareness of the trillion-dollar transfer of wealth now under way, and the emergence of numerous tools and vehicles that support philanthropy and the philanthropic spirit. Most of these new organizations share a vision of strong and vibrant communities.

One of the overlooked findings in the 2005 edition of *Giving USA* (Giving USA Foundation, 2005) is that wealthy Americans put a lot of their money into philanthropic foundations. Gifts to foundations grew by 8 percent, totaling $24 billion, a bigger percentage gain than to any other type of nonprofit organization. In fact, wealthy Americans gave more money to foundations than to health organizations.

These data show a renewed interest in increasing foundation assets, which slowed after a peak in 2000–2001. It also is evidence of at least a few other trends: the trillion-dollar transfer of wealth,

new wealth-establishing foundations, and family philanthropy, where second and third generations are now adding to the asset base of established family foundations.

The conversation one can have with new foundations is far more exciting than the one with older foundations: these foundations are not cutting back. For example, the assets of thirty-seven hundred foundations created in 2001 were $5.2 billion in 2001. In 2004, these foundations had assets of almost $13 billion. While many new foundations are small or even unfunded, in 2004, more than five thousand had at least $1 million in assets.

The top two thousand new foundations created since 1996 each have a minimum of $4 million in assets. The largest number is located in the Middle Atlantic states, but foundations created in the Pacific are making the most contributions (see Table 11.1).

Women's roles in new foundations

As part of Jankowski Associates's research partnership with Women & Philanthropy, we researched the role women play at the top twelve hundred new foundations, which made more than $2.1 billion in contributions in 2004. The research identifies the type of new foundation, board composition, and sources of funding.

Most new foundations are family foundations:

- 801 of the top 1,200 are family foundations.
- 279 are independent or health care conversions.
- 47 have corporate trustees.
- 73 are corporate affiliated.

About 23 percent of new foundations have a female top executive or both a female top executive and female board members:

- 106 have a female top executive.
- 659 have female board members (often no hierarchy).

Table 11.1. Locations of the top two thousand new foundations

Number	Region	Assets	Giving
171	New England: Connecticut, Maine, Massachusetts, New Hampshire, Rhode Island, Vermont	$2.3 billion	$145.1 million
513	Middle Atlantic: New Jersey, New York, Pennsylvania	10.3 billion	576 million
282	East North Central: Illinois, Indiana, Michigan, Ohio, Wisconsin	4.4 billion	242.5 million
99	West North Central: Iowa, Kansas, Minnesota, Missouri, Nebraska, North Dakota, South Dakota	1.3 billion	69.5 million
289	South Atlantic: Delaware, Washington, D.C., Florida, Georgia, Maryland, North Carolina, South Carolina, Virginia, West Virginia	4.5 billion	282.7 million
45	East South Central: Alabama, Kentucky, Mississippi, Tennessee	684.1 million	42 million
158	West South Central: Arkansas, Louisiana, Oklahoma, Texas	3.2 billion	126.4 million
95	Mountain: Arizona, Colorado, Idaho, Montana, Nevada, New Mexico, Utah, Wyoming	3.3 billion	127.2 million
345	Pacific: Alaska, California, Hawaii, Oregon, Washington	16.2 billion	613 million
3	International	33.7 million	$763,547
2,000		46.2 billion	2.3 billion

Source: Jankowski Associates, Aug. 2005.

- 174 have both a female top executive and female board members.
- 246 have no female board members.
- 15 have corporate trustees or are not codable.

Women, either alone, as part of a couple, or as part of an estate, have invested more than $3 billion in establishing and funding new foundations (Table 11.2).

The challenge facing philanthropy is how to increase individual philanthropy regionally and encourage the growth of endowed

Table 11.2. Sources of funding for the top twelve hundred new foundations

Source of Funding	Total Donated
Males	$6.10 billion
Females	$1.04 billion
Couples	$1.58 billion
Foundations and trusts	$6.31 billion
Estates	$2.70 billion (about 20 percent women)[a]
Corporations	$3.18 billion
Other	$1.56 billion
Total	$22.47 billion

[a]Source data are based on gifts received of $2 million or more going back to 1999.
Source: Jankowski Associates, Aug. 2005.

assets for philanthropy. After twenty-five years, the women and philanthropy movement has experienced enormous success in changing the role that women play in running foundations and nonprofit organizations. However, the percentage of foundation funding going to programs and projects that affect the lives of women and girls remains under 10 percent. One new window of opportunity is stewarding the donors and boards of new foundations.

Increased levels of philanthropy require a deeper knowledge of and commitment to one's community. In today's global economy, communities are diverse and widespread. The recently published *Making the Case for Better Philanthropy* (Pease, 2004) is helping to launch the in-depth conversations necessary to deepen donor engagement in the women's funding movement across a range of domestic and international concerns.

Over the years, Jankowski Associates has surveyed hundreds of new foundations. One attribute that often defines new philanthropists is an awareness that the path to social justice starts as a personal journey. The philanthropic spirit must be nurtured at a personal level where one's web of relationships provides an authentic touchstone to one's experience of the world. The outcome is that new donors in general, and women in particular, are taking charge of their wealth and deciding with more rigorous thought and direction how to invest in nonprofit organizations to

achieve longer-term goals and to have more impact. Systemic change seems possible from this perspective.

How four foundations make a difference for women and girls

Let us now look at four foundations that illustrate new directions taken by women philanthropists or that have a high potential to affect the lives of women and girls.

Healthcare Georgia Foundation

The Healthcare Georgia Foundation was established in 1999. In 2003, it had assets of $117 million and giving of over $4.2 million. Its program areas include addressing health disparities, strengthening nonprofit health organizations, and expanding access to health care. It is an example of a health care conversion foundation. A recent report by Grantmakers in Health reported that there are now more than 170 health care conversions, with assets of approximately $18.3 billion; about 22 percent have been created since 1999.

Conversion foundations represent an important new style of institutional philanthropy. They are created from the sale of a publicly supported nonprofit, such as a hospital, to a for-profit company. The proceeds from the sale create endowments that provide grants and services. They tend to be staffed and diverse: 95 percent have women board members, and 76 percent have board members representing racial/ethnic minorities. Most health care conversions incorporate women's health issues into some aspect of their community health initiatives (Grantmakers in Health, 2005).

Healthcare Georgia is a particularly interesting foundation because it represents the potential of health care conversions and other foundations to bridge urban and rural conversations. It operates statewide and supports direct service providers, with interests ranging from mental health to disease to pregnancy prevention. It also funds capacity building, health careers for women in nursing

and medicine, public policy analysis, collaboration, and meeting people's health needs from infancy through old age. The size, scope, and structure of health care conversion foundations have the potential to build the knowledge and create the groundswell of will necessary to address the health care funding crisis.

Sunshine Lady Foundation

Doris Buffett founded this foundation headquartered in North Carolina in 1996 through her own generosity and inherited wealth. The mission of the Sunshine Lady Foundation (SLF) is to invest in organizations and programs dedicated to providing opportunities for the advancement of education, well-being, and new life choices for disadvantaged people, with special empathy for the working poor and families in crisis. The foundation is an example of a number of new foundations that make grants as pass-through entities. Money comes into the foundation each year as gifts received and goes right back out as grants. These foundations are not endowed. In 2003, the SLF had assets of $1.2 million, but donated close to $5.0 million.

The main focus of the foundation is stopping domestic violence. It fully funds and operates the Women's Independence Scholarship Program (WISP), which provides college scholarships for survivors of domestic violence to enable them to find employment and therefore work toward independence. Buffett funds scholarship programs based on her belief that "education is a powerful tool that breaks down barriers and opens doors of opportunity." Her WISP scholarship funding does not stop at the money needed to pay tuition. The foundation funds whatever the scholarship recipient needs in order to move toward independence. This flexible model, in service to the recipients' needs, may fund day care for one recipient's children or a car for someone else.

Doris Buffett has decided to give away all of her money before she dies. She feels it is very important to encourage those who are financially able to become active philanthropists during their lifetime rather than leave a legacy. Not only can a philanthropist personally direct the use of funds, but she can also experience the joy and satisfaction of seeing the results of her giving and knowing she

has made a difference. Buffett's passion, vision, and energy draw others into her circle of giving. She has a vibrant network of staff and "sunbeams," who are the volunteers she depends on to seek philanthropic investment opportunities in their own communities, which they will oversee for the foundation. She collaborates closely with social service organizations to provide the range of support needed on a case-by-case basis for her grantees, and her staff provides mentoring support to scholarship recipients.

The Sunshine Foundation has built Boys & Girls Clubs, operates several scholarship programs, sends at-risk children to camp, gives generous awards to public school teachers and outstanding workers in the field of domestic violence, funds prison education programs for men, and has developed a philanthropy curriculum now being taught at several colleges and universities.

Buffett has always viewed philanthropy as an investment in people and organizations capable of having the most impact on people's lives. "We are a hands-on organization; we tweak everything on a regular basis, " Buffett comments, and she runs her foundation like a business. Her funding is pragmatic but also has a fresh sense of urgency. Buffett advises donors to envision a goal, devise a plan to accomplish it, and then get started. "When you're helping people," Buffett comments, "let them know you have faith in them. Become a partner. Collaborate. Make a deal. The people I have helped tell me my faith in them has been a big factor in their success."

Buffett knows that in our culture, money is power. The more money one has to give away, the more power one has to do good, which for her is helping people who have experienced bad luck. Anyone who has wealth has had good luck, whether they earned it or inherited it. After all, most of the critical decisions about our lives were made before we were born, and we had nothing to do with them. This idea embodies the Buffett theory known as the "Ovarian Lottery": you cannot take credit for where you were born, the color of your skin, your gender, who your family is, how smart you are, your athletic abilities, and more. Obviously good luck does not shine equally on everyone. Buffett advises, "Pass the

power on. Life is so hard for some people. Change someone else's bad luck into good luck."

James A. & Faith Knight Foundation

This foundation was established in 1999, and in 2003 had $14 million in assets and grants of $632,301. It is a regional family foundation that makes grants in two counties in Michigan. Its program areas are women and girls, animals in the natural world, and internal capacity.

New foundations are popping up in communities all across the country (see Table 11.1). Their interests vary. Some focus on certain priorities, others on certain regions. This foundation decided to do both. It was created through an estate, and family members were given the role of donating the money. Peg Talburtt, formerly with the Michigan Women's Foundation, is its executive director.

This foundation is another good example of the learning curve many new foundations travel as they decide how to focus on what Talburtt calls "good grant making." It takes new foundations several years to figure out what they are and what it means to be philanthropists. At some point, a foundation's members wonder: Are we doing a good job? Most people do not have the training and knowledge to make funding decisions. But once the question is asked, a new phase emerges. At that point, the foundation can hire a staff person to help them do it or do it themselves. Either way, the decision marks a point of maturation in the new foundation life cycle, moving from creation to a more strategic philanthropy. Many new family foundations feel a deep responsibility to become good stewards of their assets.

One way to do this is to evaluate their effectiveness. The Knight Foundation's desire to evaluate its own effectiveness resulted in the creation of the Michigan Tool Kit (which can be downloaded at http://www.knightfoundationmi.org). Modeled on the Institute for Women's Policy Research's Women in the States project, this tool kit provides clear directions on how to create county-level reports on the status of women.

Using the tool kit to create a county-level report on the status of women has had several benefits. The report had more impact than the statewide report because it provided information more likely to be picked up by the local press. It keeps the conversation alive because more people are touched by its finding, and it encourages collective engagement in the data collection and in follow-up meetings and conversations. As a grant maker, it provided the Knight Foundation with county-level data that will help it make better investments in two of its focus areas. Finally, the first report now serves as a benchmark to help the foundation and the community assess their impact over time.

The Knight Foundation's funding of the development of the Michigan Tool Kit provides a clear example of how a small foundation can have national reach and impact by creating and sharing tools that help nonprofits and donors communicate their value and measure their effectiveness.

Isabel Allende Foundation

Isabel Allende's novel *Daughter of Fortune* is a profound meditation on the search for love; deciding to live in the present moment; the power of making decisions with one's time, talent, and resources that recognize each person's essential human dignity; and choosing to wear our identities as women—to embrace the fullness of our potential to give and receive, to love and be loved, to be powerful and self-determined, but most of all, to be in relationship.

The book's generosity of spirit is reflected by the charitable foundation Allende created in 1996 to pay homage to Paula Frias, her daughter who passed away in 1992. According to the foundation, "We know that the quality of life for families and communities improves when women are given access to education, healthcare, and skills, so they can take care of themselves and their children. The more we empower women, the greater chance there is for them to overcome poverty and become a more compassionate and connected place. We therefore primarily support organizations that help those in need, especially women and children, by providing financial aid for education, healthcare, and protection." The

choice of the word *protection* is unusual and important because it addresses a major concern for women in the global economy.

The foundation received seed funding from the sale of *Paula*, the best-selling book Allende wrote, inspired by her daughter's life and untimely death, and has received annual contributions from Allende. The foundation's assets in 2004 were $6.7 million, with giving of $287,475. Its Web site is in English and Spanish, and it takes online applications. The foundation provides grants and scholarships in San Francisco and in Chile. It also sponsors the Espíritu Awards, granted to celebrate, honor, and support positive and compassionate action in the areas of literacy, education, shelter, health care, and the pursuit of peace. Over time, the foundation has focused its mission and strategies, raised its average grant size, and has decided to concentrate on smaller nonprofit organizations where its support can have higher impact.

Conclusion

The new foundations highlighted in this chapter provide several clues to the direction that fundraising and development must take to engage donors at a deeper level. These philanthropists seem to be turning away from the notion of giving back and replacing it with the simple idea of giving. How they decide what "giving" means varies.

Each of the new family foundations describes using explicit knowledge, facts, and information that drive decision making, in combination with knowledge learned on the journey to becoming better philanthropists. This journey connected them more deeply with the people and organizations they serve, as well as with their own attitudes toward giving. This tacit knowledge came from subjective insights, beliefs, values, and a body of perspectives that propelled them to more inspired philanthropy. Moving forward, explicit knowledge helps them stay focused on results and allows them to experiment and take risks. The tacit knowledge keeps them humble and connected.

The Isabel Allende Foundation captures in one sentence a theme that is emerging among new philanthropists: "We only have what we give."

References

Council for Aid to Education at the RAND Corporation. "Voluntary Support to Higher Education Survey, 2005, 2004, and 2003." http://www.cae.org/content/display_press.asp?id=55.

Ford Foundation. *Close to Home: Case Studies of Human Rights Work in the United States.* New York: Ford Foundation, 2004.

Foundation Center. *Foundation Giving Trends: Update on Funding Priorities, 2004 Edition.* New York: Foundation Center, 2004.

Giving USA Foundation. "2004 Giving by Type of Recipient." June 2005. http://www.aafrc.org/gusa.

Meade, M., and Capek, M. E. *Effective Philanthropy: Organizational Success Through Deep Diversity and Gender Equality.* Cambridge, Mass.: MIT Press, 2005.

Pease, K. *Making the Case for Better Philanthropy: The Future of Funding for Women and Girls.* Washington, D.C.: Women and Philanthropy, 2004.

KIMBERLY OTIS *is president and CEO of Women & Philanthropy, based in Washington, D.C.*

KATHERINE JANKOWSKI *is research director and CEO at Jankowski Associates, headquartered in Frederick, Maryland.*

By working together, women philanthropists and nonprofits can make significant strides to increase giving and improve the quality of life for all.

12

Launching new initiatives and raising a call to action

Martha A. Taylor

THE FUTURE OF THE WOMEN's philanthropy movement may well define the direction of philanthropy in the United States, just as it changed philanthropy at the end of the twentieth century. Women's funds and giving circles akin to women's clubs from the end of the nineteenth century have developed around the nation. Women's programs are now found in universities, colleges, the United Ways, community foundations, and hospitals. Individual women philanthropists have shown unprecedented leadership in terms of immediate large gifts and naming opportunities in their lifetimes. Businesswomen are changing the shape of the workforce and philanthropy. The profession of philanthropy is changing too, with women now the dominant percentage of development officers. The culture of development has shifted from market-driven language to more donor-driven language.

I challenge you, the reader of this book, to consider yourself a leader of the women's philanthropy movement and build on this momentum. What are the new initiatives that we should launch as leaders of the women's philanthropy movement? What is the call to action for the modern women's philanthropy movement?

NEW DIRECTIONS FOR PHILANTHROPIC FUNDRAISING, NO. 50, WINTER 2005 © WILEY PERIODICALS, INC.
Published online in Wiley InterScience (www.interscience.wiley.com) • DOI: 10.1002/pf.136

First, I must discuss the financing of the women's philanthropy movement infrastructure, one of the variables to ensure the continued speed of the movement's momentum. The infrastructure is the organizations and individuals who provide the leadership, programming, media relations, teaching, and research that propel the field. Without adequate funding, the growth will continue, but at a slow pace. Many of the following leadership initiatives described will take additional funding. Individuals such as Maddie Levitt, Lorna Jorgenson Wendt, and Jo Moore and foundations such as Kellogg and Atlantic Philanthropies have provided enlightened support in the past. Groups and individuals must work together to seek financial support for the objectives of the overall women's philanthropy movement.

Leadership Initiative One: Focus on priority issues

How do women change the face of America? How do they make a better world? The vision has to remain steady. The movement must address the priority issues as follows: ensure peace and justice at home and worldwide; work for equality for women and all peoples worldwide; narrow the difference between rich and poor; preserve the environment; promote excellence in education, especially for those of lower economic means; ensure quality culture and the arts; provide better and more accessible health care; and prevent violence against women.

Tracy Gary and Karen Payne (2005) report on a survey of women working on behalf of women and girls nationally and internationally. The respondents identified top funding priorities: leadership development, education, combating violence against women, and economic empowerment. They stated that education was the key factor in raising the quality of life for women everywhere.

Women's funds are not the only ones addressing the challenges facing women and girls. Many women give to mainstream organizations, designating their gifts for programs to help women and

girls. Other women give to organizations and causes that benefit all in society, thus helping women and girls indirectly.

The women's philanthropy movement is not only about funding women and girls. The women's funding movement is surely the basis for the larger movement. However, no organization or sector has a corner on social change. Education is the biggest social change agent in the world. Health care can improve people's lives. The arts can transform the human experience.

The strength of the women's philanthropy movement is the collaboration of those representing different causes, interests, and organizations. A spirit of collegiality will be the source of great momentum for the future.

Leadership Initiative Two: Increase collaboration

A creative tension exists between the individuals and groups in the movement. Some of this tension is good. But good communication, understanding, and working toward mutual goals are better.

Issues are part of the divide. Leaders of women's funds have wondered if those in mainstream philanthropy are forwarding the cause of women and girls sufficiently (Moore and Philbin, 2005). If the various groups gathered periodically, much could be accomplished. Lack of funding for the infrastructure of women's philanthropy initiatives is another problem. The Women's Philanthropy Institute (WPI) could play a role in its new home at the Center on Philanthropy at Indiana University. WPI can be a resource for all women and philanthropy groups by providing speakers, speaker training, research, and fundraising expertise. But this collaboration must go far beyond WPI and the center's role.

For collaboration and cross-pollination of ideas, each nonprofit organization, women's group, or family foundation should include leadership from other sectors on boards and advisory groups. For example, women's fund leaders could serve on university committees, and vice versa. This will take some commitment of time so

that each can better understand and help the general cause of women's philanthropy.

Those who are affiliated primarily with a social service agency, a medical facility, a women's giving circle, or a college should reach out and work with a women's fund to sponsor community donor education programs. Women's funds, hospitals, universities, United Ways, and giving circles can partner to conduct joint programs, fund grants, or donor education programs. Each individual can be creative to determine how best to advance one another's causes and the movement of women's philanthropy. The whole of society will advance faster as a result.

As we collaborate, we must keep a sense of humor. One of America's most generous philanthropists, Oseola McCarty, said: "I had a cousin who made me laugh all the time. She told silly stories like I had never heard before. I tell you, laughter is a good release. It's a blessing to be able to laugh at yourself" (Maggio, 1996–1997, p. 45). This is excellent advice.

Leadership Initiative Three: Reach out to more women

Expanding women's giving circles, women's funds, and women's philanthropy programs within mainstream nonprofits is a top priority. We also must increase efforts with segmented groups of women and determine special programming for them.

Business and working women have been identified as one of the high-potential new audiences because they are earning their own money. Working together to reach business and corporate women could encourage a new giving spirit, moving women from consumerism to altruism.

Women volunteer campaign leaders are another audience. Many women leaders complain of isolation. For many years, women board members and others have discussed holding a summit of those who serve on boards for nonprofits, family foundations, and women's philanthropy groups. Bringing the leaders of the women's

groups in higher education together, for example, would help develop capacity and build powerful collaborations.

Groups of women affiliated with religious organizations have offered leadership in philanthropy for generations. In the modern movement, the new educational programming formats that have been launched should be increased. Leading Jewish women philanthropists such as Barbara Dobkin have inspired others (Jewish Women's Archives, 2005). Interdenominational efforts by Nancy Berry in Texas and Rosemary Williams in Connecticut are examples of outreach that should be expanded. Williams's seminars are strengthened with the use her book, coauthored with Joan Kabak, *A Woman's Book of Money and Spiritual Vision: Putting Your Financial Values into Spiritual Perspective* (2001).

Although the baby boomer generation may be the largest and best educated in history, Generation X women are now coming into their own, and more outreach and programming needs to be undertaken to involve them. Will they give in the same ways as their mothers have?

Widows have always received attention by planned giving officers, and planned giving expert Robert Sharpe gives further validation of a concept the movement has stressed: showing women as philanthropic role models. At the Association of Fundraising Professionals International Conference in April 2005, Sharpe noted that planned giving publications should feature testimonials of individual women because they are the biggest audience for planned gifts. He said, "Featuring male donors should . . . be the exception to the rule" (Sharpe, 2005, p. 2).

Minority women philanthropists have held innovative conferences and meetings. African American Jean Fairfax, a founding member of Women & Philanthropy and trustee of the Arizona Community Foundation, advocates working within the power structure for change (Women and Philanthropy, 2005). More outreach and educational outreach efforts are needed to reach minority women.

Efforts to reach the traditional audiences of older women and major gift givers must also continue. Cindy Sterling's research has

shown that a bequest is still the preferred planning vehicle for women (Sterling, 2005). Many women still favor bequests rather than outright major gifts in their lifetimes. As a result, many conversations about large gifts with women must continue to begin where a large number of women are most comfortable: with a philanthropic plan and bequest. Women may back into current major gifts when they become comfortable with the concept and the nonprofit gains their trust with good stewardship of their bequest intention. For example, a woman who has designated a bequest for a scholarship may decide to start a scholarship in her lifetime after attending scholarship banquets where she meets students and other donors. Educational programming and development solicitations need to incorporate these concepts.

Other special groups to reach with media, programming, visits, and activities, after studying their interests and attitudes further, include couples, single women, lesbians, inheritors, young women, and corporate wives.

Leadership Initiative Four: Increase research and writing

Research is important to the future of the movement. Historical research has always been helpful in setting a context for current trends. Examples of past women philanthropists provide stories of courage and inspiration to women of today. Based on the work of Gerda Lerner (1993), Kathleen McCarthy's 1990 compilation of women's philanthropy history was the first major book on women's giving. Sondra Shaw-Hardy and I wrote the first major book on the modern women's philanthropy movement (Shaw and Taylor, 1995). Early work by the late Ann Castle (n.d.) in compiling a women's philanthropy bibliography created a recognized field of study, which continues at the University of Michigan.

Mary Ellen Capek's several publications and research have been important to the movement. Her 2005 book with Molly Mead offers

strategies for strengthening nonprofit organizations and foundations through a commitment to diversity and gender equality.

Applied case studies are most helpful to philanthropists and practitioners. In addition to case studies research, statistical analysis is needed on a number of different issues, using a variety of cohorts. A study by Rooney, Mesch, Steinberg, and Chin (2005) is an example of research that illuminates gender differences. One of the most important findings of their study is that single women are more likely to be donors and to give more money than single men are once statistically controlled for income and educational attainment. Similarly, married couples are more generous than single men after controlling for income and education.

In 2000, the powerful Committee of 200 women executives released a report on the philanthropy of its members. Merrill Lynch underwrote the cost of the report (National Foundation for Women Business Owners, 2000). This substantial study has been the primary source of information on businesswomen for the past five years. Now researchers must update this study and do more research on businesswomen to create a sense of momentum, excitement, energy, and interest.

Organizations, practitioners, and academics must undertake more research. Recently academic centers have begun to take leadership on the issue of women's philanthropy research. This means more faculty and graduate students will produce much needed research. Graduate students have completed important research papers in the past, including Joan Fisher (1992), Elisa M. Davidson (1999), and Jeanie M. Lovell (2004).

Additional topics that need exploration include strategies and measurement of success for donor education, development initiatives, and women's philanthropy programs; giving patterns and attitudes by generation, education, geographic region, ethnic and racial group, and level and source of wealth; decision making on giving by couples; lesbian giving practices; financial indicators of wealth among women; giving challenges for well-to-do women; the role of women in the intergenerational transfer of wealth; planned giving

motivations and type of vehicles that women prefer; women and religious philanthropy; women's priorities for funding and responsiveness to key issues; women trustees, campaign and board leadership, and giving; media use and effectiveness in communicating to women about giving; and trends in women's philanthropy. Best practices research and case studies would be helpful on the topics of women and girls' fundraising strategies, giving circles, donor education programs, and women's philanthropy initiatives and programs within nonprofits and higher education. Comparisons should be made with men donors. Focus groups, surveys, individual interviews, and historical analysis should be used as appropriate.

In addition to research, other writings and publications should be encouraged. Some of the best reflections on women's philanthropy have been written for individual college women's programs or city women's funds. For example, Miss Hall's School in Pittsfield, Massachusetts, holds an annual philanthropic roundtable and publishes the results (Miss Hall's School, 2001). Philanthropy advisers such as the Philanthropic Initiative in Boston publish other excellent writings such as *Raising Children with Philanthropic Values* (Remmer, 2004). Such publications need to be more widely distributed and made available.

Additional books and printed material need to be disseminated. Self-publishing may be the best way to disseminate information. The individual stories of courage by women philanthropists inspire others. The Center on Philanthropy can provide excellent leadership in this initiative of research and writing.

Leadership Initiative Five: Expand the message through media coverage and education

Changing attitudes in society about almost any topic can be greatly influenced through various media and communications—newspapers, magazines, publications, television, movies, theater, and educational programs. Two of the primary ways the women's

philanthropy movement has spread is through the media and educational programs that inform, inspire, and change the culture of women's philanthropy.

Media

The media and publications have played a significant role in advancing the movement. In 1992, the University of Wisconsin-Madison and the Johnson Foundation at its Wingspread Conference Center sponsored a summit of sixty national leaders in women's philanthropy. "Develop a shared marketing campaign to publicize the value of women's philanthropy" is one of the conference's unmet mandates (Thompson and Kaminski, 1993, p. 53). A collective marketing campaign with media involvement needs to be launched nationally. Business leaders initiated a media and educational campaign to stress science and math education in the United States, with one of the key audiences identified as women and girls. A women's philanthropy media campaign should have similar national aspirations.

Higher education and alumni magazines are featuring more stories about women's philanthropy. Showing women as role models in philanthropy and in campaign leadership generates more gift commitments. New research and information could stimulate more excitement and interest in the movement. To create momentum, the media, reporters, communicators, and women's magazines all must be involved.

Development education

Twenty years ago, after the first women's fund had been in existence almost ten years, the vast majority of American women did not know about the modern movement. One of the reasons was that women were not being asked personally for major gifts or being treated the same as men in the gift-giving decision-making process. Single women were often ignored. Working women were a new phenomenon. The development profession was in the dark ages about approaching women. Because development officers are often

a primary source of information for donors, educating development officers and reinventing fundraising became a priority for the women's philanthropy movement.

Unfortunately at about that time in the late 1980s, heavy sales language was being applied to development for the first time. This mind-set did not relate to women. They did not respond to the traditional solicitations based on quid pro quo and loyalty. No special gender-sensitive appeals were presented to women, and no major gift programs existed to attract women to leadership in higher education or other nonprofits.

The vast field of women's communications and psychology had not been applied to philanthropy. The only part of the profession that believed in the concept in the beginning was planned giving professionals, who knew that women end up with most of the money. A few enlightened development leaders believed in promoting the concept: Pat Lewis, Judith Nichols, Deb Engle, Cheryl Altinkemer, Bruce Flessner, Bobbi Strand, Jack Ohle, and Andrea Kaminski. No emphasis was given to encouraging women to donate based on their own values or to donate to their colleges. Instead, development officers often encouraged women to give in honor or in memory of a family member. The result was that many women were not as connected to their giving as they could have been. They did not find that passion or the true joy of giving. Thus, they did not give to their potential. The bright exception to all of the above was giving to the women's colleges. Leaders in the women's colleges such as Sister Joel Read and Nicki Tanner had been advocating the idea of women's philanthropy for years, yet they faced parity issues.

Through books, publications, research, conferences, speeches, and workshops, the women's philanthropy movement grew through development. Leaders helped spread the word at professional organizations such as the Council for Advancement and Support of Education, Association of Fund Raising Executives, and the National Committee on Planned Giving. A focus on women as donors resonates more now that 60 percent of the profession is women. A number of men have been strong supporters, such as Robert Rennebohm, Gene Tempel, and Peter Buchanan. Along the

way, a small minority has been critical of the movement, including those who say they do not want to separate women into different programs. However, these people are usually committed to asking for more gifts from women through the regular development programs and have incorporated many of the concepts of the movement into their day-to-day work. In the final analysis, the entire field of development has changed for the better because of the women's philanthropy movement.

In the past two decades, development offices have changed the way they do business in order to reach women more effectively. The tools range from research and computer systems to board selection and campaign leadership. Many more development offices need to ensure that they are even more gender and diversity sensitive. Separate women's programs help to reach out to women as a special group. Although important, not all organizations may be able to afford separate programs. However, all development offices can change standard operating procedures to improve gender and diversity sensitivity. Recording gifts and crediting women properly still seem to be one of the biggest problem areas.

A specific unmet goal of the 1992 Wingspread Conference was to get women into leadership positions within the mainstream philanthropic organizations. Women and other diverse groups not only want to speak publicly at forums but sit at the board table.

Donor education

Nationally, the women's philanthropy movement has been at the forefront of donor education. The Council on Foundations, the National Center for Family Philanthropy, Forum of Regional Associations of Grantmakers, and Association of Small Foundations have held forums on philanthropy in which women have been leaders. These leaders include Jane Justis and Ellen Remmer. WPI was created in great part for donor education, and WFN is committed to this purpose.

According to WPI, the five stages of women's philanthropy education are inspiration, knowledge, action, lead, and legacy. The goal of WPI's curriculum is to include the best teachings of

women philanthropy education in America today. A new donor education initiative must be launched: a collaborative approach with joint funding that includes all groups and capable individuals interested. Training of new speakers is an important element of this initiative.

How can individual donors, WPI, New Ventures in Philanthropy, WPN, grant makers, Council on Foundations, Women & Philanthropy, giving circles, and other organizations involved with donor education collaborate to provide a new level of education, inspiration, and discussion to further women's philanthropy? It is essential to work together and organize speaking and outreach.

Cheryl Altinkemer, Purdue University, and Debra Engle, formerly at Oklahoma State and currently at Iowa State, are role models and trailblazers in the area of education for both philanthropists and development officers. They created innovative donor programming at their institutions and worked tirelessly to advance donor and development education nationally for all causes.

Other leaders of the women and philanthropy movement know that education is the way to change minds and hearts—through the media, educational programming, and face-to-face individual meetings. This is how to develop the movement.

The women's philanthropy movement is similar to the women's suffrage movement. The foremothers championed suffrage as a way for women to make a difference. They used newspapers, town hall meetings, and women's clubs. Large conventions and gatherings were essential. Publications and inspirational writings were key (Anthony and Stanton, 1981; McBride, 1993).

Raise a call to action: Women's philanthropy will change the world

As leaders of this movement, our message and our deep personal belief is that through philanthropy, women will change the lives of individuals and the world. Women will change institutions for the better. It would be impossible to work so many hours on this cause,

fly so many late-night airplanes, and make so many sacrifices if we truly did not believe in the power of women and philanthropy.

Yet women must not be asked to share some empty slogan about changing the world. Humans have faced challenges before, and that is why it is essential to issue a new call to action for women and philanthropy. Incorporate this call to action into programs, education, and media messages.

First, advance the common good. We must stress the traditional definition of partnership for the common good in America—that government, business, and private philanthropy each has its role. When the movement began, American society was different. Thirty years ago and certainly twenty years ago when the movement gained momentum, private philanthropy supported many organizations, but government played a major role. Some are attempting to shift more and more functions of our society to the nonprofit sector. Philanthropy cannot take over the functions of government in providing basic social services like public higher education, museums, and many other functions. Taxes are crucial to the functioning of a civil society. Women's organizations and others in the philanthropic sector have been equally guilty of not clarifying this important balance. Instead, only the importance of philanthropy has been emphasized. The power of women's gift dollars has eroded because of declining government dollars.

Jane Addams, one of the fearless foremothers in women's philanthropy, led the fight for women's education and then established homes and programs to care for the poor in Chicago. She founded Hull-House, resulting in the change of child labor laws and the conscience of America. The Center on Philanthropy honors her through the Jane Addams Fellows. Those women's club workers in Chicago and across the nation worked to get their social service programs to become government programs. It was their definition of success (Addams, 1981). Today, we see many programs going off government funding, and we see people—especially women and children—suffering in our communities. It is our challenge as philanthropic leaders to give, secure, and seek funds to alleviate this suffering. It is also essential to communicate what is happening

when government funding is dropped and what these cutbacks mean to individual lives.

American women advance the common good through their tax and philanthropic dollars. The partnership of the two must be stressed. Both sources of funding are basic principles of democracy that are the foundations of the nation.

Second, promote world peace and understanding. Does it appear shallow that when terrorists strike and the nation is at war, women are told they will change the world? The answer is clear. The world is changed one individual, one action at a time. A woman who makes a philanthropic gift, especially one that is strategically given to reflect this woman's values and vision, changes the life of one person or activity. The effect ripples around the world. Jane Addams, always the role model, took her cause further. She knew that the streets of Chicago would never be safe when the streets of Europe were in turmoil. She became the first president of the International Women's League for Peace and Freedom.

Women's philanthropy must always relate to the larger challenges of the world. It is essential especially in times of hatred and religious turmoil that women extend their benevolent hand and give of their loving hearts. As leaders of this movement, we must seek answers to these larger issues. Some of the most inspiring work recently has been completed by the Global Fund for Women and other individual and collective efforts in war-torn areas such as Afghanistan and Iraq. Just as with Jane Addams, our work is essential for peace.

Third, reenergize through new spiritual and personal connections. Women will be moved by societal needs, but in the final analysis, they will be moved by their deep sense of caring—whether that is personal, spiritual, or religious.

How do we make the case to businesswomen that philanthropy is good business? Business models are self-evident. It is critical to focus on deeper motivations. Civic responsibility does move people to give. But in the women's philanthropy movement, it is essential for us to stress that altruism and caring work in motivating

women. A desire to see the world changed, the life of an individual transformed, a disease cured, or a situation altered is the heart of philanthropy.

Offer the world the women's model of philanthropy. Many men are now following the women's model, with baby boomer men following the motivations of women of all ages rather than their father's giving patterns. They like the deep benevolent tradition of women's philanthropy. They want more accountability and entrepreneurship. Kay Sprinkel Grace's adage applies: "Remember that the new philanthropy is not like your father's philanthropy—it is more like your mother's" (Grace, 2002, slide 8).

American women have changed much since this movement began. Although the approach has been uncoordinated, the message that has been communicated collectively has moved the mindset and challenged American women to be philanthropists: to improve society and change themselves in the process. In giving of self, you will find self.

Women have come a long way in America with property rights, voting rights, and now full philanthropic partnership with loving families. Still, many families exist where no thought is given to their giving habits or to which nonprofits they are giving. Other women are stymied by too many direct mail solicitations and no clear philanthropic vision. What mountains could be moved if women were doing the simple, radical act of giving generous gifts in their own names, to the areas of their own choosing, and being publicly recognized for it so others will be inspired to be generous also.

Maya Angelou (1993) said, "When we cast our bread upon the waters, we can presume that someone downstream whose face we will never know will benefit from our action" (p. 15). Thus, it is with all of women's philanthropy—whether given to health care, higher education, women and girls, environment, religion, or social services—the ripples go forth.

As with philanthropy, leadership has a ripple effect. Your leadership and influence has and will create waves of caring across America. We have the power to change the world. Let us begin the change.

References

Addams, J. *Twenty Years at Hull-House.* New York: Penguin Books, 1981.

Angelou, M. *Wouldn't Take Nothing for My Journey Now.* New York: Random House, 1993.

Anthony, S. B., and Stanton, E. C. *Correspondence, Writings, Speeches.* New York: Schocken Books, 1981.

Capek, M. E., and Mead, M. *Effective Philanthropy: Organizational Success Through Deep Diversity and Gender Equality.* Cambridge, Mass.: MIT Press, 2005.

Castle, A. "Women and Philanthropy Bibliography." N.d. http://www.women-philanthropy.umich.edu/donors/.

Davidson, E. M. "Report on Women's Philanthropy in the United States: Trends and Developments." Unpublished paper, City University of New York, 1999.

Fisher, J. "A Study of Six Women Philanthropists of the Early Twentieth Century." Unpublished doctoral dissertation, Union Institute, 1992.

Gary, T., and Payne, K. "Called Out." Unpublished report, 2005. [Available from the authors at lcarus3500@aol.com.]

Grace, K. S. "Values-Based Philanthropy and the Importance of Stewardship for Women." Presented at the Women's Philanthropy Institute, Center on Philanthropy, Indiana University, Pontiac, Mich., July 18, 2002.

Jewish Women's Archives. "Paean to a Troublemaker: Barbara Dobkin." Aug. 18, 2005. http://www.jwa.org/discoverrecollections/dobkin.html.

Lerner, G. *The Creation of Feminist Consciousness: From Middle Ages to Eighteen-Seventy.* New York: Oxford University Press, 1993.

Lovell, J. M. "Women's Philanthropy Programs at Coeducational Colleges and Universities: Exploring the Concept at Luther College." Unpublished master's thesis, Saint Mary's, University of Minnesota, 2004.

Maggio, S. "Simple Wisdom for Rich Living." *Advancing Philanthropy,* Winter 1996–1997, pp. 44–47.

McBride, G. G. *On Wisconsin Women: Working for Their Rights from Settlement to Suffrage.* Madison: University of Wisconsin Press, 1993.

McCarthy, K. (ed.). *Lady Bountiful Revisited: Women, Philanthropy and Power.* New Brunswick, N.J.: Rutgers University Press, 1990.

Miss Hall's School. "The Spirit of the Gift: Philanthropy and the Inner Life." Pittsfield, Mass.: Miss Hall's School, Apr. 18, 2001.

Moore, J., and Philbin, M. "Women as Donors: Old Stereotypes, New Visions." In E. Clift (ed.), *Women, Philanthropy, and Social Change: Visions for a Just Society.* Medford, Mass.: Tufts University Press, 2005.

National Foundation for Women Business Owners. *Report on Giving by the Committee of 200.* New York: Merrill Lynch, 2000.

Remmer, E. *Raising Children with Philanthropic Values.* Boston: Philanthropic Institute, 2004.

Rooney, P., Mesch, D., Steinberg, K., and Chin, W. "The Effects of Race, Gender, and Survey Methodologies on Giving in the U.S." *Economic Letters,* 2005, *86*(2), 173–180.

Sharpe, R. "The Widow's Might." *Give and Take* (Robert Sharpe Company), May 2005, pp. 2–4.

Shaw, S., and Taylor, M. *Reinventing Fundraising: Realizing the Potential of Women's Philanthropy.* San Francisco: Jossey-Bass, 1995.

Sterling, C. "Motive Operandi: What Motivates Women to Give the Way They Do?" *CASE Currents*, May–June 2005, pp. 33–37.

Thompson, A. I., and Kaminski, A. R. *Women and Philanthropy: A National Agenda.* Madison: Center for Women and Philanthropy, School of Human Ecology, University of Wisconsin-Madison, 1993.

Williams, R., and Kabak, J. *A Woman's Book of Money and Spiritual Vision: Putting Your Financial Values into Spiritual Perspective.* Maui, Hawaii: Inner Ocean, 2001.

Women and Philanthropy. "1998 LEAD Award Recipient: Jean E. Fairfax." *Woman and Philanthropy News and Research*, Aug. 18, 2005. http://www.womenphil.org/newsletter/300/newsletter_showl.htm.

MARTHA A. TAYLOR *is vice president of the University of Wisconsin Foundation and cofounder of the Women's Philanthropy Institute.*

The chapter provides some of the basic fundamental concepts of women's philanthropy and contact information for a selection of national organizations for women's philanthropy.

13

Additional reference material

The Six C's: Women's motivations for giving

Sondra Shaw-Hardy, Martha A. Taylor

- Create
 Women want to create new solutions to problems.
 Women like to be entrepreneurial with their philanthropy.
- Change
 Women give to make a difference.
 Women are less interested in providing unrestricted support to preserve the status quo of an organization or institution.
- Connect
 Women prefer to see the human face their gift affects.
 Women want to build a partnership with people connected with the projects they fund.
- Commit
 Women commit to organizations and institutions whose vision they share.
 Women often give to the organizations for which they have volunteered.

The Six C's are from Shaw, S., and Taylor, M. *Reinventing Fundraising: Realizing the Potential of Women's Philanthropy.* San Francisco: Jossey-Bass, 1995.

NEW DIRECTIONS FOR PHILANTHROPIC FUNDRAISING, NO. 50, WINTER 2005 © WILEY PERIODICALS, INC.
Published online in Wiley InterScience (www.interscience.wiley.com) • DOI: 10.1002/pf.137

- Collaborate
 Women prefer to work with others as part of a larger effort.
 Women seek to avoid duplication, competition, and waste.
- Celebrate
 Women seek to celebrate their accomplishments, have fun together, and enjoy the deeper meaning and satisfaction of their philanthropy.

Plus Three C's for the twenty-first century: The results of women's giving

- Control
 Women are taking control of their lives, their finances, and their philanthropy.
 Women want more accountability from their philanthropic gifts.
- Confidence
 Women have gained the confidence to become philanthropic leaders.
- Courage
 Women have the courage to challenge the old way of doing things and take risks with their giving to bring about change.

For development officers: Twelve tips to secure more gifts from women

Sondra Shaw-Hardy, Martha A. Taylor

1. Understand women's potential. Research the facts on widows, working women, women business owners, and women in the corporate world. Know that women will outlive men by seven years. Use these and other impressive figures to convince your organization that they should be paying more attention to this important constituency.

2. Research women's giving to your institution including a history of women philanthropists and giving statistics. Provide role

models from the past by featuring outstanding women philanthropists in the history of your organization.

Identify new prospects for your organization by reviewing women's donor records. Especially consider hidden prospects, for example, single women. They give more than married couples and single men when income and education are the same.

3. Understand multigenerational giving and women's desire to help their children learn how to give. Look at ways to do this within your organization or institution by inviting women to involve their families in your events. Provide separate programming for different generations and workshops for your donors on multigenerational issues, including a panel of family members talking about their personal philanthropy.

4. Engage women in your organization by using the Six C's of women's giving motivations: create, change, connect, commit, collaborate, and celebrate. While looking at ways to engage more women in your organization and institution, be sure you have each of these Six C's included in your efforts.

5. Through publications, events, and donor education, create a culture of philanthropy among your women donors. Highlight women as individual major donors in your publications to be role models for others. Feature women in leadership positions.

6. Use all or some of the concepts from the different women's programs that have worked with a variety of organizations, ranging from women's leadership councils to giving circles. Create an advisory committee of women donors. Let the women look at all the options carefully and choose what they think will work best for your organization.

7. Understand the differences between women and men—how they think and communicate. Use gender-sensitive communication techniques when talking to women donors, especially during a gift discussion. Ask women in a way that is comfortable for them.

8. Connect women's values to programs of your organization. Because women's motivations are not based as much on loyalty but rather on values, make the case for how the gift will reflect their values and make a difference in one life or many lives.

9. Ask women for major gifts. Women are the overlooked constituency. More and more gifts are being made jointly. Be sensitive to generational differences. Visit as many women as you do men. Remember that planned gifts are still a preferred major gift for many women.

10. Properly steward and recognize a woman's gift. Recognition may be more personal and not public. Many women still want to remain anonymous. Encourage women to be public with their giving to inspire others. Address women correctly; nothing makes a woman angrier than to have her husband thanked when it was her gift. And address her by the name she prefers.

11. Involve women when planning for and conducting capital campaigns as both volunteer leaders and prospective major donors and in your feasibility study.

12. Make sure you have women in leadership in your nonprofit as staff members and board members. Woman donors look to see if women are in the organization and what positions they hold.

For women philanthropists: Ten strategies for more effective giving

Martha A. Taylor

1. Begin your philanthropy as early in life as possible. Even if you can't give as much as you'd like, your gifts will add up and begin to form your legacy.

2. Find your passion, and focus your gifts rather than scattering them. Think about two or three areas or causes you want to support with your major gifts, and make this your philanthropic mission. Not only will your gifts have more impact, but you will find your giving more satisfying.

3. Work for parity in giving in your household. You and your spouse should have equal voice about which causes your contributions support and the amount given. Follow your values in your giving.

4. If you can, give out of your assets to the causes you are passionate about.

5. Give while you live so you can see the benefits of your action and learn how to give strategically.

6. Consider your philanthropy as another child, your investment in the future of our world. When planning your estate, if you have two children, divide your estate in three, leaving one-third to each child and one-third to philanthropy.

7. Consider the strength of numbers. Organize with others to provide a pooled gift that can make a project possible. Establish a giving circle that meets regularly to give strategically together.

8. Leverage your giving. Increase your impact by challenging others to support the causes you hold dear.

9. Teach the art of philanthropy to the next generation. Instill in your children and the other young people you associate with the values you treasure and your commitment to support them. Be a philanthropy mentor to your family members and friends.

10. Enjoy your philanthropy. Celebrate life on your birthday with a philanthropic gift that you might not have thought possible. Philanthropy can be one of the most meaningful, rewarding activities in your life—and your legacy.

Resources on women's philanthropy

Organizations with an asterisk provide information on giving circles.

Association of Small Foundations
4905 Del Ray Avenue, Suite 200
Bethesda, MD 20814
301-907-3337, www.smallfoundations.org
A national membership association of more than twenty-nine hundred philanthropists that helps to guide smaller foundations with few or no staff leaders and administer their foundations.

BBB Wise Giving Alliance
4200 Wilson Boulevard, Suite 800
Arlington, VA 22203
703-276-0100, www.give.org
BBB Wise Giving Alliance is a source of information on larger, well-established nonprofit organizations.

Council on Foundations
1828 L Street, NW
Washington, DC 20036
202-466-6512, www.cof.org
The Council on Foundations helps foundation staff, trustees, and board members in their day-to-day grant-making activities and has a variety of information available on its Web site and in print. The council has interest groups related to family foundations.

Forum of Regional Associations of Grantmakers*
1111 Nineteenth Street, NW, Suite 650
Washington, DC 20036–3603
202-467-1120, www.givingforum.org
Regional Associations of Grantmakers (RAGs) are nonprofit membership associations created by private grant makers to enhance the effectiveness of philanthropy in their cities, states, or regions. New Ventures in Philanthropy is a national initiative of the forum. A local RAG and/or New Ventures coalition can provide information and resources based on philanthropic interests.

More Than Money
P.O. Box 1002
Concord, MA 01742
866-306-8200, www.morethanmoney.org
More Than Money offers publications, programs, events, and discussion groups to encourage and support individuals to examine the impact of money in their lives and to act on their highest values.

National Center for Family Philanthropy
1818 N Street, NW, Suite 300
Washington, DC 20036
202-293-3424, www.ncfp.org
The NCFP was established by a group of family philanthropists to focus on the importance of families engaged in philanthropy and their effective giving.

New Tithing Group
One Market Street, Stuart Tower, Suite 2105
San Francisco, CA 94105
415-274-2765, www.newtithing.org
New Tithing Group is a philanthropic research organization committed to increasing charitable giving.

Resourceful Women*
P.O. Box 29423
San Francisco, CA 94129
415-561-6520, www.rw.org
Resourceful Women promotes positive social change by educating and empowering women to make informed choices when investing, spending, and contributing their money.

Women Donors Network
1170 Hamilton Court
Menlo Park, CA 94025
650-833-6750, info@womendonors.org
WDN is a philanthropic community for those who refuse to accept the status quo. From supporting voter registration efforts, to funding international programs assisting women's quests for economic independence, WDN unites powerful, visionary women who are committed to effecting lasting fundamental change.

Women & Philanthropy
1015 Eighteenth Street, NW, Suite 202
Washington, DC 20036
Women & Philanthropy is an association of more than three hundred grant makers and others mobilizing the resources of the philanthropic community to achieve equity for women and girls. It is the oldest affinity group of the Council on Foundations.

Women in Philanthropy Internet Bibliography
http://www.women-philanthropy.umich.edu/booksreports/index.html
This annotated Web-based bibliography provides listings of dissertations, newsletters, books, articles, and Web resources for study on women and philanthropy. The University of Michigan Office of Development provides ongoing research and hosting of the site.

Women's Funding Network*
1375 Sutter Street, Suite 406
San Francisco, CA 94109
415-441-0706, www.wfnet.org
WFN is an umbrella organization for women's funds and foundations internationally.

Women's Perspective
421 Meadow Street
Fairfield, CT 06824
203-336-2238, info@womensperspective.org
Women's Perspective provides transformational education for women seeking to understand their spiritual and economic power. It provides a Web newsletter, seminars, publications, and programs.

Women's Philanthropy Institute*
550 West North Street, Suite 301
Indianapolis, IN 46202–3272
317-274-4200, www.women-philanthropy.org

WPI is a philanthropic service of the Center on Philanthropy, Indiana University. It educates, encourages, and inspires women to effect change in the world through philanthropy. WPI has national focus and provides programs of donor education, research, information delivery, and technical assistance to those working with women philanthropists.

202-887-9660, www.womenphil.org

Index

Other Titles Available

NEW DIRECTIONS FOR PHILANTHROPIC FUNDRAISING

PF49 **Expanding the Role of Philanthropy in Health Care**
William C. McGinly, Kathy Renzetti
ISBN 0-7879-8264-4

PF48 **Exploring Black Philanthropy**
Patrick Rooney, Lois Sherman
ISBN 0-7879-8085-4

PF47 **Reprising Timeless Topics**
Lilya Wagner, Timothy L. Seiler
ISBN 0-7879-8060-9

PF46 **Global Perspectives on Fundraising**
Lilya Wagner, Julio A. Galindo
ISBN 0-7879-7862-0

PF45 **Improving and Strengthening Grant-Making Organizations**
Joanne B. Scanlan, Eugene R. Wilson
ISBN 0-7879-7841-8

PF44 **Transformational Leadership: Vision, Persuasion, and Team Building for the Development Professional**
Stanley Weinstein
ISBN 0-7879-7653-9

PF43 **Fundraising as a Profession: Advancements and Challenges in the Field**
Lilya Wagner, J. Patrick Ryan
ISBN 0-7879-7271-1

PF42 **Philanthropy Across the Generations**
Dwight Burlingame
ISBN 0-7879-7408-0